# DRAWING FIRE

## The Diary of a Great War Soldier and Artist

PRIVATE LEN SMITH

Collins

Collins
A division of HarperCollins Publishers
77–85 Fulham Palace Road
London W6 8JB
www.harpercollins.co.uk

First published by Collins in 2009
This edition 2012

1 3 5 7 9 10 8 6 4 2

Editorial direction by Louise Stanley
Design by Richard Marston
Editorial by Kirstie Addis

A catalogue record for this book is available from the British Library

ISBN 978-0-00-731568-0

Printed and bound in Hong Kong by Printing Express

# CONTENTS

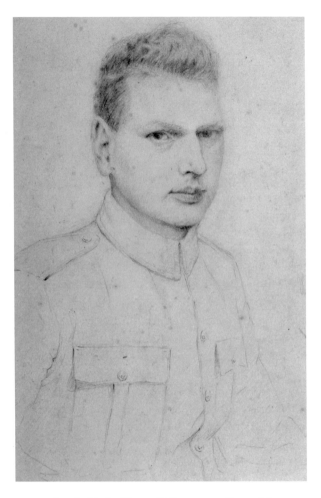

Len Smith, 'by Horace G. Rose – one of my pals'

# ABOUT LEN SMITH
# AND THE DIARY

Born in 1892, Arthur Leonard Smith grew up in Walthamstow, north-east London. His father Arthur George was born in Bicester in 1868; his mother Sara King in Lugershall Bucks in 1867. He had two brothers, Harold (known as Sid) born 1894, who was a gunner during the war, and Percy born 1900 (known as Nibby).

Len enrolled in the 7th (City of London Battalion) as an infantryman on 19 September 1914, his 23rd birthday. He saw it as his patriotic duty, which he described as a 'compelling urge'. His training was mostly completed in Watford, and he and his comrades sailed for France on 17 March 1915. He thought of himself as 'an ordinary bloke in khaki'.

The Battalion, known as the 'Shiny Seventh' due to their shiny buttons and badges under all circumstances, experienced their first major action at Festubert in May 1915 which Len described as 'general wretchedness ... everything just mud and water', and subsequently fought at Loos (September 1915), Vimy (May 1916), High Wood (September 1916), Butte de Warlencourt (October 1916), Messines (June 1917) and Cambrai (November 1917).

One of the biggest battles Len took part in was at Loos on 25–28 September 1916. This was the first time the British used poison gas, which unfortunately wasn't a success as the wind blew the gas back to their lines. It was during this action that Rudyard Kipling's son John lost his life; Robert Graves also

fought there. Estimates put British casualties at around 50,000, German about half that number. Len describes himself as being in a kind of 'weak trance' from the inhuman strain of the battle. He was almost the sole survivor of A Company's attempt to scale the Double Crassier.

In March 1916 Len was drafted to 140th Brigade Sharp-shooters as a sniper, 'a job I hated, but orders is orders', and became an observer and accredited War Artist with an official pass to work at large over the whole Brigade sector. Artists like Len were used as an early form of espionage, their detailed drawings enabling troop movements to be reported, and terrain mapped extremely accurately.

Brigadier General Cuthbert commanded him to prepare a detailed panoramic drawing of the enemy trenches facing the lines – this drawing took four days, during which Len hid in shell holes within yards of the enemy trenches (reached before daybreak and after dark), peering over the lip of the crater when he thought it relatively safe. He had to avoid sniper fire and mortar shells almost incessantly. The drawing was two yards long when completed.

After a severe bout of trench fever he was transferred to the Royal Engineers Special Branch works park (situated mostly in Belgium but transferring to Lille at the end of the war) where various ingenious devices were created for camou-flage purposes. Possibly his greatest achievement during this time was helping to create a hollow steel tree that was used as a listening post. Len crept within yards of an enemy head-quarters and drew the tree so accurately that a replica could be made by engineers, which replaced the real tree under cover of darkness. Underground tunnels led soldiers to the tree and they were able to report back on enemy movements.

During a 10-day spell of leave in 1917 Len married his childhood sweetheart, Jessie Hookham. They were childless. Post-war he carried on his work as an illustrator and notable commercial artist (including working on a campaign for Crosse

and Blackwell Jams), and spent his final days in Bexhill, where he took commissions to paint watercolours of houses in the area. He died in 1974, aged 83, sketching up until a few days before his death. His wife Jessie lived to the age of 99.

## LEN'S DIARY

Len wrote his diary longhand on tiny pieces of paper torn from a notebook, which he kept hidden by concealing them in his trousers, known as puttees. These were smuggled home, along with many colour sketches and drawings and souvenirs including two poppies taken from No Man's Land and a German prayer book taken from an abandoned trench (all but one or two remain in the book). Shortly after the war Len wrote up all his text into a carefully and lovingly crafted diary, along with his drawings and sketches. His skills as an illustrator were put to use in a unique way, creating this extraordinary record of life in the trenches. The diary includes over 350 illustrations, and covers Len's entire Army career from signing up to Armistice Day. Apart from an abortive attempt by Len to get the diary published in the seventies, it remained for years in a cardboard box until rediscovered by Len's great-nephew, David Mason.

## A NOTE ON DESIGN

In order to make it as easy as possible to read, some design changes have been made from the scans taken of the diary. Each of the pages is faithfully reproduced as they were in the original diary (bar one or two minor omissions) but the original handwriting has been replaced by a font (FCaslon).

Some pages have been left with the original handwriting to enable the reader to see Len's script in the original form.

*To the Reader*

In reading this diary – should you be tempted at times
to ridicule or deride its flaunting of all the accepted rules
of good writing (grammar, spelling, punctuation etc) it
will be well to remember that it has, with definite reason,
not been embellished or altered in any way from the
original scrawl in an old French note-book.

I preferred to retain a faithful copy of the diary
as written on the spot – "the spot" being oftimes sordid,
noisy, terrifying, wretched and utterly uncongenial to
clear thought and orderly writing – and thus, tho' it does
not possess literary style, easy to read and understand.
Yet I feel even in this very fact – it rings true and therein
lies some claim to your kindly interest, as a faithful
portrayal of the atmosphere which at that time prevailed.

It is a jotted down, rambling description of events
day by day, strung together anyhow (as life was then) with
no definite aim in view either to use or publish. Rather
a mere pastime, just as one would take a hand at cards,
or play the mouth-organ.

Remember too, there was always the persistent thought
in the back of one's mind – that it was all foolish anyway –
that no effort was very worth while, there might never be
a "tomorrow". Therefore, friend, take it as it is written,
a simple narration of how that big war in our time touched
the life of one, Smithie in France.

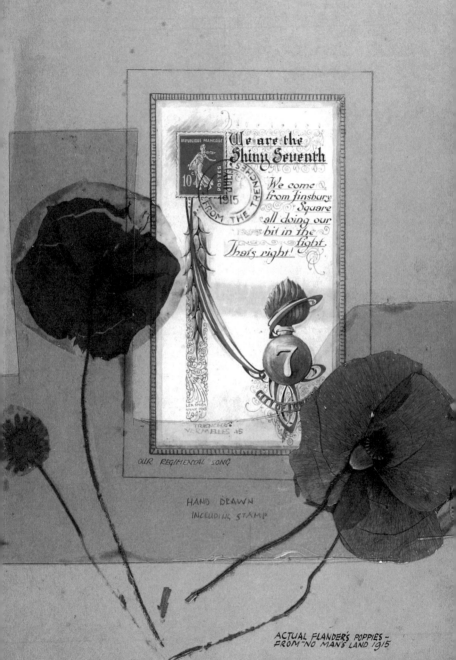

We are the
**Shiny Seuenth**

We come
from Finsbury
Square
all doing our
bit in the
fight.
That's right!

RÉPUBLIQUE FRANÇAISE
10 c
POSTES

FROM THE TRENCHES
1915

7

TRENCHES
VERMELLES 15

OUR REGIMENTAL SONG

HAND DRAWN
INCLUDING STAMP

ACTUAL FLANDER'S POPPIES —
FROM "NO MAN'S LAND 1915

USED TO DRAW THESE WHEN
OUT AT "REST" SOLD THEM FOR 1 FRANC (10ᴰ)

7

# A FINGER IN THE PIE

YPRES

ARMENTIERS

BETHUNE

LOOS

VIMY

ARRAS

SALT

7

Leonard Smith's
1914 - 1918

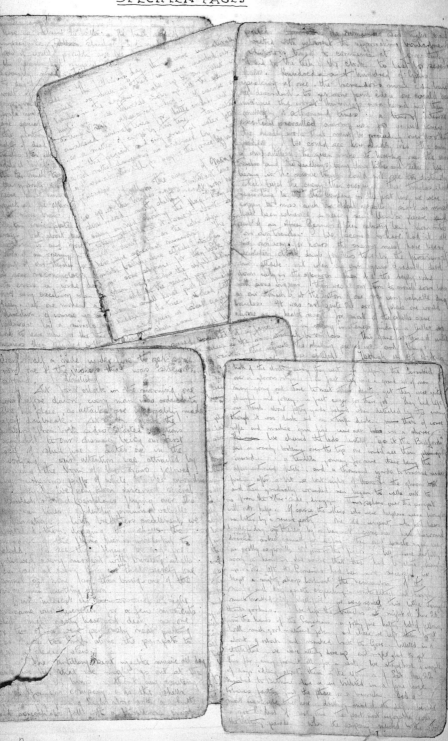

# My RE-WRITTEN DIARY of "THE GREAT ADVENTURE"

*Leonard Smith*

AS A "CIVIE" SEPTEMBER 1914.

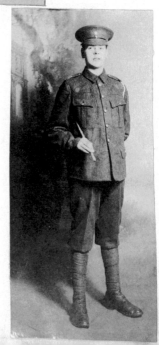

ENROLLED
14 SEPT
1914

Enrolled in

# "The Shiny Seventh"

7th London Batt?

Sept 14 · 1914.

The 7th London is a very gallant band. It hails from East London and is proud of it. Also it has its Cockney sense of humour, for it calls itself the "Shiny Old Seventh," and has as much zeal as any "crack" corps.

*WE ARE FIGHTING FOR A WORTHY PURPOSE · · · And we intend not to lay down our arms until this purpose has been fully accomplished.*

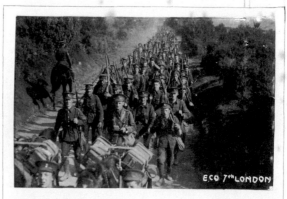

E.CO 7th LONDON

**OFF TO**
# CROWBORO'
*14 DAYS UNDER CANVAS*
*Mostly snow-rain-mud*

## THE TALLEST "TERRIER."

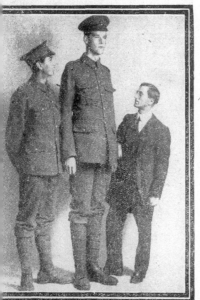

*"GEORGIE" CHAPMAN*
*My 6'9" pal. too tall*
*to sleep normally in*
*bell tent - slept sitting*
*with back up against*
*pole. Eventually allowed*
*to sleep on dining -*
*table in Marquee --*

rivate G. Chapman, a London Territorial, who stands
6ft. 9½in. in his socks.—(*Daily Mirror* photograph.)

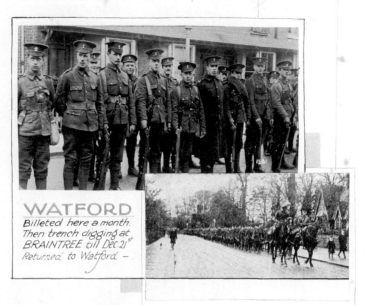

## WATFORD

*Billeted here a month.*
*Then trench digging at*
*BRAINTREE till Dec. 21st*
*Returned to Watford —*

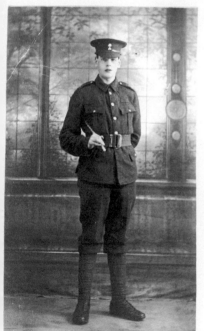

*Usual  Route marches - fatigues - parades.*
*Bayonet practise - firing — skirmishing*
*until we eventually*

## Sailed for
## FRANCE
### 17th MARCH 1915

WATFORD
1914

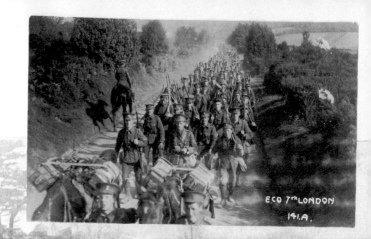

E.CO 7TH LONDON
141.A.

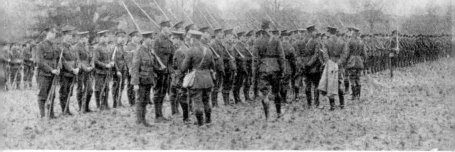

WATFORD    1914

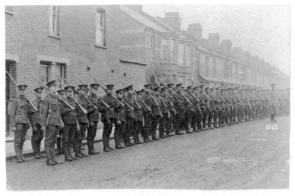

WATFORD    1914

# Arrived

Arrived at Southampton Dock, and after having some considerable time to spare – in which to stroll about watching the shipping etc, embarked at 10 o'clock in the evening.

Although all feeling of sea-sickness was happily absent from us – owing to the very calm water – I for one felt the seriousness and novelty of the situation being on board a troop ship, bound for the war zone.

The voyage seemed most weird – the little red and green signal lamps being the only lights discernible – the remainder of the boat merged into the pitch darkness of the night. Dead silence too prevailed the whole time, save the regular beat of the paddle wheels. Our boat the SS EMPRESS QUEEN was making wonderful speed. It was the well known pre-war pleasure vessel – reputed to be the fastest paddle boat known.

Soon after leaving harbour, we came upon our escort of cruisers, who made a

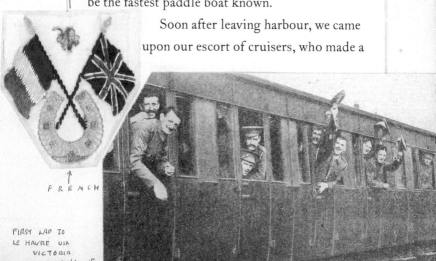

FRENCH

FIRST LAP TO
LE HAVRE VIA
VICTORIA
MARCH 15.

sort of avenue, ranged on either side – the length of our trip, keeping the boat's passage open, and safe by means of intermittent rays from most brilliant searchlights; no sooner had we left the range of one than we were covered by the beams of another. The one stationed at Portsmouth harbour was glorious in its brilliance, showing up the whole of the ship, like the rays of the sun. We reached Le Havre about three o'clock in the morning and remained impatiently aboard till long after daybreak.

 Eventually we disembarked – a thousand odd – sorted ourselves out and marched through Le Havre town. Our first impression of this large French seaport was not a bit encouraging, and the more we saw of it, the less we liked it. The town itself looked filthy and the kiddies were quite in keeping with it.

We were as a matter of fact rather "done up" not having had any sleep aboard owing to the excitement and our cramped quarters, so that when we came upon the hill up to the camp – it was cruel hard labour to stagger along – and half way up a halt was called to

enable us to lie down in the road – and get our "second wind" before continuing the ascent to OSTREHOUE camp some two miles ahead. When we arrived we found it to be a temporary base for incoming troops – where we were all jolly glad to stay for the remainder of the day and until the following morning.

The wind was bitterly cold and bleak at dawn next morning when we were hustled out to proceed to Havre Railway Station. A violent rushing about in the semi-darkness, no time for any food or a wash but packed off post haste – till finally we just had to hang about Havre station with chattering teeth till midday, most of the time sipping innumerable cups of stale coffee from a French woman just to pass the time away.

And then began a journey, that for sheer misery and discomfort knocked the ole Great Eastern Railway crowded fourpenny workmen's trains into a cocked hat. A sort of large goods waggon with filthy smelling broken floor, no seats of course, no windows, only a small opening, a mere slit in the side, like cattle trucks with a bar across and a sliding door, a small

glimmer from an evil-smelling hurricane lamp in one corner – and into this were packed or stuffed 46 fully equipped men for 26 hours, with rifles and provisions thrown in for two-days rations. To lay down for sleep was impossible, in fact to assume any position at all was a Chinese puzzle, we fitted each other like a jig-saw puzzle, and the man who engineered this mode of travel ought to spend the rest of his life packing dates.

At length this introductory trip through the "Fair Land of France" came to an end, and we were dumped down at a small station, of the village named BERQUETTE. Here we squatted about, tired, cold and hungry, wanting our "mummies" very badly, and proceeded to make a meal of bully and biscuits which went down with much relish, helped by a mug of tea we had procured through the engine driver letting us have hot water. When eventually sorted out and satisfied we settled down into a three hours' march to the little town of LA VILLE AUCHEL, which meant we were getting considerably nearer to the "front",

meeting on the way the inevitable dirty children running, whining alongside for " sooveneeer bisqueete", "ceegarette", and also the various undreamt of odours that seems part of France, or at least our particular bit.

I was eventually billeted in a stable, with eleven other chaps including my two chums Tom Wade and Jack Myatt at the back of the yard belonging to one of the town's myriad estaminets or beer and coffee houses.

JACK
TOM

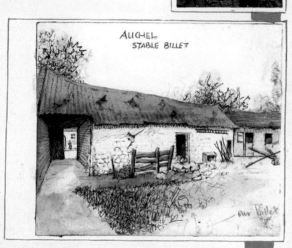

AUCHEL
STABLE BILLET

10 MEN LIVED HERE

OUR DESIRABLE RESIDENCE —(ALL MOD. CON.) AT AUCHEL 1915
"A FATE WORSE THAN DEATH" WAS TO FALL IN THE STINKING MIDDEN
WHEN IT WAS DARK

Our first duty to ourselves was to clear out the place, for we were the first humans to inhabit this home that "gee gees" had obviously only recently left. After which we found or "won" some boards and clean straw and made a comparatively luxurious compartment. I had just managed to be first in the crush to "scrounge" a blanket – claim a portion of the place for my "kip" – when I "clicked" for a 24 hours' guard.

This was rotten hard luck – for there was no guard room as we were used to in "Blighty", and for a sleep during one's turn off duty there was only the cold stones by the Church railings in the market square – surrounded by transport which had to be most closely and conscientiously guarded. It was awfully weird to me this first night

AUCHEL

MY FIRST NIGHTS "GUARD" IN FRANCE

AUCHEL

in the pitch darkness of a strange town to note the sky now and then light up – hear the distant boom from the guns and begin to realise how near we were to the serious business and all that we were bound to encounter before long. It was the first time so far one had been on guard with rifle loaded and orders to challenge *once* only before firing. It had its funny side too – when I suddenly pulled up a "dirty stop-out" Frenchman and heard his excited and frightened explanations before I said " pass friend".

When at last relieved – on going back to the boys – I was astonished to see the barber had been working overtime – and met my pal Jack with his head shaved to the skin and Tom who prided himself on his coiffure was like a shorn lamb too – minus his wonderful moustache. According to orders I followed suit and a brighter set of jail birds were never seen.

We were here kept busy on silly sorts of jobs to keep us out of mischief "Army fashion" – up at dawn, cleaning up buttons, kit inspections etc – till 8.30 when we were all sent to bed and tucked up comfortably?

AS YOU LIKE IT → AS YOU DONT

But we didn't go to sleep by any means, just settled down to make ourselves hoarse, singing all the marching songs we knew – "Mademoiselle from Armentières", "She's a Cousin of Mine", "B Bill the Sailor" and such time worn favourites till eventually the S. major bawled out that "he'd be very greatly obliged if we'd shut our pretty little mouths"?

We spent the next two or three days and nights like this, just sort of waiting for something to turn up.

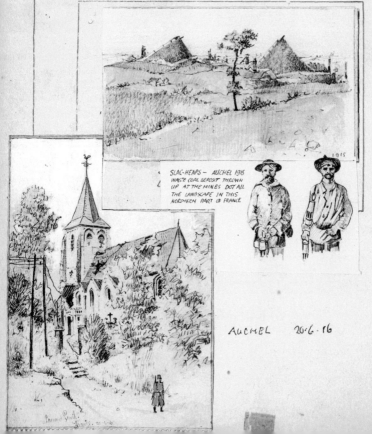

SLAG-HEAPS – AUCHEL 1915
WASTE COAL DEPOSIT THROWN
UP AT THE MINES DOT ALL
THE LANDSCAPE IN THIS
NORTHERN PART OF FRANCE

1915

AUCHEL   20·6·16

DISTANT MINES
NEW LE MINES

OBSERVER WITH
PERISCOPE

LITTLE STRAY DOG
WE KEPT AS A MASCOT
HE THRIVED ON OUR MAN
SIZED DOORSTEPS - (ARMY
BISCUITS)

RECIMENTAL
MILITARY POLICE
(MURPHY THE MENACE)
CAN'T THINK WHO'D
WANT A SKETCH OF
HIM FROM THE
FRONT - NEVER MIND
HIS MUM LOVED HIM,
(WE ALWAYS DOUBTED
THE FATHER BIT)

Bonne et'

Pte Mullin

DID THESE
LITTLE PORTRAITS
ON OLD SCRAPS
OF PAPER
TO SEND HOME TO,
TO MUM OR HER
FOR THE FABULOUS
SUM OF ONE FRANC
ABOUT 10P

Pte Scott Batchelor
1915

1/3/16

7. 3. 16

Nobby Clarks letter
" Dear mum please send me
a cake — ten bob and the 'Christian
Herald . P.S Dont forget the
Christian Herald."

Poor Ole' Ginger's letter
has'nt brought him any joy

LEASH·14 1916

Sam reads his good news
'for the hunpteenth time

("Dear Sam we've got a
young un") Kate

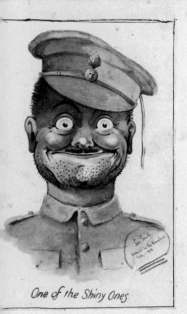

One of the Shiny Ones

OUR LITTLE WOODEN HUT IN THE
WOODS — QUITE HEAVENLY AFTER
THE SHATTERED RAT CELLARS
3 - 4 - 16

LEN SMITH 1916

Drew these at
rest or in reserve
trenches for pals
to send home.
1 franc each about
10 pence

LEN SMITH 1915

ESSARS
NR BETHUNE
1915

SO NICE TO SEE
A COMPLETELY
WHOLE CHURCH
THESE DAYS

OUR BILLET.   ONE OF THE COSIEST WE HAVE HAD.

ANOTHER BILLET.

14/7/16
Contains jolly dec
cellars which a
very useful wher
the Huns shell t
village – somew
too frequently.
There are obviou
signs qit have
caught a packe

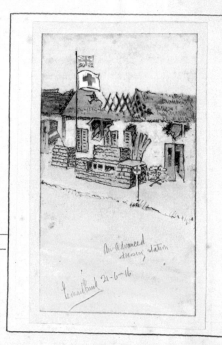

ADVANCED CASUALTY
DRESSING STATION
MANNED BY HEROIC
DOCTORS AND NURSES

1915
OUR PRIMITIVE GAS MASKS

OUR HAND GRENADES · TIN OF EXPLOSIVE IN A
JAM TIN · WITH A TINDER TO BE STRUCK ON A
PIECE OF EMERY ON THE SLEEVE · USELESS WHEN DAMP

THE EFFICIENT HUN GRENADE
HOLD STICK PUT FINGER IN
LOOP · THROW · LET GO HANDLE

Dear Jack — These are the
only "Birds" we ever see!

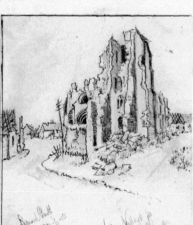

Leon Smith
20-6-15

Our Village
Smith

COMMUNICATION TRENCHES VIEW FROM OUR
DUG OUT
Leon Smith 6-16

SHELLED WAY BACK
IN THE LINE   17·5·15
ARMEL

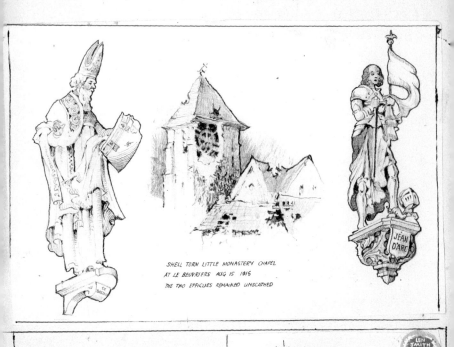

SHELL TORN LITTLE MONASTERY CHAPEL
AT LE BEUVRIERS AUG 15 1915
THE TWO EFFIGIES REMAINED UNSCATHED

JEAN D'ARC

ST BASIL?

THE SNUG

"A NICE LITTLE PLACE IN THE COUNTRY"
NO REASONABLE OFFER REFUSED
SMALL GARDEN - OLD ESTABLISHED TREES
POND.

Much to our surprise – on one of the long route marching stunts – we were suddenly halted on the road-side and in quite an informal way reviewed by Field Marshal French – he gave us a most inspiring address and expressed genuine satisfaction with our appearance – and our apparent fitness for the big job ahead.

The following morning we were ordered to pack up and in due course, moved to the town of BÉTHUNE some twelve odd miles further up, "foot slogging" – the roads now became increasingly difficult, so cut up had they been with transport and our heavy artillery. At BÉTHUNE we were quartered in a large block of buildings – which we

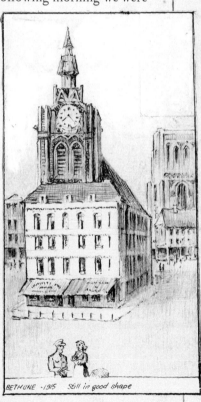

BETHUNE · 1915   still in good shape

found were pre-war Gendarmes' barracks. *Compared* with our previous diggings this place was nearly comfortable – just bare stone flags and one blanket between two but all so much cleaner than hitherto. Although this was a massive building of stone, the sky for the most part was our only covering – the roof having not long since "gone west" and a high hole rent in the wall and through the two storeys. (We learned nearly a hundred Indian troops had been killed here, by a heavy German shell having landed on the building whilst they slept at night. They were a company of the Indian Lahore division – fine fellows of whom we saw quite a lot in the FESTUBERT Sector.) Room was very cramped in our compartment with over forty fellows allotted to a space – made for the usual compliment of six gendarmes. Anyway we soon settled down and made ourselves at home – and in many senses were a very jolly party.

We were parked in this town for two days – and were allowed a fair amount of freedom – shopping in town,

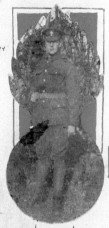

Going for walks and having a "cushy" time generally. This photograph was taken by a Frenchman at an exorbitant price - during our stay here. ◆ ◆ ◆
On the eve of the 25ᵗʰ March whilst we were in bed having our usual lusty sing - song before "bye bye"

the orderly sergeant burst in breezily with Company orders and the Colonel's congratulations to our "A" Company on being the first in the 4ᵗʰ Battalion to go to the trenches at six - o'clock the following evening 26ᵗʰ March. ◆ ◆ ◆ ◆

NOTHING is to be written on this side except the date and signature of the sender. Sentences not required may be erased. If anything else is added the post card will be destroyed.

I am quite well.

I have been admitted into hospital

{ sick } and am going on well.
{ wounded } and hope to be discharged soon.

I am being sent down to the base.

I have received your { letter dated 25 3 15
{ telegram „
{ parcel „ 27 3 15

Letter follows at first opportunity.

I have received no letter from you
{ lately.
{ for a long time.

Signature }
only. }     Len Smith

Date 15 3 15

[Postage must be prepaid on any letter or post card addressed to the sender of this card.]

(25343) Wt.W3497-293 1,760m. 4/15 M.R.Co.,Ltd.

MY 1ˢᵗ FIELD SERVICE CARD

We were all very thrilled at this, and cheered lustily –
quite glad to know our "playing at soldiers" had
come to an end and at last our chance had come to
put all our arduous training and preparation to
some sound practical test. Well the moment arrived
when we were all ready in our full war-paint –
loaded with two bandoliers each of ammunition,
iron rations for emergency, field dressings
stitched in our tunics,  identity discs around our
necks etc. and not forgetting the "hold my hand
mother" feeling – for we were all a bit subdued
at the notion of "a first night" up there – and
wondering how we'd behave when at last "really up
against it".        Our way lay by the LA BASSÉE
                    canal which flowed through

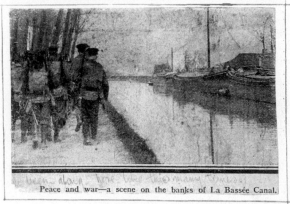

BÉTHUNE and GIVENCHY on into the German

Peace and war—a scene on the banks of La Bassée Canal.

lines – the water had been poisoned by them to prevent
its use for horses and in colour was bright yellow and
dirty from the filth and wreckage that came down from
the battlegrounds – many times we have seen swollen
green bodies floating along – Germans mostly – with
bits of houses, doors etc. The sound of rifle and gun fire
increased in intensity as we proceeded and frequently
the roar of long distance shells could be heard passing
overhead.

We followed the towing path for some two miles
then halted for a time at the swing bridge at GORE –
exchanging lots of good natured chaff with the old
regulars up here – after which we proceeded for a solid
hour and a half, and with every step the firing in the
distance seemed to grow in volume. We now began
to see on every hand – signs of strafe and wastage –
tremendous holes in the road, houses absolutely razed
to the ground, barbed wire running along either side
of the road. Dead horses, smashed guns and timbers –
everywhere some tale of hard fighting. Our way
lay through a cemetery – where the graves had been

SHELL HOLE
ALL OVER ROAD

821. La Grande Guerre 1914-16.
de-C.). Maisons démolies.

torn open, with results that can hardly be imagined, the church itself was merely a huge pile of stones – and the village of FESTUBERT nothing but ruins and desolation. Our first really horrible experience since leaving home.

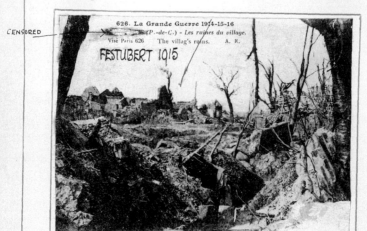

626. La Grande Guerre 1914-15-16
(P.-de-C.) - Les ruines du village.
Visé Paris 626    The villag's ruins.    A. R.

FESTUBERT 1915

We now had to wait for cover of darkness under-ground in some cellars in a state of pent excitement, which was not helped by the order "no more smoking". At last we were ordered to form single file across shell torn land – pitfalls everywhere – till eventually we stumbled on the trenches, occupied by the "Worcesters", which was

our destination – the enemy's line we were told was about 150 yards to our front. There were no trenches here such as we had always visualised – the ground being all too utterly wet, marshy and boggy – digging was out of the question; both the Germans and ourselves had resorted to sandbag breastworks. They are truly marvellous examples of man's work in their own peculiar fashion. Tens of thousands of canvas bags had been filled by these tired weary men – in terrible haste and constant danger – a never ending wall to keep out death and agony where humanly possible.

These breastworks are some six feet high, and quite five feet wide with occasional little niches left to fire – or *cautiously* look through. Sections are arranged like this with traverses – to accommodate a little group of six men – the idea being to limit the effect of

a shell burst. Goodbye to the blokes in that little area – but those the other side would live to fight another day.

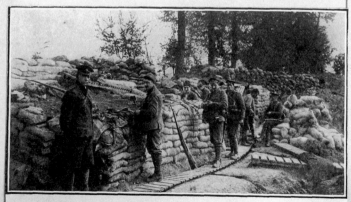

ON THE WESTERN FRONT.
British troops in the first-line trenches

AN 'OLD BILL' AND 'GREENHORN'

We found the "old sodgers", with whom we were mixed, jolly fine men, wonderfully good natured and helpful to us very "green soldiers" – happy to put us up to all the tricks of this new trade.

We were placed in our sections, that is, told off to our own little patches of wet puddled clay – and look-out men were picked and posted to duty. This meant a sort of sentry duty. At night time the job being to keep one's eyes glued ahead in the direction of the enemy's line in case of suspicious signs, to give the alarm and fire – and by daylight to keep constant vigil through steel plate peepholes.

The Germans proved very hot shots in this neighbourhood, and to show oneself above the parapet was almost equivalent to suicide. Reg Stone a pal of mine fired at something through his loop hole – and almost immediately back came a bullet through the aperture and into his arm. He was a very astonished, as well as a badly wounded, man and it taught us to be wary.

We made ourselves as much at home as possible and were jolly grateful to be shown where to get water though

it meant a mile's treacherous walk in the dark, over slush and debris – and when it was at last procured smelt and tasted of Lyddite.

At an hour before the dawn every morning *all* those in the line have to mount the firing steps in an attitude of preparedness – experience teaching that attacks from the enemy invariably occur at this time, when it is most difficult to see. It's truly a real "Monday morning feeling" to be roughly wakened from a nap (if one is off duty) and made to mount the fire step – in the chilling cold all dark and eerie – one even imagines the tree stumps to be Germans, and any burst of firing the prelude to an attack.

At seven o'clock on our second morning the artillery from both sides started up at once and led off in grand style – somewhat to our dismay – it was our first taste of battle and a really hot strafe it proved for more than an hour and frequently the call for "stretchers" was taken up from one mouth to another along the line.

Later on in the morning our

BUTTERCUP

FROM "NO. MANS LAND"
FESTUBERT 1915

attention was attracted by hearing the boom of guns followed by numerous puffs of cotton wool smoke in the sky – this was our first experience of shrapnel, then we discerned several British and French aeroplanes circling about overhead and over the German lines – flying low enough at times to draw rifle fire from the Huns. We watched this new show with breathless excitement, and were staggered to see the calm, unexcited manner with which the airmen would control their craft – despite the bursting shells and imminent danger of being brought hurtling down – maybe right into the Germans' hands. Our interest in the unusual sight (to us new "trench wallahs") overcame our discretion for a few moments and might easily have cost us dear – had we not had a sharp reminder in one poor chap having a sniper's bullet put through his head – he having popped up above the safety level of the parapet to get a clearer view.

WE KNOW OURS
BY THIS ON WING

The Artillery kept up the music all day, in different bursts of frenzy and then died down, but not to our immediate danger – as the shelling was heavy stuff that goes high overhead with a long whine,

a whistle and a thunderous crash a mile or so beyond the front lines; English and German – just replying to each other – incidentally demolishing the remaining bits of village in the way. But our own particular share of the show came about tea-time, for the Germans opened with shrapnel some 400 yds to the left of us, and not very far in the rear, we thought it must be more aircraft. But to our dismay we saw the shells bursting nearer our bit of trench and they were evidently making a mark on us – maybe thirty or forty came over, creeping closer each time till they began to burst right by us and our cover was practically nil – we could only duck behind a few odd boards and sandbags. One piece of shrapnel pierced a neighbour's mess-tin and set a box of matches alight; he had to have a coat thrown at him and be rolled in the mud – but did not escape a severe burn on the back. There were some very nasty wounds handed out in this little strafe and we were mighty relieved when finally the spasm died down and thus ended our first lesson, our real baptism of shell fire.

At last our time came to be relieved and we

started slowly trudging out of the line about 8 o'clock when it was sufficiently dark. Snipers seemed to be aware of our route back and potted at us quite a lot, one man getting a bullet through his cheek whilst yawning – it went clean through his mouth and out of the side of his face – just enough of a wound to send him to back of the line for a nice rest. Lucky beggar.

We came back to an old, badly knocked about chateau and were left to our own devices largely, so long as we kept to the cellars and showed no movement to the enemy – we made the best of the opportunity to have a good sleep – before embarking on our next stunt which we were detailed for the next evening: a fatigue party which we were to learn is a very precarious job indeed, if anything worse than actually staying in the trenches.

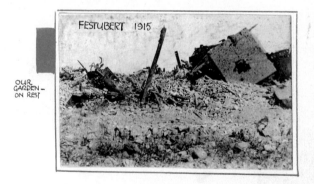

FESTUBERT 1915

OUR
GARDEN –
ON REST

Our job was to carry hurdles, stakes and sandbags up to the firing line to be used in the extension of the breastwork trenches, every inch of the way is beset with danger and difficulty – through the utter darkness and no lights to be shown. Our billet out of the line here was a sort of dump – and the stuff was brought thus far by the transport for us to hike on foot to the line. A Sniper troubled us a great deal from the start, and potted at us as we passed by a certain spot – very frequently – (he was located hiding in a tall tree at the back of our lines eventually and reached it each night through a tunnel

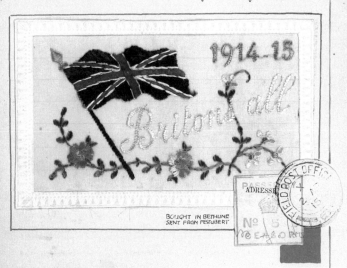

1914-15

Britons all

BOUGHT IN BETHUNE
SENT FROM FESTUBERT

ADRESSE

PASS
No 5
CENSOR

FIELD POST OFFICE

running underground from his side to ours). Part of the journey on this "working party" took us along a road covered by the rifles of German snipers and from its position and reputation well deserved the name of "Suicide corner". Here bullets whizzed by within inches of our heads and now and then somebody crumpled up with a moan. A fellow in front of me got a real fright – he was carrying a large box of our famous Army biscuits and a bullet suddenly hit the tin – making a frightful din especially when he dropped it in the eerie silence. One instinctively ducks on hearing the whistle of a bullet but it's silly really – the one that is heard has already gone past. After a bit one realises it's just as safe to go straight on and not bother. The chaps say if it's got one's name on, it will get you anyway.

Well we delivered our goods eventually and got back to our "kennels" having taken hours to do three or four miles all told – there's so much halting, "mind the barbed wire on the right", "look out shell hole on left" and falling flat on one's "tummy" when the Very

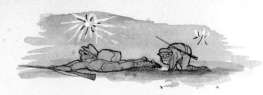

lights go up – to slop down in a puddle of mud at home would win a ticket for "Colney", but out here's the vogue many times during a night.

Whilst on duty in the trenches the next day I saw a man get shot through the head – he had fired through his loop hole and foolishly waited to see the effect of his shot. This is not at all an unusual case although the aperture's only about 2" x 9". The Germans here at least are jolly good shots and not as English papers would have you believe. It seems somewhat incredible that they find such a target at about two or three hundred yards range, but we understand they have their rifles fixed mechanically onto our peepholes, which they find by means of telescopes attached to the rifles and also by exact spotting of the flashes we make when firing through at night. One must of course *never* look over the top in daylight and so there's a very strange fascination about a peephole.

LOOP HOLE

We keep them covered with a cloth but sometimes one feels an irresistible desire to cut out the dread monotony of doing nothing, and have a jolly good look round, despite the feeling it may be a final one.

A pathetic sight called our attention on the way up here – a very crude war cemetery – just numerous mounds of earth thrown over the bodies with rough little pieces of wood, and here and there crosses placed by a chum. Here one saw that great haste had been necessary and so arms and legs in tattered uniforms were left protruding in many cases.

We were only in the line for a few days and then came back to do more working party duties. One of these jaunts took us through the one time small town of Givenchy – which had been inhabited by about six thousand – but now not a soul remained.

This place had been taken and retaken many times – and shelled, so that scarcely any building was left standing. Greater ruin could scarce be conceived. Broken chairs, beds and household goods laying about

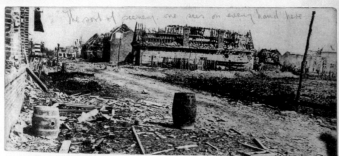
The sort of scenery one sees on every hand here

everywhere all in a jumbled mass, the roads broken with tremendous holes.

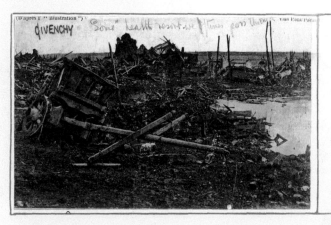

A large church which had almost been brought low by shells stood in the midst of a churchyard and here again we saw the repetition of a startling fact that has been noticed by troops again and again in many parts of the shelled area – a massive crucifix which the French so much adore, still standing intact among a sea of debris; all around shattered and yet this untouched – miraculous.

It looked most impressive and majestic in the brilliant moonlight – and gave rise to many serious

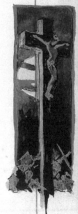

thoughts and discussions even among the boys – who scoff at any other demonstration of religion.

Our job this night was more of a navvying nature – we were dished out with picks and shovels and taken to some spot, not so marshy as the rest, where we were set to dig trenches. Still we got very well plastered over with wet clay – and I felt we were like a lot of human spoons just stirring round in a mud pudding.

OUR TRUSTY TOOL TO ENABLE US TO BURROW LIKE RABBITS

Every now and again machine gun fire would sweep across in our direction making us pretty glad to be getting deeper. We were kept hard at our job for some hours, then were told to pack up in time for us to get out of the enemy's sight before dawn. We were taken back to our old barracks at BÉTHUNE, our way laying past the LA BASSÉE CANAL and before we concluded our trip we witnessed a most gorgeous sunrise – I've never seen the like before. It was a treat after being in the pouring rain all night, or at least the greater part, it came suddenly and left off the same way.

That day and the following we were given quite an easy time, much of which was spent in scraping ourselves clean and having paltry little kit inspections.

On Thursday 1st April at 6 o'clock we were paraded to move off for the firing line – which was to be a momentous occasion as far as I personally was concerned. We moved nearer and nearer to the danger zone – and at a spot halted, loaded up with ammunition and waited till it was completely dark. A guide then came along to pick us up and lead us to a new destination – we were to occupy the line to the right of FESTUBERT this time, in the centre of the district known as GIVENCHY brickfields – a place of dreadful repute mostly tenanted by our Guards, and on the enemy's side the Prussian Guards. A truly "hotshop" we'd heard it called (and it was). This was rumour so far – we were not there yet. Our way lay through what looked in the gloom like a fine avenue of massive Poplar trees – then across some fields and along a winding narrow road.

We were split up into two little groups – squads – about 16 in each with intervals between each squad so that should a shell burst it would only account for the limited number together. I was on the left of the first row of no.1 squad – when Lieutenant "Bunny" Prince turned round and said "Smith, pop back and see if the water cart is following". I went back a considerable distance and stumbled across them somehow, then retraced my steps trying hard to find my way and catch up with my little crowd. Bullets were often whizzing past and I was suddenly startled by a sentry jumping out from nowhere it seemed to warn me to crouch low from that point and be very wary – that was his special job. Well I did *not* waste his advice you can bet.

At last I came across the boys but to my alarm they were sprawled flat all over the ground and somebody hissed "lay down you 'B' fool" – again I took advice and, laying down, crawled to where my pals were; then I found my own special chum (from Watford days onward) had been shot in the stomach by a rotten Sniper. Tom Wade was a "dear old chap" only 23 years of age.

We had to leave him to be attended to by the stretcher bearers and proceeded warily on our journey, I for one very crestfallen. It was odd to learn that when I was told to go back, on the errand about water, Tom had stepped up into my place – so that I evidently escaped his fate, quite by luck. Nearing our destination we had a final stretch of open road to traverse and were suddenly very surprised and alarmed to be bathed in the beams of a searchlight from the enemy's lines; of course it caught us unawares and made us an excellent target for their marksmen. We flopped very unceremoniously on our tummies – but were not all quick enough to escape a "packet".

When we got to the trenches – the Inniskillings were very bucked to see us – to welcome us new tenants of a plot of ground they themselves had got very sick of. We had the usual good natured chaff and banter, they telling us "we'd entered into the gates of hell", and we boasting "we'd have the war cleared up before we finished our spell".

Anyway we settled down – sentries were posted all along the firing steps, and the remainder allowed to sleep if possible. I went with two or three others

UNDER ENTIRELY NEW MANAGEMENT

LITTLE BOARD HANDED OVER BY OUTGOING TROOPS

scrounging about at the back of the trenches for some wood and made a bit of a fire in a brazier – we had to be jolly sure not to let any undue glow appear above the breastworks; it was so bitterly cold this night – freezing in fact, and we were foot sodden with wet cold mud. We soon found "the brickfields" GIVENCHY all we'd been told to expect – there was constant expectations of raids, and Very lights were used galore. We were ordered frequently to put a burst of rifle fire over – during the night – and one man detected a German working party or listening patrol quite near our barbed wire (they'd been surprised by a sudden Very light) – of course we gave them a hail of shots to share among them. Rifle and machine gun fire was the only order on the menu until a little after dawn – when we were first introduced to those mortal terrors – trench mortars – they are *the* limit, like huge toffee apples sailing over rather slowly in the air. They have been brought to a fine art by the Germans – they send one over to the left of a section one moment, we all scoot to the right and by the time we arrive panting, another one has been sent and is about to drop among us – we run back and almost fall into one another – terrific explosion. It's impossible to describe how much damage, death and destruction they're capable of. The enemy keep this up for several hours at a stretch – we try to

THE "WIND UP" WHISTLE

help things by posting a man with a whistle – one blast when he sees one coming over left and two when the direction's right. Of course don't think all we do is to bunk from the stuff that comes over – far from such is the case; if one is on sentry and the larger percentage are – then one has to stick where placed and risk all that's coming. When on duty we sit on the fire step holding the rifle aloft with bayonet fixed – to which on the point is affixed a small looking-glass – a primitive periscope. We see quite a lot of the front – we very rarely see any signs of life from the enemy but give constant alert vigil for any tricks. Through my mirror here I have seen several of our khaki bodies strung on the barbed wire in front of the Germans there – some listening patrol caught, or engineers or attacking party maybe. And it has been too dangerous for any to go out and bring them back – it would only multiply the dead to no purpose. There's been a Gurkha entangled on the wire – minus legs – just in front of our barbed wire since before we came here – and at different parts of "no man's land" are strewn different bodies – German and English – in most grotesque positions.
I had held my periscope up only twenty minutes before it was

OUR FIRST
PERISCOPE

MAROC 1915

PERISCOPE VIEW OF HUNS TRENCHES
FOR THE SENTRY ON DUTY

shattered by an enemy bullet – evidently it had gleamed in the light and been seen "over the road"; this was a common experience, the Hun made a mark of them. Jerry did not have things all his own way – we gave a pretty good account of ourselves in many ways – a bit more if anything than "tit for tat".

It was a pretty tough place to get food and water to, anything hot to drink was out of the question, so that after three nights and days we were tired from very little sleep and perishing hungry, and were cheered to know that at night we should be relieved again. We left this place in a snowstorm and finally slopped down into billets at BÉTHUNE.

IRISH STEW
SERVED HOT
(SOMETIMES)

Next morning it happened to be Sunday and although our breakfast was not brought up to us in bed – we were allowed to stay in "kip" till pretty late – then we had a real hot, steaming dinner and every bit was like gold in value after our comparative privations. During the afternoon, while I was sitting about writing letters with the other boys, the orderly sergeant entered our room with the sad news that Tom Wade's stomach wound had proved fatal in hospital. This was a real shock to us – he was a bright lad, the "life of the party" – and to me especially it was a blow, because we almost joined together, and billeted at Watford, we had such a fine

farewell sing-song with his people – his girl, and friends and it had ended like this.

I was known to be his close pal, and was allowed to go to the mortuary to see him – only a poor ghastly white face, the rest swathed in white sheets ready for burial. The following day – no.3 squad – Tom's squad paraded at the hospital and with three others I had the privilege of acting as a pall bearer to the cemetery – just a plain unvarnished box with draped Union Jack – about 30 of his acquaintances marched behind. I had seen many dead by now – but this all seemed so much nearer home to me. His grave was one among two or three hundred, all with strange little white crosses – the following day we collected all the francs we could muster – *not a fortune* – and asked permission to make a special pilgrimage to take a bouquet of flowers to our old pal. A funny French bouquet of strange beads was all we could get.

Wednesday April 7th we paraded at 7 a.m. for a march back to AUCHEL, arriving about midday. Here we returned to our aforesaid billet, and spent an hour or two trying to make it in some measure habitable.

THE LAST OF DEAR OLD TOMKWADE

OUR FRENCH WREATH

Our immediate neighbour a pig – a big black fellow, seemed to recognise us as old acquaintances and grunted a welcome.

Our stay at this place took the form of a rest period – in name only – for we were not given a moments rest from 6 o'clock reveille till bedtime. We had to keep up our name ('SHINY SEVENTH) all the time – shining buttons – & kit inspections – long route marches etc. We had some very arduous training in bayonet charges and attack formations – together with skirmishes on a large scale with the rest of the brigade. It had been raining from the time we came to Auchel till now – but it had not prevented us carrying out these stunts and incidentally getting us quite hardened to all weathers.

The countryside hereabouts is so very different to English scenery – chiefly owing to an absolute absence of hedges, either side of the road – or between fields – as we are accustomed to.

Another unusual sight here – is to see quite a decent sized cart or barrow drawn by dogs in harness, sometimes a team together composed of four will pull a waggon with a women sitting on the shafts.

Some of the men and boys who work in the collieries round about here – present a most ludicrous appearance, with their iron hats – or leather caps, their loose blouses in which they

GET OUT O' BED
YOU LAZY B——

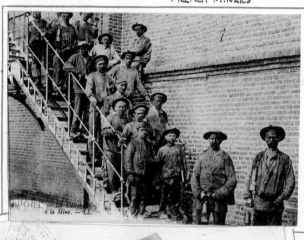

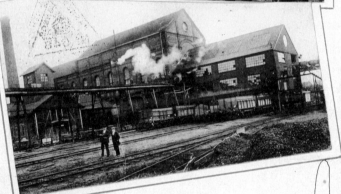

Stuff their grub,—and their flimsy trousers. they have wooden clogs, coal black faces, and always a little barrel of beer, strapped on their backs— an idea some of our boys would love to copy.

'THUMBS UP'
FOR THIS
'DREAM PACK'

We were taken to the baths at the biggest mine here, and it was a mighty welcome experience – a real hot wash. The miners are fortunate in their equipment – quite the best devices one could imagine – there are two or three hundred separate compartments, for each man has a shower bath to himself. A cute wheeze to prevent pickpocketing is an arrangement of ropes – they are attached at one end to the wall in a little case that has to be unlocked with a key, having a corresponding number; the rope runs up the wall then along the ceiling and comes down the centre fitted with about six butcher hooks; one unwinds the cord – lets down the hooks – hangs boots, trousers, coat etc on, then pulls them all up to the high ceiling.

Tuesday – 13th late in the evening we paraded for what was called a night concentration march. Four platoons of a company – taking each a different route proposing to arrive at a prearranged destination with all speed and as nearly together as possible. No. 3 Platoon moved off at ten o'clock and started on a very enjoyable march – we were not allowed to smoke or even whisper – why goodness knows, it was pitch dark. And after about four miles we left the road and proceeded single file down a bridle path through a

field – then had to tear our way through a thicket; we were in a nice muddle, had to be dumb – and kept barging into everything. We eventually got out in the open and came upon what seemed in the darkness a massive wall. Our Officer got very excited – had quite lost direction and we were soon following him up what turned out to be one of the slag heaps. We were choked with coal dust getting as black as niggers and all sense of dumbness was gone – the language was darker than any coal. As fast as we tried to climb – so we went tumbling down in a shower of slag. The only thing to be done was to retrace our steps and give up trying to meet the other crowd – this we did and got back to our billet long after dawn and hours after the other platoons had been in bed. We *were* bucked – oh yes! very – with our guide and friend ? the officer.

At two o'clock in the afternoon we had a sudden message and were bundled out post haste, marched off very hurriedly and after a couple of miles pulled up, stood to attention, and were inspected by Sir Douglas Haig. He was impressed with us – *so he said* – but I think we were more impressed by seeing him, in the flesh – and greatly inspired – he looked so

Sir Douglas Haig

wonderful and imposing as a soldier on his horse. It seemed to do the boys a lot of good – to be sort of noticed by so great a man. Of course – despite our hurried scamper to keep the appointment – we didn't look too bad. Our buttons were always shiny – wherever we'd been or whatever we were doing. The "Shiny Seventh" was a difficult name to live up to sometimes.

"NOMATTER WHERE YOU ARE – LET YOUR BUTTONS SHINE AFAR"
"The SPIT & SHINE BOYS"

We left AUCHEL next day – and took a different direction stopping at the village of ALLONAYNE. Here we settled most comfortably – in a stable – but with nicely constructed straw beds, and even electric light – due to the fact that a crowd of Engineers had been billeted here for a long period. The old farmhouse folk were exceedingly kind and would make coffee for us at any hour we liked for two sous a time. It was our chief song all day – "Caffay O'lay manure please".

OUR LANDLORD AND LANDLADY

We had quite a sort of holiday at this small town for about six days – then one lovely sunny morning April 19th, we packed up and made once again for BÉTHUNE, to be eventually billeted in a French schoolroom and not the Gendarmes' barracks as before – it was a change for

OUR "SCHOOL BELL"

the better, for instead of one small window high up in whitewashed walls, for a big crowd of men, it was practically all windows allowing us the air we were used to and plenty of light – the cooky waggons were in the playground and in one way and another it was all rather jolly. There was only one little tap for the kids' drinking water, for the use of two hundred and fifty men (from the three rooms) and was the scene of many civil wars.

OUR COOKER IN THE PLAYGROUND

FIELD KITCHEN DAILY MENU DINNER · STEW LUKEWARM AND GREASY CUBES OF FAT BOBBING ABOUT LIKE CORKS · TEA WAS BOILED IN THE CASUALLY RINSED COOKER POT · LIKE THIN GRAVY BREAD DRY OR SOAKED , WITH TICKLERS MUDDY JAM . SUPPER "NEVER GOT NONE"

We were kept hard at it – running parades, rifle drill and so on, and then were free till nearly dark – when each evening we were taken up to the line the back of QUINCHY for working parties, mostly carrying heavy boxes of ammunition – food, or the mail. We so often have to bolt down into a ditch or hole or flop down for machine guns that almost invariably the loaves of bread (if any) get soaked and the letters get all smudgy and blurred. But neither depreciate in value to men hungry for food and news. It's all done at great risk of life – because the enemy knows full well the wants of the front line, and that crowds of men are out at night trying

to supply their needs somehow.

We did this for about a week, then on St. George's Day April 23 reveille sounded at 4 o'clock, breakfast at 5 – of dry bread and mustard pickles. Ooh! And we were away to the first line of trenches at six o'clock (the first time we had started for them in daylight), the reason being we were going to a different section, more to the right, nearer LA BASSÉE and about 3 miles from the front line in the communication trenches. We were shelled heavily long before we got to them however and, although we were in single file, many casualties occurred – in fact we had an awful hectic time, lads here and there suddenly crumpling up – killed or wounded – shrapnel was playing havoc with us; it all seemed so unreal and fantastic to be crossing a field thus with the sun shining beautifully and birds singing, and yet perhaps in a minute or two would come one's turn to bid it all goodbye.

It was at last a blessing to scramble into the comparative safety of the communication trenches.

They are truly wonderful pieces of work, allowing one to travel at least eight feet below the ground surface, in safety at least from rifle fire and machine gun wickedness, their shots skim above the top. As the crow flies the actual distance covered would only be half as much, but they are purposely built all zig-zag and winding, to ensure greater immunity from shell fire. There is only just room for one man to pass another and here and there we come across cute little dug-outs where chaps are to be seen cooking, writing or playing Solo – they are supposed to be at "rest" really in support – to be near at hand in case of emergency in the front line. The trenches themselves too are very interesting here, with human touches – they cross and recross each other like streets and even have names painted on boards – there's "Coldstream Lane", "Glasgow Road", "Harley Street",

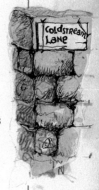

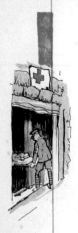

"Old Kent Road", "Hertsford Lane" etc. all giving an unmistakable clue to former occupants of these "front seats of the stalls". There are also special underground dug-outs for the ambulance stations and company stretcher bearers.

We arrived at our special bit of the line, which was a part of the famous brickfields, and relieved the Sixth Battalion who certainly seemed very glad for us to "hold the baby" – they had had a rough time and gave us dark hints as to what to expect. We saw here that the miners were at their deadly work down in the tunnels towards the enemy. I was ordered to go along to our extreme right with a corporal and my pal Billy Must, and remain in a sap. This juts out into "no man's land" quite a bit, in advance of the front trench and within 50 yds of the Hun – rather a lonely exposed position. Our job was to keep especial watch on a mine crater opposite (through the periscope) – it was so near to us that the Germans could have

leapt over in a few seconds – we had to ensure
they did not surprise the lads in the line. The nasty
part of this stunt was the constant whirr-whirr
of the German miners boring underneath us, and
the feeling we all might go sky high at any time.
This period in the line was a new experience in
shell fire – both sides kept up fire day and night –
whizz-bangs featuring especially on the menu. The
Germans would have a jolly good hour at us with
shrapnel and evil smelling Lyddite – a dose of
rifle grenades for luck – finishing up with a nice
hot black pudding or two of trench mortars – then
our Artillery would pay back with interest, and
we'd be praying for cotton wool or something to
deaden the noise, and more cover to keep off the
deadly peril that hemmed us round. The trenches
would suddenly be caved in and in running to
get help for some poor bloke one would find
oneself almost in view of Jerry – through the gap
made. I had gone round a traverse to have a jaw

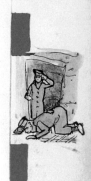

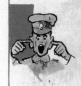

with a pal (during one of my reliefs) when a most terrific explosion occurred behind me, knocking me over with the concussion. I looked round to see the spot I'd just left, one mass of black smoke and flying debris. This was a shock for I felt sure they'd got two of my chums I'd just passed. One only was in a nasty mess, the other had dodged it somehow like me – we patched ole Fred up somehow and then had to "set to" to remake that bit of the trench. It was a trench mortar – and it's interesting to read a "Daily Mail" quotation about them I cut out of a paper sent with some tuck from home: "The feature of these projectiles is that if they fall into a trench, they kill any human within ninety feet – the air pressure tears the lungs to pieces". That's that – will you take one with you sir – or shall we send it home in a plain van?

We were in a considerable spell this time and began to get a bit worn and jaded. The "Shiny Seventh" were as bright as could be in spirit but you'd laugh had you seen them after several days

NOT A NASTY DESEASE · BUT OUR BIT OF SHELL PITTED GROUND WITH TRENCHES RUNNING THROUGH.

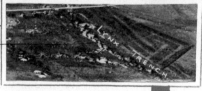

– not so bright and
spic and span – but
rather more business like in every way. There
being no spare water for washing – no shaves, hair
close cropped, clothes torn, shrunk and generally
mucked up, hats all wibbly wobbly with the wires
taken out, and so-on gradually getting down to
"Old Billo" and "brass tacks". Our boots began to
stick to our feet like our togs – not having been
taken off for so long.

   Then one evening we were relieved as soon as
it got dark and we wended our way back to our
own previous billets, getting into "bye-bye" none
too soon.

   We were off again early next morning and in
for a real good march to another small town about
five miles south of BÉTHUNE – LUPIGNY.
Perched on a hill top – commanding a gorgeous
stretch of country – we were put into quite comfy
billets (for our tastes by now were not fastidious)
and remained here several days – moving again

HA! HA! NO SHAVE :
HE! HE! NO RAZOR
" WATER

on Monday 3rd May, to within a mile and half of the line at GORE which we had already passed through earlier in our travels, by night.

(Here we met our *other* most dread enemy of the war in large numbers – the straw in our billets not having been changed for weeks we were soon smothered in lice and so spent all our available time trying to catch the beggars – they became the burning question of the day as we bought candles to drop them in the flames.

ONE OF OUR MORE LOUSY JOBS

When once a family moved into the seams of one's trousers or tunic – they were faithful unto death and never left us.) We were at GORE a day or two then received orders to parade at seven in the evening for the firing line – having had some experience of French life by now we made a point of rummaging round the one or two funny little shops (windows all boarded up etc.) and bought whatever we could afford, or they supply in the way of grub. I got a couple of typical French loaves – the size of a cartwheel but no real guts in them and several bars of muddy chocolate –

FRENCH LOAVES STRAPPED ON HAVERSACK. –

and at 7 sharp our whole crowd wended its way toward the fireworks. We met a real soaking downpour with a display of lightning such as I for one had never seen before – it was terrific and the thunder too – we were as blind as bats and to make things more difficult we had to cross and recross a stream over narrow planks; more than one mistook direction and puddled about in the stream, which was shallow it seemed, but smelt atrociously. By gum! it seemed an endless nightmare of a journey until we struck the communication trenches. In the intermittent periods between the lightning and thunder the machine guns were busy from the enemy – which was very inconsiderate of them considering our plight.

In the diary there may seem to be a rare lot of repetition – a sameness – sort of "up the line" – "down the line" – working party – then trenches, and as a matter of fact this seemed to be the whole character of our job so far – very monotonous and dull for the greater part, no occasions for displays of dash and daring to

*one man quite collapsed in this storm – with shock or what seemed to be a thunderbolt there was such a terrific crash*

DUG-OUTS

A BIT MORE OF THE OLD HOME

write home about, no knowledge that we were winning or losing or doing anything to make history sound bright and snappy. We just lived in mud and an endless series of discomforts – tried to remain as chummy and cheerful as possible with each other, hoping for the best and trusting it would all be worth our while somehow – someday.

Well getting back to those communication trenches they were as slippery as a "Jew on a business transaction" and as much as we could do to proceed. One foot would stick and sink in, then it would pull out with a "squelch" and the other would then sink and be immovable – it must have been hours before we completed our journey. We were now situated at a spot known as "Brewery Post" – though one would need a wonderful nose to find any brewery. The place seemed fairly quiet for our first night and in the morning; after quite a breeze blowing up from our side – then theirs – the guns quietened down and we thought of breakfast. I had long since lost my precious loaves on the journey up and had to be content with biscuits and bully.

Bully is quite interesting – taken continuously

GET A
'MOVE
DUCKS'

for the first six months – after that a bit wearing – and they say that after six years, just a habit.

What a game getting breakfast is in a trench – the wide extensive search for wood, the joy of finding some old bit of farm waggon, breaking it up with the entrenching tool, then the hunt round for paper, usually ending in one using the precious little letters from home – real sacrifices for a drop of something hot. After much excitement, dark threats and adjustment we manage to put several mess tins on our crazy fire (in a bucket maybe) which is very patiently kept fanned to life with our hats. Should any man knock the fire over or several mess tins, or drop any mud in already muddy water, let him beware – better for him that a kerbstone were hanged round his neck.

The Germans were very near to us in this area. We could actually hear them singing and oftimes they'd shout something rude in German and we in excellent English? asked for various food dainties to be brought us by the waiters opposite, only instead of ringing the bell for them we pulled our triggers.

FROM THE
LONDON RITZ
TO THE WAR
FOR FRITZ

We were in the front line for eight days this spell and after the first day - things began to buzz with a vengeance and we could get no sleep day or night,- just a doze standing up maybe.- but ever on the watchful, intense alert, at various times we had all the various items on the straff programme of their side and ours, and lost a good many men one way and another. We had heard rumours of a big intensive bombardment to be put over by our guns on Sunday morning and at the time named, to the tick of the clock. they opened up.- it started at four o'clock and lasted full blast for seven hours, Such a bombardment is beyond my description. the sky seems a mass of flames - the air is drenched with fumes and smoke, all is chaos and confusion,- for us in our trenches it's bad enough,- for the enemy well - hell could be no worse, Of course they are too busy looking after themselves to be normal at these times and it's possible for us to mount the fire step and look across. What a wierd awful picture - we see the sand bags torn apart - men thrown right out of the trench - we are so near - the body and head of a German officer

was flung right on to our parapet. all the time we watch with sickening interest, there's the fear that our guns may fire short, and suddenly find ourselves sky high. It is no unusual thing. and not even blameworthy when all is considered. how the line zig zags etc. We were exepectantly holding ourselves ready, to get the order to attack. it's the usual procedure to cut all the barbed wire first, with the guns, then they cease suddenly. for us to dash across and complete the work they have begun on the enemy's side. To thrust, jab and shoot, all in our way. Anyway this time the order was not given when the big strafe ceased, and we had little time to wait. before the German reply was delivered with interest—it was our turn to be crumpled and crushed. harried and flayed with every kind of explosive. what a time they gave us. Neither side seemed to gain much by the stunt, and they certainly lost enough in killed and wounded. We all grew thin in this bit of Flanders—"put years on us". not the slightest chance of a wash, not a "cat-lick" - no boots, clothes or puttees off for even half

an hour during the eight days.
And food got very scarce –
more scarce than comfortable –
it was so difficult to get
supplies up to us here. We had
to have our iron rations and
tighten our belts to forget
our tummies. Perhaps a bag
of wet tea would come up –
we'd have no water for it –
or one time a spare sack of
bully beef might come up –
not much to share round –
no biscuits to eat with it and
left with a bigger thirst
than ever.

HAD THIS TAKEN AT A SMALL TOWN AFTER A LONG
SPELL IN THE LINE – THAT ACCOUNTS FOR THE
"HARD BOILED" LOOK.

All good things come to an end – and we came
out to a little way back, in the support lines. Here
we were in trenches running through some ruins,
and we happened to have four howitzers in our back
garden; every time they fired – it felt like a whack
on the side of the head and they kept up almost
continual fire for hours – literally asking for trouble –
and we were warned to expect German replies by an

early mail – and so, frankly, kept very near our dug-outs ready to bunk down should occasion demand.

Eventually a salvo of six came over trying to find out gunners and in the search blew a dug-out right in – killing a poor chap who'd just left me to get some writing paper. He'd dived down the steps just as the shell caught the parapet – don't suppose he felt the shell even as much as I the concussion.

While here we were practically flooded out – it rained like blazes for hours – at one time some of us were in our dug-outs wearing only overcoats and boots, ringing out the wet from socks, shirts etc – the rain poured into the dug-out like a waterfall and made it puzzling to know where on earth to go to dodge it.

Whilst in the support trench we had an easy time, really our job was to be close at hand – to the front line people – but we had quite a lot of little jobs to keep us going – water fatigues and such like capers. Then we came out and moved back a little further to some tumbled down cottages on the roadside (did not know the name of the village – if ever it was one). A spot known as the "tuning fork". We were here for several days and were more or less left alone during

daylight – allowing us to sleep, which we much needed in the comparative security of being out of the line. When darkness fell, we had our constitutionals – loaded up with barbed wire coils, stakes, trench mortar bombs and other firing line furniture, invariably coming back less in number and glad to be whole ourselves, ready to pack down for a "kip" just as dawn arose.

On Sat. May 24th I was picked for guard, starting at eight o'clock in the evening – but instead of the boys going off on a working party they had to parade at midnight to go up to the line again. I was taken off sentry duty but the other thirteen of the guard had to remain behind and wait to be relieved by another crowd – why I was not left, goodness knows. Anyway we were taken to the second line of trenches to act as reinforcements to the Staffs. and Warwickshires who were making a surprise attack before morning. The Germans got wind of the affair somehow, and we were given a really hellish bombardment as reinforcements – the attack from the troops was a great success and they gained considerable ground – the trenches around us were

HALT! who goes there

almost obliterated and to move up nearer, and to get
to the front lines (just vacated by the regulars who had
gone after Jerry) was a ghastly unprintable affair – we
were by this time moving about in daylight in the open,
a mark for the German gunners, and they treated us
awfully rough. They literally swept us with shells and
machine gun fire – and fellows were going down on all
sides with ghastly wounds and pitiful groans.

Our Major was struck down, and then a corporal by
my side had his arm torn off – we were not allowed to
stop and aid them, our job lay ahead. We had to by
hook or crook get to the front line – to get ready for the
expected counter attack. There were two ditches to
cross and I was suddenly blown off my feet by a shell's
concussion, and pitched into a large old shell hole,
in clambering out very wet and smelly, I had to crawl
over a "Jerry" all swollen and sickly yellow – he must
have been there for ages, he looked an oldish man by
his scrubby short beard but his scalp had gone –
I was haunted by his appearance for days. We had to
scramble through a gap in one of the old breastworks
and had some difficulty as there were four dead horses
piled in a heap impeding our path. We got to our old

front line (of the previous day) and saw the ladders
etc. where the Staffs. had gone over. Then we were
taken still further ahead to occupy the line the
Huns had just vacated in a hurry – we of course
were running over the recent "no man's land" and
saw the slaughter that had occurred that morning
to win a strip of land for England. Germans and
British laying side by side – killed by the bayonet
or gun – and our fellows were still falling; it was
almost in the nature of a charge to be in full sight
of the enemy and subjected to shrapnel etc to
prevent us getting on to our objective.

" MOTHER
WAS IT
WORTH IT "

When we did eventually get to the German
trench we found what remained of the regulars,
who were mighty glad to see us – for they knew
we were relieving them after their gruelling
experiences. We got down to the comparative safety
of the trench and looked round a bit. No time for a
leisurely stroll about though – there was hard work
to do for every man.

The German trench seemed an impregnable
fortress and we gasped with astonishment to realise
any troops could possibly wrest it from their hold.
"Jerry" had been here seven months – his officers'
luxurious concrete dug-outs were a real surprise
to us – different to anything we'd yet struck.

Very deep, lined with wood, the walls plastered with pictures, many not "quaite naice", home photographs etc; there were tables and chairs, electric lights and everything to make them "home from home". A curious thing too was the colour of the sandbags. Instead of like our own canvas they were made up of various materials – red, white, blue and yellow – materials got together it seemed from many odd sources.

sse allemande avenue de la Gare

GERMAN DUGOUTS

These trenches teemed with snipers' holes and machine gun emplacements, and there were many gadgets to indicate the whole place was systematically mined.

Of course by the time we arrived the whole show was in wild confusion and to judge by the bits of foodstuff – equipment and so on thrown about everywhere – the Hun had left in an alarming state of funk tho' the numbers of the enemy laying everywhere who would never run again told a tale of surprise and ferocity of attack undreamt of. Many, many of our poor fellows were also there – locked in deadly embrace with some machine gunner, impinged on the barbed wire or laying in some awful heartrending position having given all for their country.

GERMAN LINE

The main job for the living now was to literally turn the trenches round – they having till now been used to face in our direction of course, and we had to work like demons to get a new front to the German line – making a parapet of the parados – transferring the loop holes over to other side and so on, working hard against the expected time when a counter attack would ensue. The enemy were quiet for some hours happily, no doubt engaged in their own job of making their new quarters as a front line habitable, then they seemed to suddenly wake up and gave us hell's delight – sending all kinds of stuff crashing over to our trenches – spoiling most of our pretty efforts, and making themselves generally a confounded nuisance. As Dusk fell they quietened somewhat and extra sentries were posted along the fire steps as usual. About nine o'clock our platoon No. 3 was ordered to "stand to", pack up goods and chattels and move along the trench till we came to an opening in the breastworks, we were then led out to the new "no man's land" to make an effort to find and occupy an untenanted trench that lay between "Jerry" and ourselves – in fact really taking up an advanced position. It was pitch dark remember, and after we had negotiated a

wide evil smelling stream, we roamed about very
bewildered and realised we were "all at sea" and
had quite lost direction. It became a panicky picnic,
we could see Very lights from both the Germans and
ourselves going up – and of course had to flop down
constantly or stand perfectly still – but no one
amongst us, for our "very lives' sake", knew which
was which – which direction to make for to find
our own side, and not Jerry. In desperation the
order was given to go in a certain direction
and risk the consequences – we were groping
along till some trenches and barbed wire
loomed up, when suddenly to our alarm an
English voice shouted "five rounds rapid", and
to our utter dismay we were swept with rifle fire.
A number of our poor fellows were caught – and
after our frantic cries that we were English we
scrambled back into our trench. A bad mistake
had been made, somebody thinking we were "Jerrys".
Although awful to contemplate, this kind of error
is entirely forgivable and understandable to men
out here. In the comfort and security of home life
reading such would seem to call for severe censure,
but to me it's like the Enquiry Board of comfortable
old men sitting round a table in security and style

probing into the affair of a wreck, asking cruel questions of a surviving crew – why this? why that? – can anyone be quite responsible in a time of abnormal strain. *No* – atmosphere is everything and must be considered – and it's almost impossible to create by written words: to have already lived days of severe strain – to be waiting on a fire step – knowing that any minute may spring a surprise on the unwary – to suddenly see in the darkness ahead – a group of silent figures loom up – (not aware that any of our fellows are out there) – well what would anyone do? I ask you.

Immediately we got our breath back a bunch of us went again out in the front, to rescue the wounded chaps (two were killed), Pete and I came across a chum who had caught a bad one – and the nature of his wound made it a very difficult task to get him back. He was a hefty fellow and to get him over the stream, we had to stand waist deep in the water and gradually, tenderly work him inch by inch along a tree trunk that providentially was across the stream – he was losing blood fast and my tunic got soaked in it. We eventually got him in – but he died an hour or two later.

I found a jolly fine German helmet when we first
went through the gap on our jaunt, a real Prussian
officer affair it looked in the dark – but when
we later got things a bit muddled had to drop it –
could not be bothered to carry it. I tried later
on to find it out there but failed. This book is
the only souvenir I could
carry away – and a whole
body which to me was
everything of course.

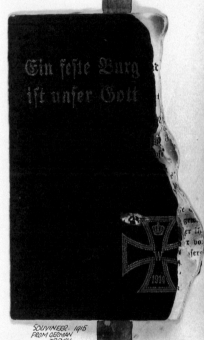

PRUSSIAN
HELMET

Ein feſte Burg
iſt unſer Gott

SOUVINEER· 1915
FROM GERMAN
TRENCH.

"A MIGHTY
FORTRESS IS
OUR GOD."

Well we resumed our
trench duty and things
became lively in a general
sort of way and the next day
the shelling increased four-
fold – about nine o'clock
an alarm was raised that the
Germans were coming over
and the Brigade bombers
were hastily summoned to
proceed up a communication
trench (which had been the
Huns' walk up to our new line, once).
They were coming down this now in large

numbers – and some others coming over the top
in extended formation; the bombers went to throw
their little bouquets at the trench crowd and we
others were getting our rifles hot bowling over
the advancing Huns. A sudden ferocious burst of
gunfire from the boys at our rear effectively
dispersed them and they retired well shelled,
shot and in disorder.

In this I was reloading my rifle and Corporal X—
was firing across when he suddenly swayed and fell
flop onto me. He'd got a nasty rifle bullet wound
alongside his head. I loosened his collar, took

L/Cpl
G. R. ROSSITER

his equipment off and dragged him in an adjacent
dug-out, bandaged him up and waited for a stretcher
(this was really a Red-Cross man's job – we are not
supposed to leave our platforms for anything –
but in this case I was very keen on the Corporal,
had known him from the first and could not see him
unconscious and neglected). I waited an hour or
more for a stretcher, but there were not enough to go
round – eventually two first-aid blokes helped me
get him into a waterproof sheet and they, holding

a corner each and I two – we scrambled with our
burden ("a dead weight") along the narrow trench
till we found an opening in the back. Had he been
conscious he'd have suffered agony – with the
bumping that couldn't be helped – over barbed
wire, countless holes and awful debris – unhappily
we all stumbled into a huge shell hole, our poor
wounded Corporal being pitched out into the
murky Lyddite water. We straightened ourselves
and set out again for the road about 200 yards off.
This was being shelled very heavily to prevent
reinforcements arriving and I shall never forget the
rest of the journey to the dressing station a good
mile further on. One of the bearers was struck in the
leg with shrapnel which left only two of us with this
heavy man. My goodness, we were glad when we
arrived. We had actually seen a tree literally
uprooted – just before we got there – about 20 yds
in front of us. All this is not talking heroism –
no medals please – it's only what everybody does
on occasion – and becomes almost routine.

We now scuttled back much more swiftly to our

former job – and found things had assumed a much more normal level and we were able to have some grub.

Next day the reserve trenches were faring very badly – shells landing right on dug-outs and trenches causing havoc with the boys there, we heard – the front line they seemed to be leaving very much alone; during the afternoon I was sitting quite comfortably on my fire step calmly looking up at my rifle periscope – and was pleasantly surprised to see the thirteen men who had been left behind on guard at the "Tuning Fork" arrive. They crowded into my traverse, one or two extra good chums of mine amongst them – they seemed tired but very jolly to have got thus far alright – and started on some food. Suddenly without any warning I was pitched forward on my face – stunned. I scrambled up and a really dreadful sight met my gaze. A shell had caught the whole lot – killed two and the rest in an awful sorry plight – we treated them as best we could and helped them get away. By a miracle I was the only one of the bunch who escaped unhurt and the other had only been a yard or two away.

Just a small splinter of a shell tearing my trousers and giving me a little flesh wound and the flash had burnt my neck a bit – but nothing to fuss about.

I was "cut-up" at seeing those ole lads go west – they were all the old originals out of my own section – we'd all jogged all so very happily for months. I felt more revengeful than shaken – but had to just go on sitting tight on my fire step – "saying nuffin" but thinking "some".

They stopped their strafe soon after this and we were left alone quiet, till about seven o'clock in the evening – when we were surprised to see our trenches filling up with fellows of the Bedford Regiment (Regulars).

Hurrah! we thought they were relieving us – but we learned they were there as storm troops and were going over the top. A couple of Bedford's stood next to a "Shiny Seventh" man in extended order close up to the sandbags. Our officer told us we were to bunk them up over the top when ready and then cover their advance with our rifles, their officer shouted "only 3 minutes to go" then a whistle and they were away. To a journey fraught with peril, and no man knew what, but they

went over gloriously. I wished the whole world could have seen them – no hesitation – many with a muttered joke to the chap hoisting them up. We were all cheered when they got over and then settled down to our grim job – as they to theirs. "Jerry" sensed them almost at once and raked them hellishly with machine guns – we had to be mighty sprightly as they whizzed on a level with the parapet. They had that rotten stream to get over – and gradually we lost sight of them in the gloom, then one by one badly wounded men began calling to us from the other side – calling to us for help and dragging themselves over the parapet with our assistance. Of course, any who were helpless were found and brought in later by rescue parties. One old sergeant came rolling over nearly on top of me – he'd been about to jump into the stream to wade across when another man behind him had toppled forward – sticking his bayonet accidentally into the sergeant's leg – he'd got a beastly long gash. We soaked it with iodine while he casually sat back smoking "an issue", bandaged it up – then "I'm hanged" if he didn't ask us to help him over the top, and he hobbled off again into the fight. "How's that umpire?" for real courage – with no audience to clap and shout approval.

Unfortunately this attack did not prove a success and the regular troops had to retire back to us – though on the left we understood the Camerons had taken a new trench and were holding it.

We had to keep a mighty sharp look out for the rest of the time – expecting a revengeful counter attack but, though much troubled by shell fire, we were saved the extra exciting items – thank goodness!

We left these trenches on the night of Thurs. 26th and "handed over" to the Canadians – a jolly fine hefty bunch of fellows they were, full of good humoured banter, and looked as if they could account for themselves very nicely anywhere. We were rather struck with their speech – a quaint drawl – and by their (to us) strange manner to their officers. One would hear a man say perhaps "Buck up Bill – mind the wire overhead" or "Don't lean on me mate, I've got enough to carry" – and to our astonishment he'd be addressing an officer. To us it seemed fine and comrade like – but of course although our attitude to our officers is entirely different in manner – due to different ideas of discipline – it all really boils down to the same thing – we respect our

CLOVER

VERMELLES
1916

officers for the most part immensely and are only too ready to give them the deference they richly deserve. Another thing – the colonials joined up in blocks of Pals – from the prairies and towns, some officers some the ranks, but still lifelong chums, whereas we were gathered together from most diverse sources and some of the brave but rougher lads would run amok without the thin but impassable barrier being strictly maintained.

We left them to it about nine o'clock and toddled along to GORE. We were all jolly glad to get back thus far away from it all – for every man was utterly done up from this spell – there had been innumerable things constantly happening, many too trivial to make a song about here but all in the main calculated to try the strongest nerves – in fact more men had cracked up with nerve strain on this journey than any we'd known. We stayed here a couple of days and were treated very leniently – idling about as we liked. Then in the afternoon of Saturday, marched to BÉTHUNE and were fixed up in a large tobacco factory. Just the place for a barracks – if only the "fags" had still been there.

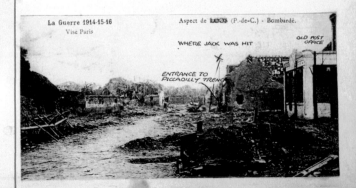

La Guerre 1914-15-16
Vise Paris

Aspect de LOOS (P.-de-C.) - Bombardé.

WHERE JACK WAS HIT

OLD POST OFFICE

ENTRANCE TO PICCADILLY TRENCH

Had a most enjoyable time here - drilling at intervals - a good deal of rest time. the cream of this rest was the bathing parades. The company marched to the other side of the town to a sort of open air baths. What a marvellous change to be plunging in the clean fresh water after the recent days of dirt & wretchedness.

We went several times - couldn't get too much as a matter of fact - and would thankfully have retired here for the rest of the war. ◇ ◇ ◇ ◇

On the Tuesday - we were strolling about in groups round the few open shops spending or borrowing our few franc notes - When cyclist messengers rode through the town - excitedly calling all men back to barracks - on return we were ordered to pack up "tout suite" and ready to move off in fifteen minutes.

It really seemed as though we'd been commissioned to go and capture the Kaiser himself.

Anyhow we marched off - and were soon uncomfortable - the day was so unbearably hot - and we were loaded up, carrying a lot of extra stuff that we'd had no time to hoist on the transport. We at least thought we were being brought up to the line for

SOMEBODY WE'D
ALL LIKE TO MEET.
(with a rifle)

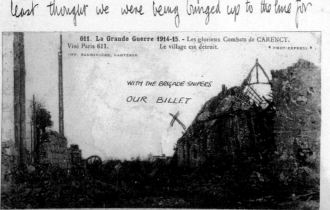

611. La Grande Guerre 1914-15. - Les glorieux Combats de CARENCY.
Visé Paris 611. Le village est detruit.
IMP. BAUDINIÈRE, NANTERRE. ● PHOT-EXPRESS ●

WITH THE BRIGADE SNIPERS

OUR BILLET
X

an emergency stunt – but instead found ourselves bivouacked in a lovely wood after 3 hours' march.

This was "*the* goods", a real country holiday camp, basking in the sun during the day – when not on minor fatigues and wondering what good fortune had come upon us thus. It was bitterly cold at night but to be immune from constant danger warmed our hearts. What astonished us was our evident nearness to the firing line – as we could hear machine gun fire very loudly and shelling constantly – but they did not touch the wood at all. And but for the noise we could have been in England.

Our perspective began to get funny during these several days and wild rumours became rampant – We were returning to "Blighty" then to Egypt, and all sorts of fantastic yarns were afloat.

When we did finally get the command to shift at 10 minutes' notice on June 1st – we were all rather intrigued as to where we were off to. It proved to be BÉTHUNE-wards and our hopes ran high until we got there when we struck off right, GIVENCHY way. Some three miles out of BÉTHUNE we were dumped in a field till dusk, spending the time round

ANOTHER
DAMNED
RUMOUR !
LAST WEEK
EGYPT –
THIS WEEK
ITALY

the cooker clamouring for tea, and lolling about –
laying on our packs, resting on our backs because we
sensed we'd need this rest to prepare for some spree
"in the wind".

IT'S NOT ALWAYS
LIKE THIS

On resuming the journey we turned up a seemingly
never ending road – a real French, straight affair
with tall poplars either side looming up into the sky
through the gloom. After a considerable time we
had to break up and go along in single file, extended
order along each side of the road in the gutters. The
Germans were in the habit of "plonking" this road
with heavy stuff each night. But happily tonight
they'd got a dinner on or something and left it alone
to us, allowing us to reach the one time town of
VERMELLES. The extent of the ruins suggested
a place of some importance, once, but by now we were
not unduly impressed by the sad look – we'd almost
come to think a town's normal appearance was like
that, a big untidy heap.

Going right through VERMELLES – at the
other side we dived down the cellars of some
ruins and came to the entrance
of communication trenches –

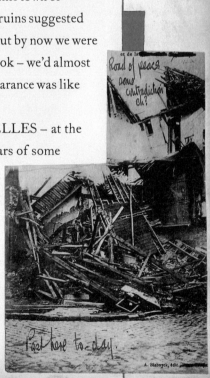

et de la

Road of peace
some
contradiction
eh?

Past here to-day.

A. Blabuyck, édit.

cut by the French out of the chalk ground. These
were a distinct novelty to us – and fine after our other
holes in the earth. The weather was good and being
chalk all the way through were very dry and comfy,
and even when it rained – it soon soaked away.

There were very few dug-outs in this second line
where we had been deposited, and to sleep at all
one had to crouch along the narrow trench – being
awakened numerous times by somebody going past
and in the dark kicking one's ribs. What troubled
me – in fact, everybody, was the large number of
blackbeetles in this kind of ground – they crawled
everywhere and I slept when possible with my head
covered by a sack and my hands stuck up each sleeve
to prevent them crawling where they would.

We were not troubled by rifle fire or small stuff
here but shelling at times was intense – we were in
reserve to another battalion in front, they baited the
Hun, we got the "fun" in the rear. I felt pretty sore at
being ousted out of one of the few dug-outs by the
meanness of an N.C.O. – but lived to be thankful for
it. A party of six who'd come off a ration fatigue had
all bundled in for a well deserved rest when a really
wicked shell caught their dug-out square on top

burying them all completely – they were found to be
beyond all aid. Another shell of like calibre came over
in the same spot very soon after, killing the sergeant
major and terribly injuring a number of us who were
trying to dig the first crowd out. We were four days in
the reserve here – then two in the front line relieving
the 1st Coldstream Guards.

There were not any great doings at this part of
the line – and Jerry's trenches were really a good way
off – with much caution one could even peep over of
the top and it was lovely to see groups of red poppies
among the infrequent patches of grass. Considering
the numerous shell holes they were very numerous
and made a very brave display – I know they thrilled
me intensely and a butterfly or two made a vast
difference to the atmosphere.

Looking way back into the blue sky could be
seen our funny old sausage observation balloons,
and dotted here and there in the distance, the
German balloons – which no doubt accounted for
some of their uncanny direct shooting. Generally
speaking VERMELLES was "cushy" – but
when our time came to be relieved by the
K.R.R.s we said "*thanks*" and wended

FLANDERS'
POPPIES

our way through about two miles of chalk – then up in the open for some three miles into MAZINGARBE.

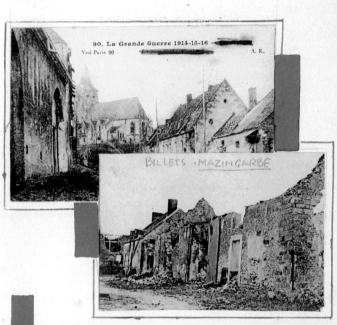

BILLETS · MAZINGARBE

Here we had a very happy time, comparatively, quartered in the yard of a rather large – but busted up and holey estaminet. No. 3 Platoon was allotted a very roomy loft – reached by a slender ladder with rungs just here and there. We "kipped" down, had a well-earned rest, got up refreshed, had a good wash and felt ready

for anything again. Of course, we had to do a ten mile march in the boiling sun just to keep up the idea of a "rest" then away to the baths about a mile off our billet – this was a trip we did jolly well appreciate, for the trenches we had recently left were inhabited with more than just humans. (It was said nobody went in those parts and came out *without a scratch*.) The evenings were the best we'd had for many a day. All the boys seemed to wake up to the joy of being a bit away from the line and we pinched every available chair for miles round – boxes-barrels-anything – and made quite a respectable auditorium for a concert. We got a waggon or two together – covered them with boards and so made a stage – then the fun commenced. It was surprising what talent we discovered – we had artistes clamouring to do a turn; when asked, there were no bashful refusals. A chap would hop on the waggon and say or do just as he liked – if any good he could go on ad. lib, with many cheers and cheeky calls, but if a "wash-out" he got off the boards pretty smart – helped by a nobby bit of biscuit on the ear, a juicy bit of spud, or any ammunition handy. But really some songs were great and real humour galore. Our cockney cook

was the hit of the show. He was in form this evening –
and nowhere in the world could have found a more
appreciative audience. We were absolutely hungry for
change and entertainment of any kind – something
that in some small measure would echo home life.

The fame of this first concert spread, and our
farmyard was crowded out – we had a jovial sergeant
who "set the ball rolling" for community singing and
the lads raised Cain between them.

We began to get swollen heads when the Officers
had decided to attend on the third evening – but just
as it was time to open the doors that were not there,
orders were issued that made us abandon the whole
affair and within twenty minutes we were all on the
road (armed with rifle and ammunition as always)
together with a pick and shovel to go on a long trek –
digging new trenches in the French quarter.

We seemed somehow to have been brightened up
by these last two days and made this trip in good
spirits – we passed a regiment of troops, they were
French infantry – and seemed staggered at our evident
lightheartedness (they take it very seriously). Later we
halted for a rest in a little village. A Frenchwoman
heard us laughing and singing and brought out chairs
for us to sit down on – which we did, the officer in

charge setting the example; this made a merry ring on the pavement outside the estaminet. We had some rollicking choruses – and a solo or two from our star songster. Crowds of French soldiers gathered round and all the old villagers – they seemed to thoroughly enjoy our Tommies' good humour and banter, but of course did not know in the least what was being sung or said – tho' to us this was all the more amusing, one could take such liberties of speech when the blokes addressed didn't compré.

We were here a couple of hours – why we halted so long we "didn'a ken pas" – then off to our job – which we slogged at till just before dawn then back for a good mug of tea and a "kip" till eleven o'clock.

SOUVENEER FROM MAZINGARBE

After a bit of drill, kit inspection and so
on we were allowed to go our own way for a bit –
I spent my time writing letters, by the pigeon
roost, it was rather a comforting Blighty sort of
feeling to hear them cooing the while.

That night, up again to the line – we had
warning that we were in for a good spell and
arrived after a seemingly thousand mile march at
a front line new to us (still chalk by the way).
We were adjoining the French army on our right,
in fact we relieved French troops – a more quiet
and generally depressed sort of "sodgers " we'd
never met yet among our crowds.

But my word! – we soon found where they'd
been living and where we were making our abode
was enough to give any man that funny haunted
look. We had a pretty rough "first night" – and in
the morning found that we were in the cornfields –
or rather (which made all the difference) six feet
below them.

It was a really nasty spell this time, and after
several days and nights of it the dirty old man
on Pear's Soap advertisement looked quite spruce
compared with some of us hairy-looking creatures

that crawled in the earth – yes like worms on our bellies sometimes. It was all like a pretty bad dream. Over thirty fellows were at one time or another packed off with some form of nervous breakdown and shell-shock. Four officers got it too, and even a day or two down there would convince anyone that such was not surprising. My pal Jack Myatt "cracked up" this journey – I missed him greatly, we were always together where possible – and I was sorry but knew he'd only gone back for a bit – sent for a necessary rest and change. He'd soon be his usual bright self – when he'd got some of the precious sleep we'd been so deprived of.

It was quite painful to see chaps struggling against utter weariness, some being perilously near sleeping on duty – the *greatest* crime of course there is on active service.

To be *really* short of water is a stunt only to be fully understood by cruel experience – I got "the bird" very heavily for just wetting the corner of my tunic to wipe my face with. It was not so much a desire to be a pretty boy – but it gets a sad necessity – you can almost hear your face click when you laugh.

THE
ROOSTER

A cup o' tea was a distant memory; from not taking boots or puttees off for so long – one's feet go quite funny. On my long periods of sentinel duty I've had to stand on one foot at a time only – like a rooster – while the other rested. Then again the food – or the lack of it – gave the lie to any idea that French fighting's a picnic. The heat of the day made one frizzle – the cold at night freeze. The chalk seemed to reflect and intensify any change of weather. And flies! – my gosh Old Pharaoh would have rubbed his eyes in some concern had he seen such a plague – you see they had such a larder all around.

Now this has been a soldier's grouse in truth, but there's a bright side when one considers how much could be suffered and yet good health and strength be retained – it proved how simply and primitively we ought to live at home to achieve constant well-being.

On a scrap of newspaper wrapped round a little gift from home, there was moaning about lack of munitions – but I dunno? – they seemed to chuck over an extraordinary amount of stuff anyway.

In fact both sides were awfully generous – the big guns setting up a general strafe then the little ones all following their example.

I was for instance on the fire step and counted thirty big shells from one battery alone being bowled over into one of the villages. It's rather a novel weird sight, to keep watch in the dark and see on every hand floating Very lights – gun flashes that tint the clouds – and maybe in one direction a sky of flames where a village is burning or an ammunition dump has been set on fire. There are various coloured lights signals too that pop up now and then.

Listening patrol was a new and interesting experience for me in this sector. A Corporal and four of us went out the other night, our job was to wander out between the two lines as near the Germans as possible, crawling all the way – and then lie flat down at some point and keep ears and eyes at concert pitch – for any tricks or suspicious signs to report from the enemy's trench. They do the same sort of thing and should both parties meet – well one or two would have quite an adventure to relate – the others would never bother the censor again; that is if the Germans

have censors. This night, crouched in a shell hole by their barbed wire we counted eight Germans leap over the parapet quite close to us – they came bent quite low right by the lip of our hole – it was a tense moment and happily very dark – we were outnumbered and too near their trenches to try any false heroics, and our corporal wisely gripped our arms and indicated "lie low". We let them go on for several yards – then began to stalk them, endeavouring to discover what stunt they were on – it was frightfully exciting and heaven knows what story would have ensued, had we been able to pursue our quest, had not a shell somewhat roughly dispersed us – when we'd sort of pieced ourselves together the Huns had vanished. We continued to hang round Jerry's homestead but apart from hearing bits of digging, guttural shouts etc – there was nothing to write home to the General about this time.

That reminds me how hungry we were for letters – and a thousand thanks to one of the good ole fatigue parties, a batch came up on the third night in this sector. I had one from home

congratulating me on being away from the line on rest in such a lovely wood – by gum! they ought to see it. As a matter of fact it was often funny. Letters took some time to arrive and when one was in the line – folk would be cheered we were out – and when out – "windy" that we were in and so on. I had some cheery news cuttings sent me – making note of our activities. Yes – "the Seventh" was being recognised as of some definite account out here – and had earned the approbation of the "regular" troops. Indeed it was an honour to be so often employed as front line troops – relieving some of our most famous regiments.

FIELD POSTMAN

Came out of this spell on July 1st back to MAZINGARBE – for a rest – more or less a repetition of all "rests" – navvying, or "Pickford's". We had to make one long trench "on the jump" the second night out – near enough for the Very lights to considerately show us how deep we were going.

Also went to a different colliery for baths at NEUX-LES-MINES. Here all the work on top at least seemed to be done by French girls – hefty labour at that – lugging great trucks of coal along rails,

tipping them etc in a fashion to shame many a city fellow. Of course they look a rare lot of black beauties – not very cuddlesome as girls go. They wear bright coloured turbans to keep their hair free from coal dust.

All the coal waste here is thrown on a heap and in course of years accumulates to a mound five hundred feet or so high – all around the neighbourhood is dotted round with pyramids, at times making quite a lovely Eastern picture against the fine sunsets appearing at this season.

The enemy has made a special mark of any big chimneys – some of the tallest still stand with holes all up the side like a tin whistle. Others are tumbled to their base in a heap.

Yesterday was Sunday and I had climbed up inside an half demolished chimney to have a bird's eye view around, when "Jerry" started to play "Old Harry" with our village – we had to make for emergency dug-outs tout de suite – there were no casualties but several large helpings missed our building by a shade. They make a row like an electric train coming out of a tube tunnel,

and when they fall, it's terrific. Our billet was an abattoir, a French slaughterhouse. It still remained for its original purpose – tho' the Hun obviously desired otherwise.

July 7th found us in the line at a very quiet spot – really peaceful – chalk trenches still among the poppies. It was a pleasant change to most of our experience – and I found time to actually do sketches of pals, and funny postcards for a flat rate of a franc a time. Fellows thought me a bit of a freak to do them there in such a peculiar studio – but I was overwhelmed with customers. They seemed to much relish the wheeze of sending a real live drawing from such a postal address. Ah! and my dears! we had sculpture too. They sold like hot cakes – replicas of our 7th Grenade badge cut out of French chalk. Like the cobbler with ill shod boots – I did some fifty or sixty with painstaking care, the help of providence and a blunt penknife but have not one myself.

DO YER LIKENESS SIR! SMILE PLEASE

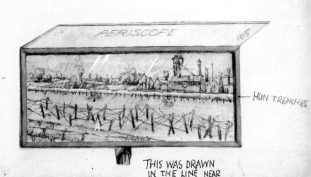

PERISCOPE  1915

VIEW OF ENEMY LINE THROUGH MY PERISCOPE

HUN TRENCHES

THIS WAS DRAWN IN THE LINE NEAR MAROC

Anyway these diversions were good for the mind and more lasting than just a game of Solo.

Eventually we came out of this model front line and trekked back to SOUTH MAROC – a sort of garden suburb. We were put here as firing line supports – and small groups of men were each allotted charming little villas. The place was strangely, fairish intact – and we were given to understand the civvies had been there till quite recently. We were the first troops to inhabit their houses – after they'd flown in a sudden terrifying panic from heavy shelling, which had certainly churned up the roads and demolished some roofs – but as I say the whole place was ever so much more "as it should be" than anything miles around. We were very strictly forbidden to come out of our houses – or show any signs of life whatever in the daytime – so we had some jolly good fun. There were fifteen of us in one homestead – and perhaps it's a bit shameful to relate – we ransacked the drawers and cupboards very soon. The clothing we found we donned and the figures we cut were screamingly funny – one man would be wearing a silk hat with a silk pyjama suit on, his khaki peeping through;

OUT AT REST FROM SPELL
IN TRENCHES

another would have a dress shirt with a pair of
feminine "doings" on. But to crown our cup of joy –
the gardens were full of ripe vegetables enabling us
to supplement our eternal bully beef – with green
peas, kidney beans, onions, new potatoes – finished
off with stewed Rhubarb. Two cooks amongst us

FRESH AND FREE
IT CAN'T BE TRUE

gladly volunteering to stick down in the murky cellar
preparing the feast – and we, scared stiff the smoke
would show from the chimneys. We went to bed in
the daytime (ready to go out on working parties at
night) sleeping in real soft, clean beds – what
comfort! – tho' we slept three or four in one.

There were roses to put in shell cases round
about the place and on the Sunday quite a crowd
congregated in one of the parlours, for a little
religious service. My pal Jack gave a snappy bright
address and all the lads joined in a lusty round of
hymn singing. One thing I could not do here, for
the life of me, was to look at any photographs of folk
on the walls – kiddies laughing etc – it all seemed
so sad and pitiable for us big hefty Tommies to be
dwelling in their homes whilst they were refugees
flying from all they held dear. One only had to

POOR OLD REFUGEES

picture folk at home, in the same predicament to fully realise the awfulness of war – and "man's inhumanity to man".

Next time we went into the trenches it was at PHILOSOPHE – and the period here could be summed up as "business as usual". Some going down in the line – "some going up".

Then back to our red brick dwellings at MAZINGARBE – they were a bit more airy this time, "Jerry" had been potting at them since we left. But there still remained the "spuds" and onions to give us two veg with our bully. The boys gathered together (crawling along by the hedges and garden walls to be unobserved) one morning to have a really good banquet. When to my disgust I clicked for a twenty four hours' guard at a railway station in a cutting, my mouth watered at the thought of the feed I'd missed – in fact I got pretty soaked what with this and the continual rain. The smoke from the chimneys began to draw Jerry's attention and his fire during this period bringing some of the houses tumbling down about our ears – it began to get very hot and we were quite ready to put "this house to let" boards up.

When we finally departed from these habitations it was to move a comfortable way back, and meant a good few hours' march to LILLERS where we found jolly decent billets.

On the second day we had an important inspection and turned out in fine form. To our joy we were all rigged out in new clobber – boots, tunics, caps etc. (not *too* soon, by any means) and had to spend much time at "spit and shine" with Bluebell and elbow grease – gradually losing our wartime rag and bone appearance.

After waiting some four hours in a field – the Divisional General rode up, inspected us and, in a brief soldierly address, showed how extremely pleased he was with our appearance and apparent fitness. Certainly we did make a brave show – with all our chests puffed out, and buttons and bayonets glinting in the sunlight.

During this spell I had orders to take a machine gun course – after having had my name on the list for some time. A machine gunner's job in wartime is a degree more dangerous than a rifleman's (except a sniper) because directly the enemy scents where

PRIDE

our spitfires are placed – they concentrate to silence them.

But still there's little to choose between any job in the line, and this particular detail is heaps more interesting – it takes quite a while to become a skilled gunner. At this time the battalion had two new "Vickers" guns, wonderful machines, firing shots at the rate of seven hundred and fifty rounds a minute. A fairly useful speed? emphasising the better part of being behind such a weapon rather than in front.

This new subject in one's education meant a real hard swot – to learn all the intricate parts of mechanism in double quick time. Machine gun drill is quite a strenuous affair, darting here and there like mad, with the heavy barrel, the stand, or the hefty belts of ammunition.

The third day saw us in a delightful spot in some woods – and we were put to our first spell of firing. Quite a thrilling pastime this – to sit behind the gun, swish on, and let it rattle out round after round at amazing speed – the noise deafening and the vibration making one's teeth chatter. Our target was situated in a huge basin cut out of the chalk – a quarry – the echo travelled miles.

After a week of this diversion – back to the general routine of the battalion – to be called upon for the guns as need for men arose. Plenty of duties to keep us out of mischief, and while here we had the pleasure of welcoming "the new blood" – drafts from the second battalion in "Blighty" to make up our sadly depleted strength.

These fresh lads were "Green", and quite eager to see the real stuff up yonder, in fact several degrees more than we were, who knew all too well – never mind, live and learn.

I did a twenty four hour guard with a raging toothache as my companion the whole time. Anybody who had failed to properly answer my challenge in the dark would have been very unlucky. I was just in the mood for trouble. There was very small hope of "going sick" and having a bunch extracted, so would have to grin and bear it – till some friendly soul offered to scoop them out with an entrenching tool.

LIKE 'TOPSY'
IT 'JUST GROWED'

Our next turn in the trenches could be summed up in one word Rotten!!! It was a real teaser especially for the new boys – a good sample packet showing the full repertoire of life in the line.

HULLOCK was the position and the rainfall really beat all records every day – the nights were bitterly cold and to crown matters we were kept frightfully hungry, transport and rations being unable to get far enough up to us for shelling and dreadful roads.

One sodden bag of mail did arrive one night – it was truly a bright spot on the canvas, we could have hugged the fatigue party whoever they were, and could hardly contain ourselves till it got light enough to read.

There were no outstanding features in this sector at this time – just continual monotonous misery, with many a good fellow's name written on the storm of shells and trench mortars that came over – veterans and new boys alike going down in crushed dug-outs or obliterated trenches.

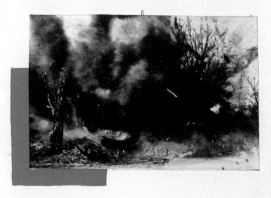

Sunday September 12th. Found us back at rest. A rest from the trenches and almost from the sound of guns of smaller calibre - as we came quite a distance back. To our utter surprise and joy we were brought here in old London motor buses. painted a dirty grey. The trench spell had played us up very badly especially our "trotters" - we could not possibly have marched many miles - and so this ride was a priceless treat. We had some jolly good sport. behaving like a pack of school-kids out on a "beano". What a novelty to get a lift after six months footing it. What horseplay - bunking one another up the narrow stairs with full kit - and the shouts "All the way to the bank" "Change here for the fire-works" "A penny all the way to Piccadilly (trench)" We made our weather-beaten faces crack with laughing. ◆ ◆ ◆ ◆

By this means we were delivered back to LILLERS. a fine big town hardly yet acquainted with shell fire. We were able to buy fairly good grub at the shops - the first thing I spotted being a couple of pork chops - which I took along to an

estaminet and had cooked with eggs and chips, the very best feed I'd had for many a long day – a party of fellows would come back to the billet and vie with each other as to who had fared the most sumptuously. We all had extra pay to come that had accrued during our non-shopping days in the trenches – but needless to say everybody was broke mighty soon after.

There came a topping concert party of Tommies to the Town Hall – who filled it to overflowing – they sailed mighty near the wind in some of their turns, mimicking our officers etc., which was all taken in jolly good part.

A Lena Ashwell party too provided us with a great treat one evening.

During the day we were kept going on quite a different type of manoeuvre over here. Practising going "over the top" – scaling ladders from trenches, advancing over rough ground and generally having mock attacks. Rumours began to grow that both English and German were preparing for a really big scrap, and ideas gained ground that we were training for a final deciding battle that would finish the wretched war and thus avoid another winter campaign, that one and all dreaded.

Night after night we saw fresh guns of many sizes, vast new contingents of men, overloaded limbers of barbed wire, sandbags etc. going all in the same direction – toward the front, many unmistakable signs of something unusually big coming off. Our letters were cut down to the bone by the censor; we were doled out with extra ammunition to each man.

And finally the day came for us to once more board the ole buses (much the worse for wear – for soldiers are none too dainty as passengers) and be driven to LE BREBY, which was of course much nearer the line. We enjoyed the journey immensely like a crowd in London going to a football final. We cheered and sang ourselves hoarse, and to all appearances an onlooker would have formed the conclusion we were *homeward* bound – not going up for some really grim, nasty work – many of us without doubt having our last ride.

For by now we had been made fully acquainted with our job to be – and for once been more or less taken into confidence over the whole business, rehearsed our particular

WE HAD A
CONFIDENTIAL TALK
BY A STAFF OFFICER
ABOUT OUR PART IN
THE COMING GREAT
OFFENSIVE

stunts some half-a-dozen times, very minutely indeed – with the stage set as nearly as possible in detail. In the proposed big push, our objective was to be the Double Crassier at LOOS – two parallel slag heaps 100ft high that the Germans had occupied for six months and had turned into a formidable fort. Our distance to go go from our line to these – some six hundred yards – a very stiff proposition for men not so long since just artisans and clerks.

On the last day before our bus trip our 47th Divisional General had attended the full dress rehearsal – coming over the course, witnessing our antics and giving us an address with "pep" in it, what to do to make "Jerry" run – and keep him at it.

LE BREBY was the typical, tumble down, shelled village – and we were allotted our billets -- my company "A" were put into a one-time schoolroom – minus windows – and the only sign to remind us it had been a seat of learning was one or two iron frames from desks, the wood had long since been picked for fires. We had a good sleep the first night – and the next day a jolly good mail came up.

We were further instructed about various things and given orders to leave our overcoats and all personal belongings behind – so that our progress should in no measure be impeded – and to make sure for all eventualities. We set to, with the rather sordid job of taking each other's private home addresses, tearing up precious letters etc. we'd hoarded for months, and clearing up generally – especially making our wills in the space provided in the pay books.

It was about dusk when we lined up in full war paint and what a motley crowd we looked, every man carrying an "extra" of some kind – all of which "props" are needed in a really big show. Every sixth man had a pick or shovel, each of us three sandbags across our chests, tucked ends under braces, smoke helmets, two days' rations and distinguishing discs to hold up in Jerry's line when we arrived to warn our artillery to lift their fire. I happened to "click" as my share a large bottle of rum to carry – veery, veery dangerous, one is liable to be mobbed – or make lifelong enemies if it got broken and lost.

S.R.D.
"SELDOM
REACHES
DESTINATION"

What the mud was like.

There we started on a seemingly never ending tramp through communication trenches to our position, taking our places by short rough wooden ladders especially erected by the engineers for the speedy scaling of the parapet. We were kindly given permission to lie down and rest if we cared to but unfortunately this was impossible – with the rain teeming down and the trenches half filled with sticky thick mud.

I for one felt more inclined to have a good think and strange are the thoughts that pass through one's mind – silly little stunts of one's schooldays, or wondering what one's folk at home happen to be doing at this particular hour, promising oneself all sorts of weird and wonderful things if only fate dealt kindly, the full realisation of the certainty that many of us would not come back while others – strong active men – would suddenly at a fell swoop, be struck down as helpless cripples for the rest of their mortal lives.

I should think we waited there huddled up for about three hours – then the order was passed along "Seventh – Stand to!"

We straightened ourselves out, had a mouthful of food with a sip of rum, then we were quite ready.

We were due to start out at four-o'clock, and had expected a terrific bombardment from our people to prepare the way - break Jerry's wire etc. - but all remained ominously calm - it began to get light and we being at "concert pitch" had an uneasy feeling it had been postponed. I am certain, we were all so obsessed with the idea of a big assault and keyed up to take part in it, that we should actually have been disappointed if there had been "nothing doing" after all.

In fact we began to get sarcastic about the gunners and wonder if they'd forgot to put their alarm clocks on. ❖ ❖ ❖ ❖ ❖ ❖ ❖

It was thundering - up above - when suddenly with one tremendous burst all the fury of the guns completely wiped out the sound of nature's ragings

The bombardment was murderous, making one almost sorry for the enemy across the way - worst than the most wretched nightmare could conjure - completely changing the very nature of the earth in front. Every gun of ours for miles round was having its say - not to mention trench mortars etc. It was bad enough for us to have thousands of shells whizzing over

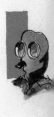

our heads for two hours – but Jerry must have thought it the end of the world, and probably it was for very many.

Quite as suddenly as it began the bombardment stopped and our gas was sent over, then the whistles blew – followed by the word, swiftly passed down the line – "Up the ladders boys and over the top".

At last we were up and doing – we had not gone far when the wind veered round, causing our gas to come towards us; the goggled smoke helmets were awfully primitive affairs – one had rare difficulty to see – and so most of us threw them off, feeling more secure, but unhappily the gas put many of our fellows out of action almost at the very beginning.

One would have thought no man could have

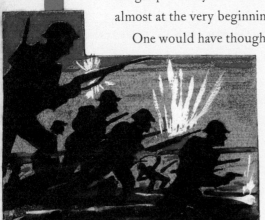

lived under the fire we had previously put over, but were astonished to find the Germans very prepared and active.

They put up a really murderous machine gun barrage – it sounded like very heavy rain on a window – and their shelling was extremely lively and accurate. The distance to our objective was quite 600 yds – and it is extraordinary what drill and discipline can make of men. Although without the slightest means of cover, we got over the ground as if at drill. Men were toppling over on either hand riddled with bullets – yet none wavered or dreamed of turning back – but kept on steadily and determinedly until the enemy's barbed wire was reached. This was unhappily not sufficiently well smashed by our guns, and caused a hold up – the high coal crassiers were lined along the top with snipers and so they had us just where they wanted us – and it was only by sheer luck that any of us got down into the German trench; it was slow, perilous work gingerly picking one's way through the mesh of wire and then there came the short rush with the bayonet. This is just where everyone who is

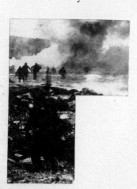

left finds himself fogged in trying to recollect exactly what did happen in that first mad minute.

I certainly don't remember how I got down – but I do know there were swarms of Huns, who made themselves very troublesome. I happened to find myself at a deep dug-out – by a machine gun emplacement – the gun had been lowered down a well on a chain (for protection I imagine). Three Germans came bounding up the steps – like cornered rats ready to bite. I stood very alert with bayonet poised ready for the first man – when I was suddenly violently pushed aside and one of our sergeants with the words "leave it to me" rushed at the foremost German with a "billhook" (a trench chopper) and cut the man's head clean in two down the centre, I don't ever wish to see such a sight again in this lifetime. The other two crouched down in panic and were bundled off as prisoners, tho' it was a toss up whether to give any quarter considering the mood we were all in – there was jabbing, thrusting, fighting for our very lives all round. Where the beggars got really "windy" and rushed into dug-outs – we'd chuck a bomb down, telling them to share it amongst them. Their fate can be imagined. Do not think for a moment many cut and ran away or hid at sight of us – no indeed, they seemed seasoned soldiers and gave a stiff resistance – showing admirable

courage for the most part – and in parts came to real hand to hand fighting. We accounted for many, many of the enemy here – but at fearful cost to our own poor fellows who were lying around with dreadful wounds. Hell could not be worse than this experience that seemed to last hours. One of my ole pals, a machine gunner (whom I'd known at home for years), was coming over with the gun on his shoulder and I looked up from the trench to see him almost out of the barbed wire – I remember plainly how jolly pleased he looked to have got over so far unhurt – when a wretched sniper got him in the head. He came down heavily and caught his throat on one of the sharp stakes, and was thus hanging up there for a considerable time – his terrible groans distressed me very much, and I very slowly with many interruptions wended my way along to find an officer.

(We had been told that if any man was so severely wounded that it was hopeless to save him – or maybe to ease dreadful pain we could procure from an officer morphia tablets that had been issued for the special humane purpose).

Well I found Lieut. R——— eventually, laying

along a fire step – calmly smoking a pipe. I asked him for a tablet and he said right-ho – just turn me over, which I did and found the box in a mass of torn cloth and blood – he'd had a large part of his back quite shot away. He asked me to give him one – then told me to get away to my job; I clambered up the sandbags to ease my chum but he'd gone, to peace and quietness.

Bombers were in great demand during this period and a very critical time ensued. A large party of Germans were discovered coming down an uncaptured communication trench and things got very desperate when we ran short of bombs – a crowd of "Fifteenth" men were coming over the top to reinforce us with more, when a shell landed right among them – what few bombs we did have now were useless, the wet had got at the tinder – then luckily a whole store of German grenades were discovered which we used to great advantage – eventually dispatching the invading Germans but not without loss and much grim fighting. Our Captain Casson and other officers were up above right on the Parapet, besides sergeants, spurring us on to further tremendous efforts.

BOMBS WERE JUST TINS OF EXPLOSIVE THAT WE STRUCK ON A PIECE EMERY CLOTH ATTACHED TO SLEEVE. USELESS WHEN WET.

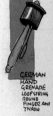

GERMAN HAND GRENADE LOOP STRING ROUND FINGER AND THROW

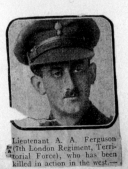

Lieutenant A. A. Ferguson (7th London Regiment, Territorial Force), who has been killed in action in the west.—

We lost each of them in a few minutes – they being in full view of the enemy's snipers on the crassier tops – but their lives were *not wasted*, their example told for victory in a way impossible to fully estimate. I shall never forget what a profound effect it had on me personally – in the midst of all the turmoil, I felt proud to be soldiering, and doing a man's job in company with such outstanding men. Captain Casson was calmly walking to and fro, up there, calling out encouragement – "at 'em boys", "stick it the Seventh" – firing his revolver the while at Hun bombers when the chance came, then suddenly crumpling up and slumping into the trench – finished. No, not finished really, he'd died, but passed his splendid spirit into ours and we carried on to subsequent victory. I shall never see or read of a better soldier all my life. We'd thought him a very tough proposition in England, when teaching us our job, but when the time came for him to show us he knew his, he did not fail.

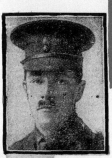

Captain Casson

The slag heaps were our next objective. A & B Companys had to climb up and try to dislodge the beggars laying all along the top. – potting at us at their ease. – machine guns were literally raining lead down, and altho' such a goodly number set out to the task, our ranks very quickly became depleted, poor fellows were rolling down covered in blood and coal dust, eventually the enemy were dislodged with the bayonet, and hand to hand fighting – the handful left, then getting back to the trench – We had been successful, but at night what a burial party – a whole host of men had to be thrown hurriedly into a big pit at the foot of a crassier. – One grave for all – the dead could be given no attention – it fared badly enough with the living – and the wounded, – we were so short of men, what prisoners we did capture (¨no prisoners¨ had been our cow) we had to send back by escort of sufficiently badly wounded men. Some fellows had been killed by cleverly devised traps – a bright helmet – (some souvenir) would be discovered on a fire step – or some other trophy in a dug-out – some unsuspecting tommy would grab it – and bang! would go a bomb or small mine through some concealed switch. ◆ ◆

Our next big job came quickly enough – a warning cry went up, and there a couple of hundred yards away we saw a grey mass of Huns stealthily advancing along the further side of the crassier. Like one man we leapt onto the parapet, dropped flat on our stomachs and fired for all we were worth, till our rifles were almost too hot to hold, machine gunners backed us up – till they were finally mown down. A nasty job – but somebody's got to do it – and it's they or us, without any trimmings.

Night began to come on, and things seemed to quieten down a bit – but not a wink of sleep could any soul get. We all had to "stand to" ready for counter attacks – expecting gas and bombardment any minute.

It rained dreadfully all night, but was otherwise quiet on our sector – seemed rather ominous and uncanny – also one felt extremely lonely with so many of the old pals silenced for ever. It made such a difference when some of the bright lads had been alongside to crack a joke with, even when "up against it" more than usual.

About an hour after dawn in the morning nearly "all out" with utter fatigue and lack of sleep I was

standing on the fire step of the trench, running round the side of crassier, when Corporal B. came up to me and said I was on a fatigue party.

We were woefully short of men, but somehow in my state of mind I felt it very unjust and said so, very forcibly. Several fellows came to see what the big row was about – I finally had to give in to an N.C.O. and followed him round a traverse, somehow going off in ill humour. I happened to be carrying my rifle under my arm, and to my complete astonishment and dismay my rifle suddenly fired – the corporal happened to have his hands in his pockets – with elbows out – and luckily my bullet just went through the small space between his arm and body, going into the traverse with a thud. Of course he felt convinced I'd tried to murder him, and unfortunately the row added colour to it. If he'd been hit – I shouldn't be writing this now.

It eventually blew over – but it was a nasty shock to me and a genuine accident, that I never remember without feeling queer about.

One had heard about such things out there, *not* accidental.

One thing I saw whilst on duty as sentry on the fire step – I happened to look back across the rear of our trenches early one morning and actually witnessed the artillery come galloping up quite close, in the open country – unharness the horses and get into action all in the space of a few minutes. It's always exciting at the Military Tournament – but to watch this in actual wartime thrilled me "no end".

Of course I had my job to do and could only glance now and again – they soon drew the enemy's fire and I was distressed to see a whole gun team go up in a huge cloud of earth and debris.

The German gunners had the range of every inch of this sector.

We had understood that after the attack we should be relieved soon – but such was not the case and hours dragged by with no sleep and shortage of food that together with continual rain made things less like a picnic than ever, and as time went on the Germans got more and more nasty with us occupying their old trenches and said so with really big stuff.

We were more than ready to leave when at last we wended our weary way out of these trenches with the prospect of a good sleep somewhere ahead.

But to our chagrin, instead of making for communication trenches and out, we were moved along further north to support the Guards. We were plastered with chalk and mud and almost sleep walkers, not over bright specimens as reinforcements to the Coldstreams – but no doubt if an emergency had occurred we should have pulled ourselves together all right. I don't quite know what the two days and nights were with them – I was in a sort of weak trance – but my! how it rained all the time.

We eventually packed our traps and stumbled out, and made a very sorry plight to behold – limping with swollen feet (standing for hours in water), sore, wet, unspeakably dirty, fagged out and straggling all over the place. I lost my crowd in the darkness and finally getting on to the main road found myself attached to a detachment of Guards (not as we all know them) but like a gang of navvies, just as unkempt and "all in" as we. When we got to the end

# GREAT BRITISH CHARGE.

## The Glorious "Shiny Seventh."

("NEWS OF THE WORLD" SPECIAL.)

## THE SLAG HEAP VICTORY.

### UNDYING FAME FOR "THE SHINY SEVENTH."

### INTO ACTION WITH FOOTBALL AND BOXING GLOVES.

London must be amazingly proud of its "Shiny Seventh." Their part in the last British advance will live in history as much for the sporting and cheerful manner in which they went to the assault of the German positions as for the heroism with which they stormed and won and held the notorious "slag heaps." Lieut. J. H. Jackson, who was wounded during the battle, writes:— " . . . I am only repeating the expressed opinion of corps, division, and brigade commanders when I say that, no finer line battalion 'went up and over' on the morning of the 25th than the 7th Battalion The London Regiment. Staggered as we are at the loss of so many dear friends—magnificent officers and men—a loss which we have not fully realised yet, the knowledge that the battalion so well maintained the good name it had already earned in the field goes a long way towards solacing us. And, after all, they died as all who have the honour to wear the King's uniform would wish to die—facing the enemy and in the moment of victory. The 'Shiny Seventh' were detailed to assault and carry the enemy's lines at a point where they had, after many months' work, turned two parallel slag heaps into a formidable redoubt, on the extreme right of the British line. Everyone knew what the task meant, for the battalion had done duty in that particular sector of our front line from the time the 'Double Crassier'—name by which the slag heap was known—was 600 yards away until, by sapping, our trenches were pushed forward to within half that distance. Hence the night before the battalion went into its place for the attack, and the C.O. issued final orders to staff and company commanders, one could feel although very little was said, that no man expected to come out unscathed. Still everyone was cheerful and optimistic as to the result, while

### THE SPIRIT OF THE MEN

was grand. There were many things for the battalion to carry, double rations, extra ammunition, smoke helmets, distinguishing discs (to put up and so stop our guns from shelling the German trenches once we got into them), that drawn up on the roadside, waiting for the motor-buses the column looked for all the world like a Hyde Park procession marshalled on the Embankment. The men in their cheery mood saw this aspect of humour, and were tickled at it. Battle pictures in the illustrated press at home usually show men doing valorous deeds whilst correctly attired for a marching-order inspection, but it wasn't a bit like that. Greatcoats were left behind, also letters and small kit. Two days' rations were carried in the packs and also the caps. For headgear each wore his goggled and metal-mounted smoke-helmet, with its front turned up, but all ready to pull down at once if gas was encountered. In addition, every man had three sand bags across his chest, the ends tucked under the braces, and every sixth man had a pick or a shovel. During the special burst of artillery fire in the preceding hours, and while the battalion stood to arms in the front trenches, the Germans replied but feebly. Half an hour before the assault, and as soon as our gas was turned on and smoke shells were sent over to cover the front, they woke up, and their shells began to arrive. The 8th Battalion (Post Office) and the 15th Battalion (Civil Service) were in support of the 6th and ourselves, two companies of the 8th, with their bombers, being specially told off to come up on the flank of the 'Crassier' when A and B Companies had got across the front German trenches and on to the slope. As soon as the word was given, over went the companies, as cool as if on ordinary parade. One man placed the company football on the parapet and kicked it 'right away.' Lance-corporal 'Johnny' Condon, the light-weight boxer,

### SAILED IN WITH HIS BOXING GLOVES

tied on to his pack. The Germans, however, were ready and opened an internal machine gun and artillery fire. Several of our officers were down before the attack reached the German front line trench. Taking that trench was not a lengthy matter. The Bosches threw up their hands and cried 'Kamerad,' while those who would not come out of their dug-outs were systematically bombed. All this time, from the top of the 'Crassier,' a heavy fire was kept up by the enemy. A and B Companies did not stop, but went on and up the crumbling slag heap, while the other companies cleared the trench, threw up a parapet, and made fire steps. A gap occurred on our left, due to the 6th diverging so as to clear the uncut wire on their original front. From this uncaptured section the enemy bombed violently. Our own supply of bombs was running out, and something had to be done quickly. Captain Lydiart had in the meantime, with the aid of the signallers, fixed up communication with the supports, and an urgent call was made for more bombs. A platoon of the 15th rushed across with a supply, but a shell caught them. Up came another platoon, who succeeded in getting their bombs to us. In the meantime the two companies of the 8th had come up on the right just at the proper moment, and the 6th on the left. Bombs were available then in plenty, and the Huns were all cleared out. It was ding-dong work all the time. In the meantime A and B were hard at it on the 'Crassier.' All who reached the top started firing down on the enemy on the other side. Captain Casson, fully exposed, and, as one of his men put it, 'as cool as if on a field day at Watford,' controlled the work here until he was struck down. Lieut. Smith was looking after his machine-gunners. He had been wounded by a bayonet in the leg, and, as the German

### SNIPERS WERE POTTING AT HIM,

Captain Lydiart urged him to come into the trench. As the latter was helping him down, a bullet hit Smith in the head. Two German machine-guns were captured, and, as there was plenty of German ammunition lying about, a lance-corporal quickly brought one of the guns into action against its recent owners. Lieut. Roberts, although wounded, did splendid work, and was as cool as a cucumber. But where all did so well it is difficult to particularise Captain Bell, R.A.M.C., and his stretcher bearers were everywhere, and there was a 'stand-easy' or an 'eight hours' day' for them. At the finish the 'Crassier' and the German trenches remained in our hands, but at what a cost! Among the killed was a lance-sergeant, whose name, we subsequently learned, had appeared in the 'Gazette' of the day before appointing him to a commission in the battalion. Then the rain came down, and the chalk trenches were anything but pleasant. The battalion held them, and also the 'Crassier,' for two further days and nights, under shell and machine-gun fire, standing to arms each night to repel threatened attacks, no sleep, very little chance of feeding, and soaked to the skin. Then the 15th Battalion relieved them, when the 7th moved out and into trenches further north, in support of the Guards, and in conjunction with the other battalion of the brigade. It was rumoured that the Guards specially asked for the brigade, knowing that they were close by, and also how our men shaped when in action alongside of them at Festubert. Plastered with chalk and mud, and falling asleep as they marched, the battalion at last moved back through the dark and the rain (or over twelve miles to a village where they were able to sleep and rest, and then given a couple of days in which to

### TAKE STOCK OF OUR LOSSES

and refit. Here it was that Colonel Faux, V.D., issued the following Battalion Order:

The Commanding Officer wishes to place on record his pride at the achievement of the battalion in the recent action at the 'Double Crassier.' The Battalion has been congratulated by the G.O.C. Division and the G.O.C. Brigade, and the Commanding Officer takes this opportunity of thanking all ranks for their gallant conduct which has added greatly to the good name already earned by this Battalion in the field.

We are now up in front again, standing by for more work." The officer who received Lieut. Jackson's letter and forwarded it to us adds:— " I was hit in the left thigh, just as I was putting in the final spurt between the wire and their trench. . . . Of course I could not take any hand in the scrap, but saw a good deal of what was going on. I saw Capt. Casson hit. A German bombing party had got right up to the south Crassier, and a number of our fellows lined the trench each side and were firing down into them. Casson was on the top as well, blazing away with a rifle, when he was hit. Our fellows were having a very thick time while I was there, but seemed to be holding their own. It was good to see them drive that bombing party out. It was a very close thing at one time. Lance-corporal Nicholson, one of A Company's bombers, was a fine chap. After he had been hit in the head he bandaged three of us up, and was crawling over to a fourth when some swine shot him. I couldn't see where the beast was, but he had shot two of our wounded men close to me just before.''

LETTER DATED OCTOBER 6th, 1915, FROM COLONEL COMMANDING 6th (City of London) Battn.

My dear Seventh,

By gad, I salute and love you. The Brigadier has told me of your performance and I know at any rate some of the price you have paid. A frontal attack on the "Double Crassier". Poor Casson, one of the very finest. How you will miss him.

I am proud to have known you all and congratulate you most sincerely.

Yours always,

(Sgd.) T. W. Simpson.

Colonel commanding

of our twelve mile tramp – it was just about dawn
– and indeed it was a "hopeless dawn" picture we
presented, despite the pitifully brave attempt the
chaps made to keep up a sort of marching step.
We were all very bucked and cheered to suddenly
come upon the Guards band which had been
waiting ready to take us over the last lap of our
journey. I don't know how I, at least, should have
stuck any more (I was using my rifle as a crutch)
if it hadn't been for this heaven sent blessing – we
found new hearts.

Arrived at the village allotted us, I found
my ole Seventh crowd again – we made for the
estaminets – and I just slumped out on the floor,
and came to, some time after, to find an old French
woman pouring hot coffee down my throat,
muttering "Pauvre Garçon" etc.

"POUVRE GARSON"

We were "bedded down" in various lofts, stables
and cowsheds, equal in merit to us, to any fine
hotel, and how grateful were we to take boots,
puttees and clothes off – for the first time in many
days and nights. I almost had to chip my socks off
from my feet.

It took a couple of days to assume anything like our normal state. The cleaning up took hours – scraping the caked mud off, washing equipment, socks and so on. Then there was the necessary fitting out with new stuff – many things having been lost in the fray. The first morning out we had a roll call – which was a very sickening affair to realise how very few of us were left of the fine battalion, that came out a thousand strong in March.

As the many names were called – the silence was very ominous – with just a "present" here and there to signify a lucky one who'd got through alright.

The battalion now seemed a very small family on route marches etc, and we had little doses of drill each day to keep us fit, otherwise things were fairly cushy, and we were left wondering just what our next action would be and where – giving ear to some fifty odd rumours a day. The recent attack now seemed to merge into memory as an unpleasant dream, trusting never to have to experience a similar week's work again (though of course to be ready for anything that might turn up). The strain is so severe at times – inhuman – that I have

READING OUT
THE TRAGIC
ROLL CALL.
EVEN HE HAD
A CATCH IN HIS
VOICE AND
SOUNDED
TENDER

heard men even envy their mates that have "gone under".

Many are the bitter experiences one goes through in this war, and the everyday indescribable sights one sees on every hand. Tame in the written word, but poignant to live amongst.

The French aptly named Loos "The Valley of Death".

Sunday – October 3rd – A church parade in a field was the principal order of the day – but I clicked for cookhouse orderly, so had to peel the spuds and wash the dixies instead of joining in the hymns, but it was all very enjoyable and peaceful by comparison. In the afternoon, as we thought to have an after dinner nap or a quiet sit down, writing to the dear folks at home, the orderly sergeant came upon us unawares (or we should have been hard to find) and collared some fifty of us for a working party. Of course orderly sergeants "reserve the right to change the programme" so there was naught to do but whistle and toddle along to the canal in fatigue dress – to unload lorries and walk a narrow plank with a hefty load which had to be shot into the hold of a barge. We had six hours of this, and if language

"SPUD BASHING"

could have done it, that barge would have been *sunk* in half this time.

Anyhow we were very ready for a supper of bully and biscuits when we got back.

Next day saw us with a big batch of brand new soldiers to make our numbers up, and in the evening at six o'clock we all fell in for a really stiff working party. Quite a nice little sample affair for the fresh 'uns – just a tramp for four or five miles to a dump, then each man loading up with a trench mortar or a heavy box of ammunition, then at least a couple of miles of real hard going over open country from our old trenche--s to the new point of the German trenches we'd recently taken. Machine gun fire was pretty deadly in this quarter, and a marvel that we did not suffer even more casualties, the ground was literally swept at short intervals – calling for great agility on our part.

We realised now what a big chunk had been gained in the last affair – whereas we'd looked ahead in front of our trenches at the Loos towers a week or two back, quite a mile off, now they were within our own lines and we actually passed under them on this journey.

They were two massive mine shafts – so extremely high and so unlike any other shafts in the coal

SEEN FROM
OUR BILLET
1915.

districts that rumour had it they were used by Jerry as observation posts and were actually erected with German money – before the war – with a foreseeing view to this actual purpose.

Be that as it might – when we had finished our task and had been right up to the front line – we came back the same way and just as our luck would have it a very breezy strafe started up, and the heavy German shrapnel bursting against the iron towers played quite a new tune to our ears.

Our artillery then started up and we were caught between a regular ding-dong artillery battle, in fact we were mighty glad of the scantiest shelter and I crouched down beside a pretty hefty tombstone in the churchyard (the church had been razed to a crumpled ruin long since.) I happened to put my hand on quite a well preserved little crucifix – which I carried about with

HAVE THE ACTUAL SOUVINEE CRUCIFIX

IN MY POSSESSION NOW

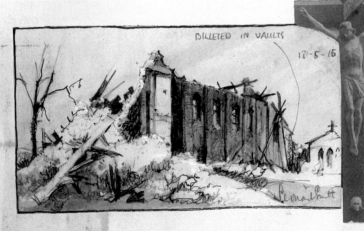

BILLETED IN VAULTS

18-5-15

me afterwards – despite many temptations to chuck it away to lighten a load.

We finally had to risk the shelling and get back somehow before dawn betrayed us to the Germans, for there were no habitable communication trenches about here – they had all been battered to pieces. As a matter of fact it soon began to get light which meant we had to more or less dodge from one shell hole to another, the place was strewn with all sorts of ghastly witnesses to past bad days – huddled up heaps of dead, burst bespattered sandbags, parts of dug-out structures, pieces of men – and now a rising mist hung about this bitter cold morning to just complete a scene of hopeless desolation – it also helped us by hiding us from prying eyes of enemy snipers and letting us get back with quickened step to a jolly good breakfast of biscuit and well frizzled bacon. With tea strong enough to stand a spoon upright in the centre – but wasn't it lovely and appetising. We slept the best part of the day – and had to spend the evening preparing for an inspection by the Corps Commandant – for which we paraded the next day. He said "we had done the task

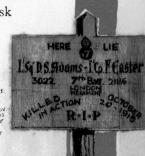

A LITTLE JOB I TOOK
UPON MYSELF IN THE
FRONT LINE.

A REPLICA OF LARGE CROSSES
MADE OUT OF SCRAPS OF
RATION BOXES. WRITTEN IN
PENCIL. THEN I SENT A PENCIL
SKETCH OF SAME TO THE MAN'S
PEOPLE AT HOME. WHO WERE
VERY GRATEFUL ALWAYS.
SOME 50 OR SO WERE DONE AT
DIFFERENT TIMES

allotted us in a most brilliant manner and our work particularly the 'Seventh' Battalion had not been excelled and rarely equalled by any other territorial battalion since the commencement of the war. He deeply regretted the many men lost, but it was all an essential feature of the job we had been called upon to tackle."

Nov 11th. We practically moved straight off this "posh", drill ceremonial affair to the trenches.

We did nothing very sensational this trip – but generally it proved to be a particularly hot bit of the line – an extremely dangerous exposed part only eighty yards from the Huns and being one of their trenches recently captured it can be readily understood how badly they treated us – and it accounted for the continual vicious shelling.

Our nerves were kept constantly on edge here – we seemed to feel it all rather keenly somehow maybe because of our return so soon after the other affair – no doubt it was necessary as experienced troops were needed and were not easy to obtain yet.

A great number of the original chaps "went west" these days and nights and the drafts we need will

make almost a completely freshly peopled battalion.

Trench life would be awful in a month or two; it was pretty bad now – one hardly dared to go to sleep for, on waking, one's feet would be frozen – one or two chaps had already caught frost-bite. It was only November but the icy cold water in the trench, little or no food to keep the body warm – only biscuits – bully and scanty cold water, told on us. We were exactly a fortnight in this resort – it seemed ten years of monotony – even the fierce shelling and machine gun music had a dread sameness about it; growing a stiff hefty beard lost its humour, no letters came up, a winter campaign seemed inevitable – so one way and another nobody was to blame who heartily envied the man who got a "nice Blighty one" from time to time. We had proved ourselves good soldiers – but living day and night with nothing new to say, nothing to read, nothing to look at but the dirty ole trench sides, or the grimy tired eyed boys was very wearing to the mind. I think all the men hated the inaction more than all.

The time came to be relieved and the pleasure was ours. All the greater, as rumour had been busy –

WHAT THE
DEVIL IS THERE
TO LAUGH AT ?

"we were in for yet another week" – and so we were surprised when the K.R.R.s suddenly loomed up amongst us in the trench and we packed up to leave them to it, with very good cheer.

We came right away back to LILLERS again, travelling by easy stages and enjoyed a really good holiday. Hard training every day but absolute freedom in the evenings – we all benefited very greatly by getting regular, decent meals and sound sleep at night, out of sight and hearing of gun fire. I was put on a course of bombing during this rest period – a pretty useful sort of accomplishment these days, they were becoming quite the vogue now and were taking a very prominent share in trench life.

SOLDIERS
FAREWELL
" GOOD BYE
ETC. ETC. "

   The divisional chaplain gave a magic lantern show in a French school room – but I'm afraid it did not catch on very well. It started well with a crowded room. We were game for anything fresh and different – but not long after the lights went out – in twos and threes the lads stealthily crept out of the door

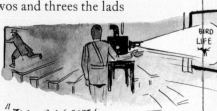

BIRD
LIFE

" THE WRONG SORT '
OF ' BIRDS MAZE "

POOR OLE " DO-GOODER "

so that he almost wound up by talking to himself. There were doings in LILLERS with much more kick in them.

Besides other things I had been carrying my jaw ache about with me for weeks – so thought a good opportunity presented itself these days to get put right. I paraded sick before the doctor to get a tonic for neuralgia. He was an awfully good sport and said "I should guard against further trouble – when exposed to the trenches again" – so he packed me off to hospital; it was a jolly pleasant change.

The hospital was in LILLERS – but boasted no dentist, so I was labelled to be dispatched to yet another one further back. All this happened early one morning and it meant waiting about there all the rest of the day, with a number of poor fellows who had just been brought down from the line.

I spent my time chatting and making myself generally useful until the evening – when I was put into one of the comfortable ambulance cars that formed a convoy of twelve, with other chaps who were suffering from grievous ailments or divers serious wounds, and thus conveyed to a place some twelve odd miles off.

This is known as a Casualty clearing station. All sorts of cases are brought here and receive temporary attention and are then packed off to various special hospital bases according to the nature of casualty or illness. On arrival here we were taken into a large wooden building and given a good feed of bread, butter and jam with hot cocoa – the most acceptable stuff I'd had for many a day, and especially for those who came straight from the cold wet trenches by other cars – there were at least five hundred cases here – mostly serious – some slight by comparison.

Of course I was virtually quite well except for the rotten neuralgia – and somehow felt a sneak to be here at all alongside fellows who would never again be whole.

Finally we were sorted out and I was parked in a tent with two Scotties, and had a period of real luxury, the best time I'd yet had in France. An actual four legged bed to sleep in – the kind of grub to which I'd long been a stranger, plenty of books to read, naught to do but rest and sit in the warm. I really felt the war could go on like this – and more clearly understood the outlook of some of the "cushy" official jobs that were

JUST WHAT THE DOCTOR
ORDERED

held by comfortable fat buffers at home – "Stick it – brave boys in the trenches" say they, knocking the ash off their cigars – or in our language " * you, Jack – I'm alright".

SAFE FOR THE DURATION

They had one or two Lena Ashwell concerts during my sojourn here – for the benefit of the patients. The doctors and nurses are most kind – and treat all with the finest consideration.

This clearing station consisted of a number of large marquees and a big wooden shed – I made a point of going over to this shed every night – to see the dozens of wounded come in, help pass round hot refreshments, give a cigarette here and there and be rewarded by a chat with some of my own battalion who with others had been brought in. Quite a big bunch turned up with frost-bite – a dreadful malady – to wear any boots is impossible and all swathed in yards of bandages and cotton wool. It's not always possible to save the toes or limbs thus affected.

THEY CALL THIS TRENCH FEET MY SECON OPINION IS , IT ELEPHANTITEA

In the ordinary way I should only have stayed at this show two days at the most – and then been sent down to a base – but there being no room at all I was kept on for twelve days – growing fat and lazy.

All good things come to an end – and time came for me to be bundled off – farther back still. To a place not quite so comfy – no beds – but plenty of blankets and good food. The top ward of a large hospital – and mostly dental cases.

Every time I looked out of the window I felt darned sorry for the boys up yonder in the line – the weather was so very severe – I could sympathise and imagine it all so well.

I was there a couple of days enjoying myself and then it came my turn to see the forceps and yell. Now this is where the huge joke comes in. The Dentist just yanked the worst one out (without anything to ease the pain) and then explained "it was impossible for him to do anything further – he could not spare the time to do the job thoroughly, plates etc." and he added "he thought it a scandal the doctor had ever passed me for joining in England – with such a mouth to try and eat biscuits" – I must admit biscuits were a real task with me; I had to jump on them always first to grind them up small.

I was a bit disappointed not to have the aches taken away – but was thankful to have even one out –

WHAT ARE YOU LAUGHING AT ?

and as I had another two days' "mike" I considered myself in luck. But doubtless the joke can be fully appreciated – as much as it was by the boys – for me to be away from the battalion and the line for eighteen days to have just one tooth out.

When eventually discharged they did not take long in getting me back to my unit. First to the stores by an ole ford situated in a small village fairly close to the line – we got there about midday. Not possible to go further up by daylight so was told to "lend a hand" cutting up stuff for company's rations until the time to trek up to the trenches – after the good time I'd had the thought seemed particularly distasteful, the one bright thought being that perhaps some post was waiting for me up there, with a refreshing breath of news from home – I'd not heard for the eighteen past days. All the food is dumped at the store such as this and a party of chaps come trooping from the trenches under cover of darkness, each collecting as much as they can *un*comfortably carry – when my little crowd arrived I got a hearty handshake all round and a joke or two off –but they seemed in a very bad way, they could barely walk or carry the stuff for general

weakness, they obviously had a real pig of a time. And from their brief remarks it had been indescribable misery – that nobody can understand other than by actually being there to experience.

I was destined to spend three days and nights in this delightful neighbourhood and found it the giddy limit. The mud and water came over one's knees in most places – without exaggeration – and it simply would not leave

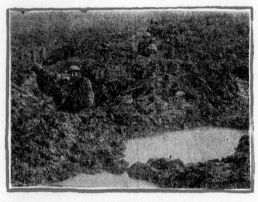

off raining. I was afraid frost-bite had caught me more than once. It became nothing at all unusual to see a man actually crying with the pain – and nobody available to take badly affected people out of it. Fatigue parties took hours to go a very short distance – and if a shell buried a man it was practically hopeless to try to rescue him out of the quagmire. I thanked my lucky stars many times that I'd escaped

such a big chunk of this trip, though in a measure I
was glad to be here for the last lap – as I was able to
give a bit of cheer, being well supplied with cigarettes,
chocolate and bread I'd received from hospital.
The chaps were ravenous and thought me an angel
(somewhat disguised). Also I came back feeling
very fit and cheerful – though nevertheless as
pleased as any when relieved.

THE ANGELIC
POST POST.

We marched or crawled back to a little village
just a little way back and had a well deserved
night's rest.

Next morning we were told it did not matter
about cleaning up – (though we needed it badly
looking like tramps or worse). We must be ready to
move off in an hour's time. We paraded and were
astonished to learn our destination was via the railway;
on the way to the station we were cinematographed
by a war office bloke and when we were moving off
in the train the same fellow had us again – to be
"shot" like this was more to our liking.

We came back a very considerable distance by
train and it took hours – so slowly did it move –
and oftimes we were able to bundle out and walk

THE ONLY TIME
WE WELCOMED
BEING SHOT

alongside for a change. Then the engine would stop we'd get some water from the driver and make tea. This happened several times – twice we had to leave our little picnic on the bank suddenly when the guard suddenly blew his funny little tin horn to go.

FRENCH
TRAIN GUARD
WITH HIS LITTLE
TOOT – TOOT

We disembarked at a fine town – full of shops which highly pleased us – and it turned out to be a time of thorough rest and change. We had a very comfortable loft for a billet – straw and blankets galore – bacon and gravy bread for breakfast – it was a considerable step nearer heaven than of late.

Of course there were long route marches – drills and such like little amusements – but no working parties of any kind. This was jolly fine – it seemed too good to be true as if one would suddenly wake to find it a dream at the bottom of a shell hole – we enjoyed strolling about the town, having time for a quiet read or writing letters in the Y.M.C.A.

Fellows started to go on leave in small lots and great excitement prevailed. The old originals were listed to go first and my turn drew pretty near.

Every man in the battalion had a reissue of kit now – with new hats, tunics, shiny buttons, all

equipment washed – all the little brass bits shone we looked very smart. Some of us who'd been in the rough side of the game were very peeved when we were subjected to sarcastic remarks from other regiments who thought we were new out and had never seen trenches.

Dec 18th.

Unluckily, leave was knocked on the head for me – my throat got very bad and I was forced to "parade sick". The Doctor packed me off post haste to an isolation ward – where he consigned me as being down with diphtheria. That was pretty gloomy being all alone in a small bell-tent for five days – almost impossible to get warm and unable to swallow a morsel.

After being under observation for this time he changed his diagnosis to acute quincies – as far as I was concerned it seemed "a throat by any other name is just has rotten". Tho', happily, it released me from isolation and I was ticketed for the base.

I travelled down by hospital train – a truly wonderful affair it seemed to me – just like a hospital on wheels with attendant nurses and doctors and everything for the comfort of sick or wounded men, hot meals cooked en route – which was as well as the journey took two days and a night.

Of course I could not view the scenery – being wrapped up in a bunk all the while. Arriving at our destination I found myself carried up a couple of floors into a delightful little bedroom, furnished as near one like home as a man could wish. Two other decent fellows shared it and out of the large French windows we had a decent view of cliffs and a fine expanse of ocean. It was well worth paying the penalty of a burning throat to get all this.

"Roches" No. 1 General was the name of this hospital – pre-war a fine large hotel at the popular French watering place, ÉTRETAT.

NO 1
GENERAL
SIDE VIEW

ETRETAT
HOSPITAL
NO 1 GENERAL

OTHER SIDE
OF BAY

For twelve days I had no food – could only drink a sip with great pain and was quite speechless, so was mighty thankful when things began to mend and I could really sit up and take notice.

We patients had a very weird costume when convalescent. A cricket shirt with flaming red tie, bright blue tunic and baggy trousers – but how much nicer and cleaner than khaki trimmed with mud.

Christmas in hospital was a real treat – the impromptu concert party, the Christmas pudding and musical games went down awfully well – everybody well enough to hobble, or be wheeled down to the big hall joined in the merriment; I was awfully sorry for one of my room mates – he was practically done, in the last stage of consumption and was too ill to be moved – so I obliged him by an hour's reading of a favourite book he had. He held my hand all the time and kept pressing it – a pathetic picture of real gratitude; when he slipped quietly off to sleep – I was able to get away to the festivities. It all seemed very unreal to be in such a happy atmosphere – while the old vile stuff was still going on up yonder.

I began to get afraid that if I stayed here much longer I should lose all my toughness and become a "featherbed" soldier. The food was plain but very appetising and together with the sea air and whole

nights' sleep, trench life again seemed to be an almost impossible existence.

We were allowed out on the beach with great coats – it was cold but invigorating to catch the breeze, throw pebbles at tin cans and generally fool about – making the best of it all while it lasted.

I was quite sorry when the time came to leave "Roches" though the last week or so there was an extra busy time for me. I was made a sort of waiter in the patients' wards. 36 Bed patients to attend to – four meals a day, one was absolutely on the run from "reveille" five o'clock till "lights out" at 8 o'clock. I think it was a good thing to have to be nippy and active again after the slack period of sickness – I was not able to write a single letter during this time.

I was eventually shunted on to the Convalescent Camp No 4 LE HAVRE. Composed of tents and huts, I luckily "clicked" a hut – much warmer. We had some funny jobs here: one party I was on turf cutting to make a lawn for the Officers; another job painting the Y.M.C.A. canteen. One afternoon at two o'clock we paraded for what was rumoured to be a dock loading fatigue. Imagine our surprise

when we were marched down into the town and led into a large cinema show and were treated to a three hours' run of good pictures – this was indeed "the stuff to give the troops". We felt very "Oliver Twisty".

Went before a "board" here: one Doctor said unfit – "throat affected through teeth"; another said – "fit enough to hold a rifle in a trench". The second Doctor won – so I was marked to return to the Batt. "toots sweet". The same afternoon I was indulged in another cinema show in another part of the town – this seemed to be a regular feature, run by the Government, three hundred of us were taken, and the gallery was filled with French and Belgian wounded. The next day they found me a cookhouse job – which I made the best of – scrounging tasters most of the time.

January 17. Next day, came the time to really depart from this camp – and a party of us were driven in cars to another part of HAVRE where another depôt existed – in  reality a huge soldier town composed of drafts for all regiments nameable. I was squashed into a bell-tent with fifteen others – an effort to lie down and awfully "nippy" too – for canvas is no winter gadget. But maybe I was getting a bit

soft and fussy through being so well looked after lately.

Monday morning breakfast at six and by half past – before it got really light – paraded for a day's hard labour down at the docks unloading ammunition, returning at six in evening – thoroughly whacked and ready for bed. The boys went to have a game at "housy" in the hut – but I took advantage of the empty tent, wrote a letter or two, and then tucked in for a good sleep while I had a chance to stretch myself.

Next day was better, we were taken for a pleasant march through the town and up to the rifle range for a good day's sport with a gun that could be fired without fear of a swift answer from a hidden sniper.

On the 27th a party of us had our names called out at 6 a.m. parade – and told to parade at 7 o'clock sharp – to move off to the station and entrain for the "Trench express".

It did not go very near the trenches and certainly was no express, in fact the journey lasted some thirty hours – a spurt for half an hour then a couple of hours' stop, which in a way suited us – we were able to get out of the train and run about stamping our feet for it was arctic cold and the snow lay all around – deep, crisp and even.

"After many moons" it seemed, we got off for good at a sort of reinforcements camp VERQUINELLE and spent the night again under canvas in a big marquee – one side had been demolished by huge gusts of wind so it did not serve to keep out the pretty stiff snowstorm we were subjected to. By the light of the few hurricane lamps I was astounded to see the type of draft we were having – just very young, inexperienced youths who seemed thoroughly bewildered with their new life already – they'd also evidently had their "legs pulled" pretty hard by old soldiers too which did not help them.

I thought the Sergeant Major here behaved very rottenly – he "rumbled" they were a "windy" bunch and so when we had lights out, he came, in a seemingly agitated manner – and bawled – "all you B——— will have something to worry about tomorrow, you'll be up the line where the Prussian Guards are breaking through and half of yer will get a sword bayonet poked up yer before yer B——— know where yer are. They'll just tread over you little worms – and every morning at five we're shelled to hell here."

Of course this sort of rough stuff did properly scare the green 'uns and some actually whimpered in utter terror. Poor kids, I felt awfully sorry for them and tried along with one or two other "old sweats" to convince them – "things were not really too bad up there and one soon got used to it etc". And no doubt they would jolly well be as good as any other British Tommy when the time came.

The camp was astir at four thirty next morning – why so early goodness knows – anyway we had to hurriedly wash, gobble up a breakfast of mustard pickles, dry bread and tea, and then scramble on to the waiting motor buses. We nearly ended the journey, almost as soon as it began with a nasty skid on the icy road – a real broadside biff against a tree then a bank. We swayed perilously stopped with a jerk – all got off pushed the bus onto its road again and off for another try.

Thus we got to LE BREBIS – then under cover of darkness slogged along on foot to our battalion at S. MAROC. This was the night of Jan 30th.

We found the "Seventh" out on rest with working party fatigues each night.

On Feb 2nd. the battalion moved across to South
MAROC and my platoon were billeted in an old
school - nothing much now to identify it as such
just a few broken forms - torn pictures - some chalk
drawings by kids on the walls, and a shell broken statue
of the Virgin Mary.

Things seemed to have got very
much more lively since our last stay here - some
months back - although to our great surprise
a number of civilians seemed to have drifted back
somehow. About noon of the first day the
enemy sent over some frightful big stuff, killing a
number of civvies. and one heavy shell landed
right between. two of our cooker waggons stationed
in the railway cutting - seriously wounding three
cooks standing by - and accounting for several chaps
who were parading for grub.

It's a most distressing sight on such occasions
to witness the terror of the civil inhabitants - women running
hither and thither with screaming children - not knowing
where to fly for safety - we often wondered what on earth
made them hang about such dangerous areas - near the line.
and put it down to the fact of their being awfully poor

and quite unable to leave their belongings - or what
was left. ◆ One shell crashed right into the
roof of the house opposite our school and almost
immediately from the neighbouring house there rushed
a Frenchman pell-mell down the street in a panic
clad in naught but his shirt. He had evidently
been in bed, maybe asleep. Anyhow he presented
a grotesque figure - though one could feel sorry for
him.

◆ ◆ ◆ ◆ ◆

After a couple of days of rest?? and much
working party business - putting France into sand-
bags etc - we left for the trenches at dusk -
Feb 5th

◆ ◆ ◆ ◆

This time it meant a good five or six miles
"hard going" to reach our destination at HULLUCH.
Over shocking rough sticky ground - We had to
"chance our arms" over open country - as the trenches
(communication) were literally filled up with mud and
water. ◆ ◆ ◆ ◆

We had to go via Loos - just a ghostly
ruin in the moonlight — leaving the old towers on
our left we kept on till eventually we dived down
Piccadilly trench via South Street and then to Regent St.

away up yonder to the front line. There we took up a position just to the right of a very recently exploded mine crater. This section was known as the "D", the trenches here being the shape of that letter.

As the other troops moved out they bade us good luck and told us to 'ware mines for Jerry had been very industrious underground of late. The poor blokes certainly looked the worse for wear – and generally the prospect was not rosy.

The first night passed off well enough – tho' shivering cold. I had an hour's "kip" on a fire step while off duty – and woke up to find my overcoat absolutely stiff with frost and actual icicles all over the big collar where I'd been breathing. I'd never felt so absolutely unhappy with cold in my life, and could not have held a rifle under any circumstances.

Early next morning Fritz seemed to wake up in a beastly bad temper and made a strong point of letting us know about it. There were trench mortars galore with a strong dash of whizz-bangs in an altogether lively programme, making an incessant call on the stretcher bearers. One poor fellow standing by my side, chatting while fixing up a

gas gong had both arms practically severed by a big chunk of shell splinter. Two other chaps were about to have a little personal scrap over a tin of bully – but their quarrel was suddenly brought to a speedy conclusion; when the smoke had cleared away they were unrecognisable. One of their mates went "wild" when he saw this – jumped on the parapet and began to the shout the most inane things to the Hun – which of course immediately drew fire, he flopped down with a thud in the trench – one bullet in his mouth, another through his brain – and so it went on all day. In places the trenches became obliterated which meant extra hard "graft" at night repairing them.

The following day our artillery was very active in the early morning. And an hour or two later Jerry retaliated so that it became a terrific duel between them. With we poor infantrymen as usual having the hottest time of the lot between both fires. On these occasions it's really hellish and this time particularly got so perishing fierce the officers ordered us all into dug-outs – or every man would be wiped out.

I happened to get down into a very deep one. Another chap was sitting just above me, with a sergeant and a corporal on the steps up near the entrance – writing letters in a gallant attempt to forget the iron whizzing around.

Suddenly there came a blinding flash, a terrific explosion and then utter darkness. A trench mortar had landed right on the dug-out, breaking the wooden supports, crashing all the parapet in and completely burying us under the debris.

The two N.C.O.s were pinned under the woodwork and sandbags and killed instantly; the other man and I were luckily deeper down which to a large extent prevented us from being completely covered with earth and buried alive – the entrance was hopelessly blocked with sandbags, earth and a mass of criss cross broken beams. There was just a tiny hole about an inch square far up in a corner through which shone a ray of light, and gave just a small hope of escape.

My back was aching horribly, being in a strained

DUG-OUT BEFORE TREATMENT

SAME AFTER TREATMENT BY
BOSCH SPECIALIST

position – something had also given me a biff on the head, but worse than all, my companion was wounded at the back of his skull and he went all to pieces – he was losing his reason rapidly. As fast as I feverishly started to dig away with my fingers so did he scream alarmingly – and tried hard to throttle me – and down in that fearful prison it became a fight for life with a madman; he was a hefty raw boned man and I should never have escaped but for the fact that he suddenly went out in a helpless heap – in a fit – or through loss of blood from his wound.

Never was music sweeter than when after what seemed hours I heard with joy the soft, dull jabs of pick and shovel, and was rescued after a couple of hours' hard digging by the quartermaster sergeant and some of the boys – I was horrified to see how mutilated the poor corporal was who'd been on the steps.

I was thereupon told to go and have a "kip" in the sergeant's comfortable dug-out for an hour or two to let some of the dust blow out of my eyes.

The sleep quite restored me and I was aroused to join part of the platoon on a job of work. The large new mine crater by our trench was rather a touchy spot as they nearly always were – we occupying one half and the enemy the other. At night time our job was to fortify the lip of the crater, packing up the sides with sandbags, literally making a new semi-circular trench of it.

The Huns were on the same game – we could hear their picks and shovels going – we both seemed to agree to let each other get on with the work for an hour or two, then suddenly they treated us to a veritable shower of rifle grenades and other death dealers – several laid down their tools for ever in this stunt and we started in to let them have a taste of the same medicine.

We were glad to be recalled from this unhealthy spot just before daybreak – to spend further hours in the front line almost frozen stiff with the icy water above our ankles, in spite of some pretty smart moves when shells burst.

The next night we had wind that Jerry contemplated a raid on us – and so a corporal, two

other men and myself were detailed to act as an advanced covering party to a group of men who were consolidating the position round a crater, our special job being to stand at the alert on the most extreme part (15 yards from the Hun) armed with hand grenades – so that should the enemy attempt to suddenly rush the position we could give warning and keep the foremost at bay as long as possible while the fatigue party rushed back to their proper positions in the front line.

We went half way through the night with just a sort of ominous calm (wonder Jerry couldn't hear our teeth chattering with the cold). And just about the time when we were fed up with peering into the gloom and seeing nothing the Corporal blew a shrill blast on his whistle – he'd seen several forms stealthily creeping upon us. Then the four of us set to work like demons lobbing bombs as fast as we could pull the pins out; it seemed about ten minutes before a couple of machine guns came to our aid and so we warded off the attack – it was really fruity and warm while it lasted – only one fellow got badly wounded. Jerry had not expected

our presence in this advanced bit and had been making for the front line where our boys were waiting – but our timely intervention stopped them trying so far.

The platoon officer thanked us for our little bit – with the remark that "he was surprised to see us looking so well – in fact that we had survived at all".

Ah, well this life was one darned thing after another: at 4 o'clock on the following morning we blew up a mine under the German trench – this was a nasty sticky business for everybody near. The ground gave a terrific lurch and then up she went in mighty columns of black smoke with very little chances going for the poor blighters involved – the displacement of air is very disturbing to the lungs and makes it difficult to gasp for breath for a minute or so.

Directly the explosion has subsided we have to dash over and complete the work of destruction with rifle and bayonet, which is devil's work among the cowed, stricken half embedded men – enemy or nay. We got a good handful of prisoners

from whom to extract information for G.H.Q. and dragged them back to our line – our job well done – for this had been the definite aim of the mine stunt. It's really surprising to find anyone alive after these "dos" – for besides those blown to "kingdom come" and others buried, they are also subjected to raking machine gun fire with a goodly load of shells to finish up with.

Of course it's "fifty fifty", we are in constant danger of our lives our side too – the Huns have always got us "on a string" somewhere. It's a never ending occupation for crowds of both German and English miners. Many, many parts of the trenches were under perfect control from the R.E. Officer's switchboard – sending men to eternity by the touch of a button. (Would look quite good sport no doubt on the pictures.)

That night our company was relieved from the front line and took over the cellars in a village a few hundred yards back.

With my usual "nose" for a good job I clicked with a corporal the "cushy" ?? job of guarding a bomb store. We were handed a list showing a nice

healthy stock of ten thousand Mill's bombs, umpteen trench mortars, stacks of rifle ammunition – in fact a pretty big collection of stuff guaranteed to make a fine large bang and commotion should Jerry aim a decent sized shell through the top. We were only a couple of hundred yards from the front line – and subjected to quite a lot of strafe all around – but fortunately nothing happened, or rather, obviously, for I shouldn't be writing about it here.

An interesting item was the switch on the wall – to put on should we suddenly be surprised by an attack from Jerry; in such case the order was to blow up the whole show – "dog in manger fashion" – we could not have it so the Hun mustn't.

Our front door was in a communication trench and at night we had fatigue parties calling from the front line – to load up with further supplies from our store. It was a nice change to have the boys to talk to after sitting about all day in the gloom – with one corporal who I'd never have voluntarily chosen as a soul mate.

We were on this three days and nights.

On Feb 9th came the German retaliation. Along a comparatively narrow front they blew up twelve mines – one very large affair under the front line that the other companies of the Seventh battalion were holding – they followed this immediately by a terrific bombardment causing many awful casualties. The enemy made a strong effort to storm their crater and take our line – but by timely machine gun fire and the help of the boys in reserve they were repulsed – one gunner earned a D.C.M. for getting his machine gun into play at the crater before the debris had finished falling. I was still at the bomb store and saw as well as felt the mines explode in one awful rumble – the next minute the corporal and I were far too busy to worry about our "end of the stick" – the arsenal among the shelling – we were handing out ammunition and bombs for dear life.

When this particularly wicked Hun strafe abated after what seemed many hours, we were relieved by the 10th Gloucesters. The battalion moved out but the Corporal and I had to hang on for some time till two new men were detailed to take over our

particular little job. By which time we lost touch with the battalion and had to hoof it on our own – getting as far back as PHILOSOPHE, we were lucky enough to get a lift on a lorry all the way to BRAQUEMONT. Nothing could have suited us better and we appreciated our good fortune the more when we saw the other boys of the Seventh staggering in. Here we got a most peaceful sleep and felt quite fresh when we all paraded at eleven o'clock next morning for a march to NEUX-LES-MINES railway station – there to entrain for LILLERS that we knew well. Eventually arriving and finding nice clean billets.

Then began a series next morning of numerous petty, bothersome parades, inspections, company drills, cleaning up stunts etc – that somehow always were the "flies in the ointment" of a rest ? period.

On the Saturday evening February 20th No. 3 Platoon "clicked" for inlying fire picket, which meant we had to stay in our billets in case of fire in the town through bombs or shells – at hand to act as firemen. At this time the billet was a loft

situated at the top of a very high building with a general shop below.

The Chaplain brought up a portable gramophone and one way and another we had a bright evening.

We tucked into bed (a blanket on the floor) about ten o'clock – fully dressed of course in case of emergency. But at midnight were suddenly aroused by a terrific crash – followed immediately by another – then we heard the drone of the engines, which explained at once Jerry planes were over us on a night raid.

We heard the sergeant banging at our street door and bawling something out – so all pootled down to go on duty. To my complete amazement he detailed the others off to various jobs but told me to go over at once to the orderly room and report – which I did, and in the midst of all the commotion (and there was some – quite a number of nasty casualties) I was handed my pass for leave to "Blighty".

I was overjoyed but suddenly went limp and thoroughly "windy", I felt home so near yet with the raid on wondered if I'd "cop it" at the last lap.

I literally ran for my life to the station – the train was due to leave at one o'clock. The French engine driver was evidently anxious to move off out of range of the airmen – for we started out sharp-to-time – but not soon enough. Tho' the station and all carriages were in utter darkness the sparks from the engine funnel must have given the show away – for no sooner had we commenced our journey than a huge bomb came down and caught the last two coaches.

Of course we stopped – bundled out to see what we could do for the poor blokes caught so badly – but an officer gave orders for the rear of the train to be uncoupled, told us to resume our places and proceed, the hospital people at LILLERS would see to the wounded.

By this time it was an effort not to get panic stricken, for fear that after almost a year from everything lovely and dear, the glorious chance might be snatched away.

Anyhow at last we got well under way and our spirits got very boisterous as we neared BOULOGNE – reaching there about eight o'clock – and then much to our disgust had to waste

precious hours of glorious liberty hanging about the dock before we could embark.

Finally we sailed out but had not proceeded far when great excitement prevailed on board, officers and men thinking something serious was on. When two destroyers dashed up at an alarming speed and diverted our course – we understood we'd been in great danger and only very narrowly escaped running into a mine. This all swallowed up time and we reached FOLKESTONE much later than we'd hoped. Of course we were extra fussy even for "Old sweats" on a joy ride, and we'd have clung to the tail-end of a shell to have arrived home quickly.

I got down to the ole Homestead at seven in the evening and from that moment began a glorious week of joy and the right brand of excitement. The first night I snuggled down in the clean white sheets was heavenly – I was sleeping "the sleep of the just" when at about two o'clock next morning I was awakened by somebody pulling me. I woke with a start thinking I was in a trench – but glad to find it was only my Father saying "they're about". I felt rather perplexed and said "who?" – "what?" – "where?" then

he explained he'd been on 'special street patrol'
outside and a bunch of Jerry planes were coming
over.      Really I didn't see the force of being woke
up - such had become such a commonplace in my life
that I wanted to lay down in my little bye-bye and
not be bothered by a few bombs -    But the dear
ole' Dad constrained me to get up - which I did and
so fell in with the general custom - of sitting down
with a cup of tea - and only the palest glimmer from
the lamp - waiting till all danger had past.

      Neighbours flocked into each other's company -
sitting under tables etc - for comfort and protection.
I was told the London Tube Stations were crowded out
with the more "windy" folk in town.

      Anyhow nothing much happened in the couple
of visits Jerry made during my leave.

      I was staggered at first to see the munition
girls coming out of factories with bright yellow faces
and arms -    The girl postmen - porters - etc was all
very strange and new to me.      Also I noticed
if a man had been to the front about a week and got
a small wound - he was recognised by all at home as
by far the greater hero - than a scarred old veteran who
had survived a year's hell and misery without a scratch.

ON LEAVE
SOME COCKNEY KIDS'
SEEING THE CAPE
"GET UP" SHOUTED O
" LOOK BOYS HERE COME
A BLINKING EARL"

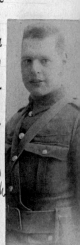

ON LEAVE

"HERO" CHOPPING WOOD
FOR THE LANDLADY
IN THE BILLET

Alas! on the seventh day, 'twas time to bid goodbye to freedom and comfort – and all the dear folks at home and the train steamed out of Victoria about 8 a.m. amid a storm of cheers and farewells from the very crowded platform. We looked a cheery-chirpy lot of fellows till we'd travelled out of sight then everybody seemed to grow glum at the prospect of leaving it all again for goodness knew how long.

Reached FOLKESTONE – then straight on the boat arriving at BOULOGNE in the early afternoon.

Having landed, we formed up on the Quay – everybody loaded with some gift or other pressed on us by friends – and then formed up to toil up the four miles of stiff climb to OSTROHOUE camp – there to stay the night and part of next day under canvas.

It was really bitter cold and rained in torrents, which turned to snow as we trooped down to entrain for LILLERS late in the afternoon, arriving to report to battalion about midnight.

Now it meant getting into harness jolly quickly – for next morning we were roused at six and paraded at eight o'clock to move off on a long trek of 17 miles to ENQUINETTE. Happily the weather was glorious – and we all thoroughly got into a

good marching mood – singing our favourites at the top of our voices etc.

When we arrived about 3 in the afternoon we were allotted nice billets, No 3 platoon getting an especially fine barn.

Next day we were out again at eight o'clock marching and manoeuvring up hill and down dale till tea-time – the following day the same capers – only much more so, being a Brigade stunt, sham fighting and so on.

March 3rd saw us billeted at THÉROUANNE. We had to get here through a perfectly blinding snowstorm – but were rewarded by the jolly fine place that our platoon was directed to stay in – actually an old mill by a stream.

THÉROUANNE (P. de-C.), Ville fortifiée, détruite par Charles-Quint en 1553.- L'Usine Électrique

This was top-hole – we had a good rest on the next day Sunday – just church parade at 10 o'clock. The padre preached a man's sermon, after which we explored the country around, and had some good sport on the stream which was frozen.

In the evening the Doctor came round to our billet – we wondered why – and our curiosity was satisfied within an hour – owing to an outbreak of fever the platoon was to be isolated. We were shunted off quickly to an old barn right at the end of the village and kept in close confinement for three days. This was a "large basinful" of luck – for the weather was beastly and we could sit round a good fire (a sort of watchman's bucket with holes) (bits of barn for fuel) whilst the other companies were going helter skelter over the fields for miles – putting in intensive training from early morn to dusk.

On Wednesday the M.O. released us from isolation and we were able to go out and participate in the finest snow ball fight imaginable – plenty of snow, beaucoup thick ears.

Thursday morning found us packed and again on the move to a village named NEDOCHION, camped here one night, then on a really long trek – marching for six solid hours through heavy snow and slush – till we arrived a bit weary at the village of BEUGIN, near PERNES, a jolly decent place.

Next day the weather changed and became lovely – entirely dispersing the snow and wet. We had struck a nice barn with a rare lot of straw.

On the Saturday evening after a pretty hard day, we were lying in bed reading, writing or playing cards when suddenly the bugles sounded the fire alarm. We all hopped out pretty quick, dressed or not – and found the next barn, "D" Company's, blazing away like mad. Somebody had upset a candle or something of the kind – we all did our utmost with pails of water but did not prevent it being razed to the ground. Of course there was a big fuss about it – especially over the cows who were burned to death in an adjoining stall – they were roasted and charred like burnt wood when we saw them in the morning. The French farmer kicked up a deuce of a row and the whole company's pay was stopped in instalments to pay for the damage.

Anyway they had their money's worth out of the show while it lasted – quite a novel entertainment, tho' of course rotten for the animals. We didn't know they were there at the time.

On Sunday we were permitted out as far as HOUDAIN, a decent sized town where we could replenish our grub stores, buy cards for home etc and have a rattling good meal of eggs and chips.

There was not much doing in this quarter save the usual rigmarole – till Thursday when we paraded and marched 12 miles through splendid hilly country going southward all the way till we reached our destination VILLERS-AU-BOIS, a little shell riven village in the neighbourhood of the LORETTE HEIGHTS, where we were lodged in exceptionally comfy quarters – huts built and only just vacated by French troops; each man had a little bed consisting of a wooden frame well off the floor stretched across with chicken wire – with straw they were wonderful compared to the usual stone or floor bed.

We were kept well on the jump next day with all kinds of teasing parades – and quite expected to be bundled up to the trenches in a new sector that evening but this was postponed at the last minute – so we had yet another good night's sleep.

Friday happened to be the anniversary of our landing in France March 17th and we had to spend the whole of the day and the following cleaning up the village — burying old tin cans and stuff — the Frenchies had littered about - they were a dirty crowd - quite different to our people we had to keep everything spotless out of the line. . this was a sticky job in places our better than trench life by far.

22-3-16

VILLAS AU BOIS

Our (present) Village church lit by shells

Sunday - church parade Cat the rear of this old shattered church - the new Padre gave us a real man's talk but the service had to end prematurely owing to enemy aircraft hovering about up above - five of them - seemed to be searching about - probably just getting information as they dropped no bombs - thank goodness.

Treated myself to a pleasant Sunday

afternoon "mike" with a bit of drawing and writing then a good "snooze" preparatory for a night's hard working party stunt, for which we paraded at dusk in the evening, and after a good four hours' jaunt found ourselves near the trenches at Souchez – and from an R.E. dump near the ole church had to stagger with huge pit props through a maze of trenches to the front line. We returned to our billets at VILLERS-AU-BOIS just before dawn – thoroughly exhausted – the logs had been a terrible weight and we had made five long journeys over awful ground.

Unfortunately we did not see much of CARENCY or SOUCHEZ on the way, the night was too dark and wet – tho' the very frequent star shell Very lights enabled us to have some glimpse of the dreadful scenes of destruction all around.

On the way back in the morning I saw rather a fine looking German under escort – coming through the communication trench. He'd been on a working party too out in front – a shell had killed his comrades and he had blindly stumbled into our line by mistake.

Monday March 20 – "A" Company paraded for a spell in the trenches – on the SOUCHEZ front – virtually no actual trenches were there, merely a series

of large shell holes, with the enemy only 30 yds distant.

As the boys were about to move up – I was surprised to be picked out by the sergeant of the platoon and told to remain behind for the night and be ready to join up with the 140th Brigade Sharpshooters in the morning.

I was very bucked – and drew the envy of all my pals – tho' very sorry to leave them. It meant another good night's sleep in the hut – and would be a very interesting branch of soldiering – sniping and observing.

I linked up with them next day and found them a jolly fine crowd – twenty men all especially picked as first class shots – five from each of the four battalions in charge of a splendid Sergeant Eager, a Corporal, and one Lance Jack.

We all moved off at eight o'clock Tuesday night to be quartered in the awful village of CARENCY – occupying a very dark but comfy cellar with wire beds and straw.

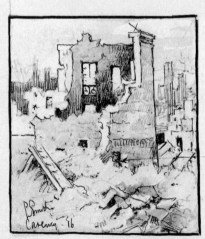

Carency – '16

CARENCY was really the worst village I'd yet seen. It smelt atrociously wherever we went.

– BILLET.

BASEMENT FLAT
MUCH SOUGHT AFTER
POSITION    NEEDS
MINOR REPAIRS

Thousands and thousands of French soldiers had lost their lives defending this sector – and their bodies had been picked clean by rats. The place was alive with rats at night time and by day one could see scores of bleached boned skeletons everywhere, even in groups – a most ghastly sight.

The church suggested having been quite a fine one – but of course was tremendously mutilated, tho' it seems to have stood all the shelling more than the

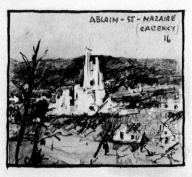

remainder of the buildings which were quite razed.

The sergeant would have everything in style as far as possible. We had one man deputed for cook and he did his job well, and the remainder were told off in regular beats – half of us being on duty up in the trenches whilst the other half rested – then vice versa. This worked very happily and kept us contented and well.

We worked a particular bit of sector in pairs – sniping where and when we liked, particularly making a point of observing all things suspicious,

all unusual signs etc. of the enemy's movements, making a proper definite report on paper to the Sergeant on the return to billet after each spell.

My first turn of duty as a sniper and observer came on the Thursday – when another fellow and myself were allotted the "Pimple" for our special attention.

As it was our first show at this kind of thing we were allowed to go up in the daytime – to just work from the (trenches ?) and after a pretty fierce journey through squelching mud came up with the old Seventh battalion.

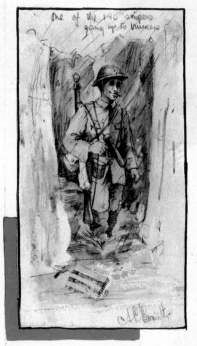

One of the 140 snipers going up to trenches

Was pleased to find my old pals and had a few hand shakes, mixed with a lot of good natured chaff – had to show them my new rifle with telescopic sights, my field glasses and telescope etc – but what surprised me very, very much was to find that a real spirit of truce with the enemy existed.

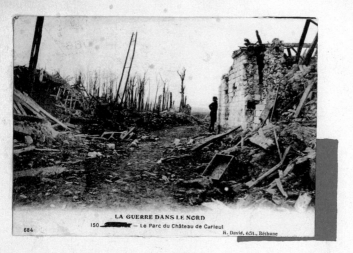

We were here facing "The PIMPLE" a huge mound of
earth on the crest of a hill the summit occupied
by the Germans. And to my astonishment the
boys were on top in "no man's land" actually
trading with Jerry. they were Saxons and were
reputed to be more friendly disposed than any towards
us. they looked a fierce bunch and many young
fellows had beards suggesting they'd been in this bit
of line for days — It was truly wierd and uncanny
to hear a frightful strafe going on further along to
our right and left yet here we were conversing as best
we could — exchanging bully beef — for some concoction of
theirs — cigarettes — photos etc. This had been going on
for days — and snowball fights had been in progress
at times — till some bright villain had spoilt it by putting

a bomb in a snowball – which of course was rank treachery – and "put paid" to the brotherly feeling for some hours. I saw two or three groups of Huns digging decent graves for dead out in the middle there – another Tommy had a mouth organ to which several of both sides danced.

While this was at its height – a very unhappy incident occurred. The Brigadier General made an unexpected tour of the front line and suddenly coming upon this state of affairs was overwhelmed with fury, he had every man called in immediately and before Jerry understood the sudden turn we were all ordered to fire. This was a mean trick and very treacherous in a sense – tho' the Brigadier was perfectly justified in his way.

After this, hell's fury poured over, they told us what they thought of us by every available means – and made things very hot for hours.

There was not much opportunity to do our particular job now – so when nightfall came Driver and I got away back to our home at CARENCY.

The next day the Sergeant gave us free – sending the other bunch out – so I very stealthily went for a stroll among the ruins, and made one or two sketches which I could do openly now – having the

Brigade Sergeant's O.K. for observation purposes.

I was able to see MONT ST ELOI from one part of this sector and made this sketch from a distance.

Up again to "the PIMPLE" the next morning at 4.30 (before dawn), climbed over our front parapet and found a deep shell hole by the aid of Very lights.

Then settled down for the day – there would be no chance of getting across "no man's land" again till nightfall.

On this occasion took care to wear the sniper's rig out – consisting of an overall and head covering with holes for eyes and mouth, the whole thing painted the same tone and colour as the local surroundings enabling me to be very near to Jerry – to see all and not be seen.

SNIPER'S COSTUME MADE OF CANVAS AND PAINTED TO MATCH LOCAL SURROUNDINGS BITS OF RAFFIA FOR GRASS TUFTS

"CHAMELEON" SNIPER

I chose a pretty busy day and got quite a healthy report of activities to take back at night – but it was also a pretty jumpy job, the shelling got quite nasty in the afternoon and what stuff missed the trenches came over in between. I began to be in dire peril and quite made up my mind to cut and run for the comparative shelter of the trenches – but the Huns would sure have peppered with machine guns a running figure in daylight. By chance nothing touched me but I was mighty glad to get away when it got dark enough and trudge back to a good dinner prepared by the cook, bless him! I had reported various things that would interest Headquarters and so was detailed to go up again next morning at 4.30. This time I chose an advanced sap for my job – and waited for the "18 pounders" to smash up the "doings" I'd reported. About six a.m. a good salvo hit right among the new machine gun emplacement I'd spotted – this was really good sport, and important to a degree.

I returned to the sap later in the day and had a good peep through my glass – carefully scanning the enemy line – when I spotted a fat German carefully lean across his parapet, which was so situated he thought he could not be seen. I had a

OBSERVER
AT WORK

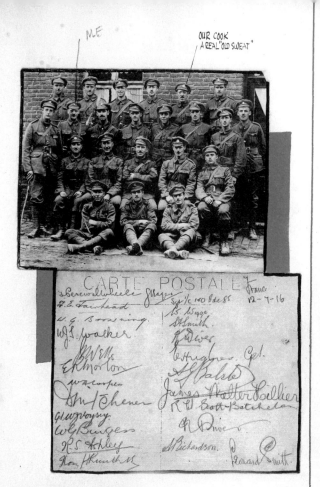

ME

OUR COOK
A REAL "OLD SWEAT"

sort of infalade view of him – sideways. He quite
deliberately aimed down into our valley where the
boys had to cross at Cabaret Rouge; by the time he
was ready for his second I'd got a "bead" on him –
got his head in my telescopic sight and "goodbye
Jerry you asked for it" – he flung up his arms and
would shoot no more. I had his life – but possibly
saved several of our men losing theirs.

A sniper can account for many more actual victims than the other fellows in the line – because they are stationed there to stay and hold – but a sniper can go where he thinks fit – up a tree, in a shell hole, in an old disused trench – in fact the more unlikely places the better.

It seems a vile job – but it's a job given not chosen and in time it becomes quite an everyday matter to lay in wait for some enemy victim. The boys in the line hate a sniper to put more than a couple of shots over in their immediate neighbourhood, they say it draws the enemy's fire too much.

On Monday had a jolly decent meal cooked by our ole man and then in the evening trekked along way back to FRESNICOURT about 4 miles. It was mighty cold with a shocking bleak wind – which we speedily forgot when we arrived at our billet – a delightful place – spacious loft, plenty of straw, a nice estaminet adjacent, with most obliging people. The village itself a very pleasant little spot nestled among the hills.

Our food got much better now in the small section – the sergeant was an influential sort of man – and looked after our welfare.

We actually had a meal of steak, potatoes and boiled rice for two days – further, on this

job we received an extra sixpence a day – quite a lot to us fellows. While here I attended a lantern show which included about ten slides of my drawings at the front – they looked well and gave much pleasure – about two hundred times enlarged on the screen.

The Brigade was now at rest and I with the other sharpshooters enjoyed a really lovely time – comparatively. The weather became ideal – and the surrounding scenery was fine. We were about three miles away from the "Shinys" so I strolled over in the evenings to see if there were any straggling letters for me and to have a "jaw" with my old pals. Could not help feeling hurt to see how tired and "fed up" they seemed.

Too bad, they're supposed to be on rest but were still worked to death with working parties and parades – I did miss "a packet" not being kept in the line the last spell, the terrible severe days and nights of bitter cold and snow – huddled up in mere shell holes. The shelling too was intense.

It all made me very thankful to know I should not have to endure quite so much of this kind of thing again. Instead of polling over hill and dale with the whole ton weight burden of a pack – we just marched out a mile or two to a pretty spot on top of a hill – LORRETTE HEIGHTS – and then spent a couple of hours with maps and telescopes on observation practice, picking out all the little villages we knew

within a dozen miles' radius – making sketches and notes.

It would take a lot of this to upset me as soldiering – but I felt to an extent I deserved a bit of smooth after a fair share of the rough.

We went to the baths at this village we were quartered in – the funniest thing imaginable, words could not do justice to the scene. Half-a-dozen at a time strip and then stand in a line behind each other. There's a big biscuit box fixed up with holes knocked in the bottom – a chap is perched up on a high box and pours about a gallon of water into this tin, when we walk through as quickly as possible to catch a drop or two, then we lather over with soap, "about turn" back again to wash it off. It's "some" bath and should suffice for weeks, and probably would.

On Sunday we paraded at three o'clock and marched to BOIS de BOUVIGNY where we billeted in a fine hut in the midst of the wood with a company of the Civil Service Rifles.

We spent several days here and enjoyed it thoroughly; the weather was quite summer like we almost

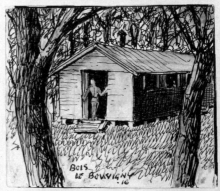

BOIS LE BOUVIGNY .16

MUTTERLY
'EAVENLY . AFTER
SOME OF THE "HOMES"
WE'VE HAD

forgot about the war here till one big shell suddenly landed on the end of our hut – completely demolishing our stuff. Fortunately it happened at tea-time and we were all eating and drinking out in the wood some way off – it was disturbing but not disastrous. We sort of expected a regular shower after this, but nothing further came over to interfere with our tranquillity till

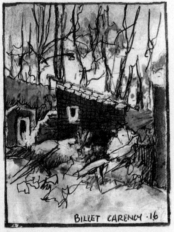

BILLET CARENCY ·16

we moved off in the evening to BILLETS at CARENCY via GOUY-SERVINS.

We found the 141st Brigade Sharpshooters were still in habitation at all available billets – so slept out in the open till next day

when they cleared out. Rats! – there were thousands of them – we could not sleep well so half of us went on a proper rat chase with electric torches and sticks – shine the torch and a whole drove could be seen for us to belabour (CARENCY was fortunately in a dip hidden from the line or torches would have been suicide to us). When we got in our billet – as above – the next night we found an organised rat hunt absolutely necessary, they were indeed a huge size and mighty bold –

absolutely swarming in the cellars. It was disastrous to leave any food about. I thought I'd got a bright idea by tying the five loaves we had in a bag and hanging it in the middle of the cellar by a cord from each corner – but in the morning the laugh was on me, the saucy beggars had walked the tight rope and eaten all the centres out of the bread just leaving the thin husks. We had to sleep with overcoats tied round our legs and collars all turned up – fastened with wire – just to leave a mere slit for breathing, and both hands tucked well up each sleeve or we should have been bitten mercilessly. We could hear their continuous squeaks which were very nerve wracking.

I've seen some nasty sights in the rat world especially one morning when I found one on my pillow – it had evidently been hit by a shell splinter and was still alive, dragging itself along practically turned inside out.

Had a letter from home telling me of a pretty hefty zeppelin raid – that upset me quite a bit. It had become an almost natural existence to live among shell bursts, bullets and whizz-bangs out here – but somehow it seemed vastly different to realise the dear folk at home were sharing and suffering from the dangerous side – as well as their other worries.

Went up into the line – VIMY RIDGE, a Sunday – up there by daybreak and spent the whole day

VIMY RIDGE 9/16

146th BRIGADE SHARPSHOOTERS

Observer Leonard Smith

Sergeant Tarpin

Enlarged sketch
of machine gun
emplacement.
in front of small
crater —
Periodic al bursts
of fire noted — every
half an hour — position
covers —
WALLEY - CHABANET
RIDGE

REPORTED TO ARTILLERY

from inside
POSITION 28 - B

MOVEMENT NOTED HERE
EITHER SNIPERS or
OBSERVATION POST

REPORTED TO TRENCH MORTARS

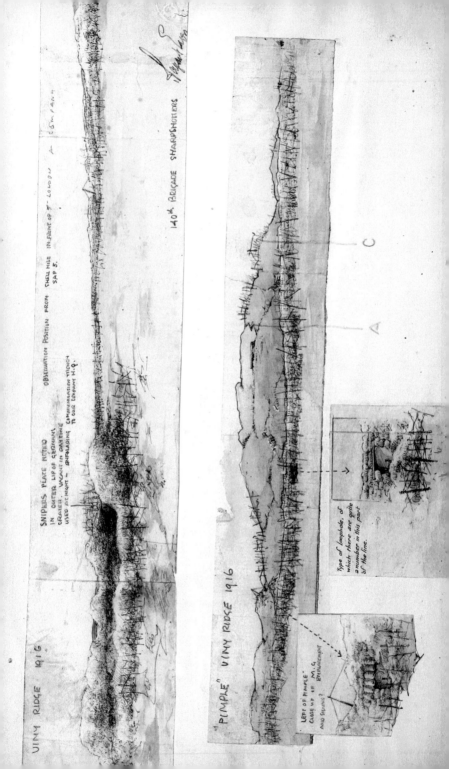

VIMY RIDGE 1916

SNIPERS PLATE FITTED IN OUTER LIP OF GERMAN CRATER. VACANT IN DAYTIME USED AT NIGHT — ENFILADING

OBSERVATION POSITION FROM SHELL HOLE IN FRONT OF 7 LONDON & COMPANY SAP 5.

COMMUNICATION TRENCH TO OUR LONDON H.Q.

140th BRIGADE SHARPSHOOTERS

"PIMPLE" VIMY RIDGE 1916

C

A

B

Type of loophole, of which there are quite a number in this part of the line.

LEFT OF PIMPLE CLOSE UP OF M.G. EMBLACEMENT AND FIGURES?

# OBSERVATION REPORT

APRIL 10 1916
VIMY RIDGE "PIMPLE"

FROM ADVANCED SHELL HOLE
IMMEDIATELY TO FRONT OF
NO. 8 LEWIS GUN RIGHT HAND
SECTION
Tᴴ LONDON REGIMENT

G 18486

OBSERVER
LEONARD
SMITH

<u>DAWN</u>

EXTENSIVE WORK CARRIED OUT BY ENEMY SINCE REPORT
OF YESTERDAY. FOR FULLY FIFTY YARDS HUGE MOUNDS
OF FRESH EARTH THROWN UP, ALSO FIVE NEW LOOPHOLES
HAVE APPEARED. FROM QUESTIONS PUT TO NIGHT SENTRY
ONLY ONE FLARE SENT UP FROM THIS POSITION DURING NIGHT.

CONCLUSION - EXTENSIVE DEFENSE WORK IN OPERATION, OR LINE
VERY THINLY HELD.

S. CHALK

<u>MIDDAY</u>

(B)

THROUGH FIELD GLASSES - SAW YOUNG GERMAN PEEPING OVER
PARAPET. GREY CAP WITH THIN RED PIPING ROUND TOP.
BROAD YELLOW BAND AND ONE BADGE - RED CROSS - WHITE GROUND
TEN MINUTES LATER AN OFFICER APPEARED WITH KHAKI
COVERED CAP TOP RED BAND - BLACK PEAK - SMALL BRIGHT GOLD
EAGLE BADGE. COULD NOT FIRE. POSITION TOO GOOD TO
DISCLOSE.

<u>AFTERNOON</u>

(C)

WORK IN PROGRESS AT EXTREME LEFT OF "PIMPLE" SUMMIT
LOADS OF WOOD SEEN PASSING DOWN COMMUNICATION TRENCH.
WITH EAR TO GROUND COULD DISTINGUISH MUCH HAMMERING
AND SAWING.
THROUGH TELESCOPE TO LEFT OF "PIMPLE" A LARGE NUMBER OF
FRESH BARBED WIRE STAKES IN POSITION - NOT YET WIRED
IN PLACE BATTERED BY TRENCH MORTARS AND GUNS TUESDAY
8ᵗʰ.
A GERMAN TRENCH MORTAR VERY ACTIVE TO RIGHT OF OUR
CENTRAL TRENCH - D. BLOCK. SEEMED TO BE IN THEIR
SUPPORT LINE - NEXT TO FLAG PREVIOUSLY REPORTED.

<u>EVENING</u>

(D)

FOR FIRST TIME - HEAVY BURST OF MACHINE GUN FIRE FROM
GERMAN SIDE OF CRATER H 2 IN CLOSE PROXIMITY TO SAP
NO. 6. 176°. COMMANDING VIEW OF VALLEY AND CABARET
ROUGE. THIS WAS EVIDENTLY A NEW EMPLACEMENT - FROM
THE FRESH EARTH AND CHALK THROWN UP. SHOULD HAVE
ATTENTION OF ARTILLERY

GROUND MIST PREVENTED FURTHER OBSERVATION.

sketching the German line with definite purpose to go with report to H.Q. The "PIMPLE" had my special attention as an aid to a proposed attack by our crowd.

Saw a lot of the new draft our battalion had got hold of, quite different to the old type we started out with – a different spirit seemed to pervade them – these fellows seemed to make a lot of fuss over trifles, with much bickering together, no idea of team spirit like we used to have – before we were broken up. I was mighty thankful to be no longer living among them – the sharpshooters were all original "die-hards", really excellent sports and much more like the dear old boys who alas had gone west.

During the course of this day I was looking through my glasses from a sap, an old one deserted save for me – and to my surprise I suddenly espied two Huns stealthily coming over to our lines without rifles – they seemed to be taking all available cover from their own people creeping round the old crater, then made a sudden dart for the trench by me – they were deliberately giving themselves up. They spoke a mixture of German, French and English and from their manner seemed quite to expect good treatment from us – expecting to be better off as our prisoners. One said he'd been a barber in Holloway Road London and the other, a waiter in Fenchurch Street. I took all particulars essential for my report and escorted them to Company Headquarters.

Eventually the Brigade came out of action here and there was a decent rest generally all round. We marched back a considerable distance and our little party was parked in this ragged little billet.

It did not look very habitable – but as the weather was behaving kindly the numerous air holes in walls and ceiling did not worry us at all.

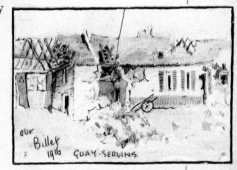

We had a jolly fine time here, and I was left free to do quite a lot of art stuff. I was quite "best boy" with the Sergeant and fellows, having been at some pains with rotten materials, to paint a board – or sign "140th BRIGADE SHARPSHOOTERS" to hang outside our billets, wherever we went. I also got busy on a number of souvenir cards for the boys to send to their various homes. It was beginning to get quite a well established business, birthday cards etc. from the front, "done with the naked hand" sold like hot cakes – I always had a waiting list of customers. They were considered great novelties, and I, something of a freak to actually prepare such things in these unusual surroundings – they were only trifles but would, I expect, be treasured for years after, not for any

art or technique, but for the unique associations.

This was the type of thing – and was done at this particular billet.

At this time we learned that the last set of sketches I had made during my last long spell of duty up on VIMY, had made rather a hit with the staff officers at Brigade Headquarters, and they had made a special

HAND DRAW CARD

point of forwarding them up to Divisional H.Q. where the General had given instructions for enlargements and copies to be made.

MY DESIGN FOR A SPECIAL BADGE FOR THE SHARPSHOOTERS

Our Sergeant coming back from leave had brought with him a good pair of boxing gloves – which we all made good use of. The party became quite a set of "boxing fans" – and when not otherwise engaged were at it – morning, noon and night. (In the old company of the "Seventh" – a professional boxer Johnny Condon had given us some useful hints from time to time and, having had several *one sided* rounds with him, found I was not quite a fool with them now we'd got the gloves.)

We had many an exciting bout, and I captured a thick ear twice, but was consoled by the fact that I'd landed the sergeant a good coloured eye much to everybody's amusement, yes including him – he was a fine sport, and shook hands calling me a "dark horse". He even dished me out with a new pair of pants, that had received a nasty puncture in the rear – when I'd been knocked over the broken wire of my bed.

Well we carried on like this for a week and thoroughly enjoyed our "beano". Then the inevitable order came to pack our traps and move back again to stinking ole CARENCY – a bit nearer SOUCHEZ, more rats and rough stuff when off duty and shells, mines and bullets when up on the RIDGE.

I was detailed to do a special job up in the trenches almost as soon as we arrived. Brigade Headquarters issued instructions for a panorama sketch of the German line – embracing their whole section that faced our 140th Brigade front, with all useful observation notes attached. This was a far easier job to command than do, it was quite too utterly fierce to attempt to draw up there at this period – the Huns' shelling was almost incessant – so I had to scramble "all over the shop", making rough pencil notes over a period of four days – real, hard risky work – and at dusk polling back to the billet cellar to prepare the whole thing as a finished coloured sketch by the aid

of one candle. A Panorama that when eventually pieced together was some two yards long.

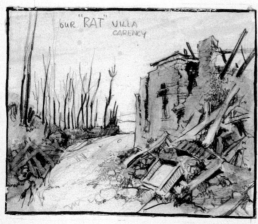

oυʀ "RAT" VILLA CARENCY

When finally complete this was handed over to the Sergeant with a very big sigh of relief from yours truly to be submitted to Headquarters.

Next day a message came through by runner that I was booked for an interview with the Brigadier General at nine in the morning re: the drawing.

This news brought forth quite a chorus of lusty cheers from my pals – and later we got quite a lot of fun when I had to go round the billet trying on other chaps' articles of clothing, my own old torn things being perfectly unpresentable – borrowing one man's tunic, another's new trousers, yet another's unfrayed puttees and so on.

Then we had a mock inspection – with many a joke before they passed me as a fit specimen of our little "crush".

Next morning I trotted off "like a dog with two" and duly reported at Brigade Headquarters, and was

taken before (or shall I say ushered into the presence of) the General, to receive most effusive words of congratulation.

"Very cleverly executed, colour and drawing mighty skilful – but above all infinitely useful" – "He thought to undertake and make such a piece of work during those several days of murderous shelling and enemy activity, bespoke much devotion to duty – and reflected all the greater credit on the work".

He promised to lay stress on this aspect when submitting it to the Major General "who he felt would highly appreciate such a sketch – that would prove invaluable at this juncture – having so realistic a drawing of the actual enemy's line at his finger tips".

Naturally I was bucked by being thus addressed by so unapproachable a person as a live Brigadier.

Two mornings after, on May 12th I was again summoned to Headquarters to receive another warm word of thanks from the Divisional General who added a remark – "that the work had been reviewed by himself and the General staff with the liveliest interest – and my name would undoubtedly be mentioned in an important dispatch".

By now, hobnobbing with "brass hats" was becoming monotonous – and I trust I've not made too much song about it – but it must be realised that in army life for a mere private soldier to be perched suddenly on a

pedestal to be singled out for a personal talk –
actually meeting and shaking hands with "the Gods" –
is something quite unusual – don'tcherknow.

It certainly was very nasty up on ole VIMY RIDGE
now. Each day seemed to add to the intense strafe all
round. We snipers had to spend practically every bit of
our waking time up in shell holes or any cover possible
near the Hun, harassing his working parties at night or
laying in wait for enemy listening patrols. There were
some nasty pieces of work done with our unerring
rifles during these spells – but Jerry was becoming so
truculent in every way we got fearfully keen to add
scalps to our records.

The bombardments were getting more fierce and at
times all hell's fury seemed let loose, mines went up
morning, noon or night, and one came across huddled
crowds here and there half demented with nerve strain
and utter sleeplessness.

It was a mighty good job we came out of this spell
when we did – it saved many a man from completely
cracking up.

We came quite a way back on May 16th – to GOUY-
SERVINS and were warned to make the best of our
rest, as there were signs that we should be mixed up in
a really serious do before long. This show was but a
poor knocked about little village but very peaceful now,

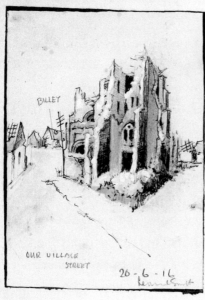

BILLET

OUR VILLAGE
STREET

20 - 6 - 16
Bernard Smith

the foliage on the few trees left was very refreshing and to see yonder the gloriously clad green hills was very lovely after staring at the bald shell - scarred earth of VIMY RIDGE - It was hard to believe the grim old war still waged over the farther crest.

◊ ◊ ◊

On the second night here our little clique went to a Divisional Concert and had a very boisterous time - we were for the nonce a happy - jolly rollicking crowd of boys - seemingly without a care in the world - relieved and at ease to be away for a short respite from the terrors that stalked by day and by night!

◊ ◊ ◊

Friday May 19 saw us wending our way back again to the "business side" of France. and we were dumped down at ABLAIN-SAINT-NAZAIRE of evil repute. It owned to an awful history of slaughter earlier on in the war. and was no health resort now.

◊ ◊ ◊

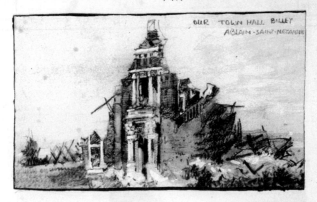

I sketched our billet as here – a delightful residence, large reception rooms, hot and cold – mostly hot, usual offices – all underground, overlooking a large stretch of country, *sitting* in its own grounds etc.

We had "won" a little hand cart to hump our rations and cook's supplies about on, and needless to say it required very skilful negotiating in the darkness over shelled roads. We of course were very "bucked" with our acquisition, it helped to lighten our loads considerably – but unfortunately not for long. As we were within a hundred yards from our village – a shell came over too nastily near, blowing the barrow sky high – and seriously injuring the two chaps whose turn it was to push. All our grub was lost, and I came mightily near an untimely end and felt "duff" for hours – tho' the only thing that really hit me was a shell splinter lodged in my bootheel, a splinter in my knee and a kosh on my rifle just by my hand. I was not hurt really, but shaken more than usual by the unexpectedness, and we were

all very sore about our two mates – who had to be attended to and smothered in iodine as best we could in the pitch darkness. We got them to a dressing station but they had lost too much blood, and so neither lasted till morning. It was a good thing we'd not all been bunched round the cart as was our usual habit – or more would have shared this fate, and I should probably have not been able to use up all this good paper and ink. C'est La Guerre!

Well we at last were tucked down amongst our old rat colony again and woke late in the morning to the gloomy realisation there was not a scrap of grub for any of us. Having come on last night in advance of Brigade Q.M. Stores would have to wait at least till well after dark that night. We were not due up in the trenches till the battalions of our Brigade were there on duty – so we had great difficulty in killing time. Jerry's observation balloons were well up and

forbade us leaving the comparative shelter of the "Town Hall" in the daylight, so there was nothing for it, but to sit looking at each other longing for a good square meal. Rations had been scarce lately, so we were not really ready for an extended fast.

At night we all went out in a body to try and find the transport to beg something to carry on with, but they did not appear – and were delayed that night, by an impassable barrier of shells Jerry had splayed on the roads for hours. So another hungry night was our lot and a tightening of belts.

When we woke next morning – knowing that unless we did something desperate we should have to wait hours till nightfall – three other hungry crows and myself decided to "chance our arms" and made a journey through the awful streets of CARENCY skeletons – dreadful smells and ghastly sights in the broad daylight for a distance of some miles – meeting no humans – as really we should have been taking cover. We expected to catch it "in the neck" any minute, but hungry bellies have no conscience. We eventually dived down some water filled communication trenches – till we stumbled upon the reserve lines of a sister Brigade. We explained our position, and were given enough grub to just whet our appetites and take back a share to the other lads; food seemed to be scarce all round and we would not have accepted any, had we not

been by now in dire need. When we did get back to the "Town Hall" we were received with genuine affection by our chums and quickly relieved of our sandbag of "Tommy". Still having ample room, in which to tuck away a lovely parcel that came up at night with the post. It would have rewarded the dear senders a hundred fold to have seen the ravenous reception of sausage rolls, chocolate and peppermint rock all scoffed together in the space of five minutes.

On Saturday May 20, we all left for the VIMY RIDGE sector and the sharpshooters settled down in a rotten old dug-out at the entrance to "CABARET ROUGE" trench. We arrived about eight o'clock in the evening and were advised to "kip down" as quick as we liked – we were in for a rough spin – and might get no more sleep for a very long time.

This dug-out was of the "double-elephant" type, made of a semi-circular roof of corrugated iron covered with sandbags, and having wooden planks inside with wire netting – enabling us to sleep one above the other, like ships' bunks.

They must have been "posh" when first rigged up but with constant use and misuse had been made filthy dirty – and as lousy as anything we'd yet struck.

About ten o'clock – some were asleep, others writing or playing cards by the light of numerous candles (no air could get in – but it didn't matter

as long as no light showed out) when suddenly came
an awful thud, complete darkness and chaos reigned.
A pretty hefty shell had landed square on our roof.
Luckily the blokes who put it up made it to stand some
of the strain – and it had only sagged in enough to send
all the bunks toppling down – and put us in a nice
pickle, not sure if we were hurt or not. We quickly
began yelling each other's names to get reassuring
O.K.s, straightened things up where we could and
resumed our bye-byes, very thankful to have no further
uninvited guests that night.

I must add that although we escaped any injuries,
a poor Scottie outside the door who'd been passing on
a fatigue duty lay in the hands of stretcher bearers with
a lump of the same shell in his throat, gurgling his last,
his one bubbling cry of "Mither" haunts me still.

Next morning two of us were detailed to be up on
"the Ridge" by dawn, and told to keep our "peepers"
open for trouble – and by gum! we soon found it. The
enemy handed it out with touching generosity.

First, they made us weep, with a salvo of "tear"
shells – they're awfully disconcerting things – one has
a dreadful feeling of complete helplessness and almost
blindness – the eyes smart badly and well up with tears
and one's nose is filled with a strong pungent smell of
dank nasturtium seeds; coupled with this twelve mines
went up in quick succession – an experience I challenge

any man living to suffer without wobbling knees.
The front line trench held by the "Seventh" chaps was
completely obliterated within a few minutes with every
man practically wiped out.

My chum and I had only passed through just
previously, and had stumbled with swollen-smarting
eyes into the entrance of an old mine shaft just as the
first mine exploded – this preserved us but we got the
shocks alright, the earth absolutely lurched with
upheavals that took one's breath away – before recovery
– another ominous rumble – again the trembling
ground – then another till it seemed the end of the
world had actually arrived. This was an awful overture
enough – but proved to be only the prelude to hours
and hours of pitiless shelling from the Hun.

Heavy calibre shells that blackened out the sky –
whizz-bangs that caught men already wounded,
shrapnel bursts low to the ground – with its ugly yellow
smoke "plugging" hundreds as they crouched in shell
holes or lay crippled.

Our shelter became untenable – we had to bunk
for our lives as a shell tore part of it down and we
found ourselves lost among a sea of bewildered men,
the air black with smoke, laden with stinking Lyddite
and rent by the pitiful cries of huddled khaki figures.

Old soldiers afterwards agreed – this fierce
bombardment was the very worst yet handed out to us

poor troops. The valley laying between VIMY RIDGE and CABARET ROUGE was now one of certain death.

We could neither go forward without strong reinforcements or get back through that murderous barrage. The Germans attacked on the right, gaining two lines. Doesn't sound much – but it must have cost Jerry countless money in shells and us thousands of valuable lives.

Of course without any maps or staff information a mere Tommy could see why Jerry was exerting all his strength to win these heights from us. They commanded such a view for miles round and every yard meant much to either side.

Nobody on earth could have held trenches against that vast hail of death dealers, and in the subsequent hand to hand fighting panic stricken men were mostly overwhelmed by fresh storm troops, big Prussians that I saw swarming over from all directions in the distance – they met valiant fighting and stubborn resistance, but their overwhelming numbers told – and practically one of our entire companies virtually disappeared – struck out of existence.

This shambles went on for so long, I for one lost all sense of panic, and save for the pain in my eyes and runny nose, got a sense of numbed, "don't care if I do die" sort of feeling possess me, and so decided to chance it – work myself from shell hole to shell hole

– across the wicked valley and back to CABARET
ROUGE. There were unprintable sights all the way
– and I was mighty glad to get to my mark without
being included among them.

Of course as a sniper just now I was a complete
"wash-out" – I'd tried to pot the Huns but my swollen
eyes only made the sights of my rifle like blobby blurs
– I "couldn't have hit pussy".

And to have just wasted shot would have been mad
– one might have been in sore need of a few at any
unexpected moment.

Getting to CABARET ROUGE I cherished a vague
idea of linking up with some of my pals, but found
they'd all gone off on various stunts – as runners,
stretcher bearers and what not. I'd long ago lost my
mate of the morning's patrol and was now just about
fed up with being such "a spare part".

CABARET ROUGE seemed quite deserted till I
came upon the "Seventh's" Colonel standing at the far
end – regarding the valley with its unceasing hail of
big and small stuff. I'd seen some fireworks during my
spin in France – but this day's work had staggered me.

The Colonel was a fine soldier and awfully cool
tho' in imminent danger where he stood – ceremonial
nonsense was not necessary here and he stopped me
with a very kindly, jovial remark, which thrilled me
somehow; he then looked at me – and *did not command* –

but quite casually said – "I wish to God I could get this communication over to Company Headquarters on the Ridge and receive some reassuring news back from them – but I'm afraid it's death to the man who tries, two good runners have not returned." Now, not to be heroic – I felt "game" for something in the nature of a real definite job – "so sprung to it" and got there and back tho' it took some hours – and went through some stuff that through escaping untouched, I felt contributed largely to my increased belief in miracles.

I've thought since in calmer days, that if I saw myself on the cinema screen, dodging about on that mile or so's stroll – how I'd clutch my seat and catch my breath – or else swear it was a faked film, exaggerating an incident nobody could "get away with" in real life.

It was a surprise that any lived to tell the tale of VIMY RIDGE – of May 21st 1916 – a Sunday – a day of rest – yes, for the thousands of dear lads.

Of course this little gain of the Huns was only lent – we full well knew that many thousands of them were booked for a single ticket to "Kingdom Come" at an early date – in our inevitable attempt to retake the lines.

X upon reporting back to the Colonel
"message delivered" He muttered
"Good God!" - thats worthy of a V.C
I'd liked to have assured him
in that ordeal a W.C were would
have been much more appropriate

That is if we'd got the goods to deliver – there were many uneasy rumours among the troops about the homeland strikes and troubles – making for a distressing shortage of shells. If any striker could have by some magic been hustled across to a front seat at this day's work, he'd have crawled home and pleaded forgiveness for the rest of his rotten life.

There were still jobs to be done – we sharpshooters earned our one and sixpence a day well enough – humping in the wounded or taking fresh troops up to their stations in the battered trenches, craters or mud holes.

I took up a party of K.R.R.s and was bombarded with the usual questions – "What's it like up here chum", "Your lot copped out much ole man" etc. Of course one naturally said oh! not too bad – tho' I knew full well what a show it was and that it would take a mighty smart estate agent to sell anybody that desirable bit of land and property – and realised with sadness these poor lads were up to take the brunt of our certain counter attack 'ere long.

Our Brigade had become so seriously depleted in the brief space of time, that on Monday night we all came out to rest billets at CAMBLAIN CHÂTELAIN to get refitted and numbers made up to scratch again.

We arrived at dawn next morning but everything had gone different to plan, so no places were vacant for

us to sleep in. This meant packing down where we stood – in the pouring rain, really it was so beastly wet, I know my paybook inside my tunic got so soaked that all the indelible ink entries were blurred beyond recognition.

We were all starving hungry and rejoiced to find our cook had risen to the occasion by begging – or "winning" – a full dixie of hot meat stew. Anyway somebody was lucky and got my share this time, it was useless to me as I'd caught a nice ripe packet of tonsillitis, and could not swallow a mouthful. This together with the constant rain was liable to cramp anybody's style and did mine, pretty effectually for several days.

When we shunted off to a wood at VILLERS-A-DAIC, I had to lay on one of the 7th transport waggons, too weak to walk the few miles. Was then put in one of the huts and tended to in a wonderful mothering way by the Sergeant and my pals.

Of course I could have "paraded sick" and got to a cushy bed in hospital – but we happened to be such a happy little family – and did all we could to stick together. After hospital treatment there was always the great risk of being sent off to an entirely new, different crowd.

Anyhow I got pretty well alright by the time we were ready to move off again - And when we paraded at 4 o'clock in the morning of May 25 felt as good as the others to "hump" a full pack the fifteen good miles to Cambrain Labourse - where we were ready to chuck ourselves down on the straw of our stable billet.   ◊   ◊   ◊   ◊

We had a good time here - spending the days in route marches - observation etc. We were taken a mighty long distance early one morning to attend a special lecture given by an Intelligence officer of another Division - this was most instructive and two hours well spent - after which we were - "let off the chain" for an hour or so before tramping back. I made a sketch of this very fine chateau - but just where situated cannot remember. and omitted to write on at the time

AN OLD CHATEAU
FRANCE

THE NICEST - INTERESTING
PLACE I've SEEN HERE IN
FRANCE. MILES FROM
THE FIRING LINE

On the 31st we had a preliminary sort of inspection by Brigadier General Cuthbert – it meant hours of "spit and shine" – then the 2nd of June saw us with the Brigade all paraded in a field, for a review by General Munro, the Army Corps Commandant. He was the ideal conception of a great soldier – and his stirring, short clipped remarks to us were a real source of inspiration. I wonder if he realised what a sweat we'd had to look such nice clean boys, and the cainings some had received – for the spots. We really looked as if the sight of a real trench would be a source of open-mouthed curiosity to us. Never mind! "it's a way they had in the Army".

While out on rest this time a Concert was arranged and given by the boys of our Brigade at DIVION in the cinema. It was a very great success – we sharpshooters were given special passes to go over there and the whole bunch of us given free front seats on the strength of my share in the show. I had been installed advertising artist and agent – by an Officer who had seen some of my stuff pass through his hands whilst censoring the letters. These sketches (as over) were duplicated by me several times and displayed in estaminet windows. Made from imagination and no "references", rigging up "Charlie" as a Brigadier was a "tall order" – nevertheless the Officers were

# GRAND REVUE

Charlie Chaplin in "Spit & Shine"

DIVION CINIMA on Friday at 5·30 p.m.

Stretcher-bearers at 8 p.m.

June 7 16
Pte Leonard Smith

very pleased and the Brigadier especially requested one as a souvenir after the visit he paid to the show. Of course there were the stage props to make too, and "Charlie's" hat band of gold laurel leaves with badge of a "Brasso" tin. A massive set of highly coloured ribbons – and a band for his arm, of blue with crossed button sticks. His gee-gee borrowed from a French kid in the billet. The scenery was indeed a real problem, and if ever bricks were made without straw, the Egyptians were beaten this time – for the result was proclaimed remarkable with such poor-scant "tripe" to work with.

The Concert was a real surprise packet for all, and would make many a show at home look "tame". The Civil Service Batt. especially had very remarkable talent – instrumental and vocal – and the Tommy who took the part of Brigadier a top-hole actor.

The "Knocks" and sly suggestions thrown at the "Brass hats" and Officers were very bold and funny – they fortunately seemed to take all in good part but maybe raved inwardly – because many things said and sung "cut very near the bone" at active service "dos".

The female impersonators were great, with togs borrowed from estaminet girls. They looked really fine lassies – better than the owners of the garments – but am afraid their jokes were distinctly 98° in the shade – very manly, and not always "quaite naice" – but they had a wonderfully appreciative, uncritical audience.

# The Sensation of 'our' War

## Brigadier General Sir Charlie CHAPLIN

**Divion Cinema at Bailock on Satturday**

"Roll up yer cripples in fousands"

*Leonard Smith June 1916*
*Divion France*

On June 13 – we moved over to HERSIN where we stayed in a really filthy billet, a stable not fit for any horse. There was in the centre of the yard as usual, the huge pit of many years' accumulated muck – whose smell breathed its age. We were only here one night but this was long enough for a real stinking adventure – one of our poor blokes coming round the narrow cobble path with a load, tripped and fell headlong into this murky deep mire. We all laughed heartily afterwards but at the time it was really serious – we had a terrible job to get him out and save him from sinking right down and suffocating; somebody hit on the bright idea of lassoing him with a rope from the old woman, it caught under his arms and by the light of candles and a torch we did the trick, but it left him pretty bad and us like skunks for hours.

We were mighty glad to bid goodbye here, next

AUX-NOULETTE

The Corner House
next Ruins                    Leonard Smith
20 /6/16

day and shift off to AUX NOULETTE, finding a decent cellar had been allotted us. Engineers had been here as occupants just previously and thus we had electric light, and wood-wire beds for which we were truly grateful.

Next day was spent very pleasantly in the lovely wood of AUX NOULETTE on scout practice map reading, observing etc. The 7th Londons were billeted about here and thus I was able to link up with my old pals Bill Must, Jones, Shakespeare and others – we swapped yarns and enjoyed the short reunion very much.

Next morning half the snipers were deputed to be up the line before dawn – 3 o'clock – and I to take my turn as orderly – to prepare a warm meal before they set out and do up their lunches for the day's work to take with them; our official cook had got a "Blighty" recently and had not been replaced.

My trench turn came on the 18th – on the night of VIMY, and it proved a fairly busy one. The "Shiny Seventh" were holding the line – along with a large detachment of naval men – The Royal Naval Division had been brought over from Gallipoli – and it seemed very odd to run up against Naval Officers and able- bodied seamen among the sandbags.

I had been worrying the Huns a bit in my own special way ever since dawn – using up a good number of rounds of ammunition – and by the afternoon was glad to sit at the entrance to one of the dug-outs for a "chin-wag" with the boys. We saw a naval officer observing from an O.P. and his orderly

gave us "the wire" that a big naval gun would be getting the range of Jerry's trenches very shortly.

I left my pals to do a bit more work, and an hour later was loping along the front line having a pot shot here and there, when an express train seemed to suddenly be running through the air – ending with an awful explosion. It was fired from *our* rear, and we expected the Hun trench to go sky high – but to our horror it fell short – right into a group of our own chaps – sending several to eternity and badly wounding a score of others. Of course there were frantic S.O.S.s sent to the gunners to re-register on to the enemy trench – but for a long time we were very suspicious and "windy" of this new naval gun that had made such a disastrous faux pas of its first exhibition.

Especially next day when a chum and I were spending our time in a "no man's" shell hole (observing and sniping) did we dread the distant boom – proclaiming a big one was coming and hoping to goodness it would reach its right destination.

Toward the evening (we were waiting for the darkness to slip back) my pal and I were discussing some suspicious movement on the enemy's parapet – when a sudden little sizzling made us look up very promptly – it was the familiar rifle grenade, and caught Faulkner in two or three places.

He was practically "all in" and
his wounds could only be dressed with roughness
and great difficulty. When dark enough,
he had to be humped through the barbed
wire somehow - then I was able to get help
to lift him to the dressing station - he was
a helpless heap and unhappily died on arrival.

◇       ◇

Had a good night's sleep when
back at billet, and next day was off duty.
which I took full advantage of - The weather
was top-hole - and with three others we
wandered round the country as far as allowed

◇  ◇  ◇

( This little
sketch is a
view of the
landscape seen
from a knoll
which over-
looked the
French sector
and shows
little bunches
of French
troops
helping the
ascension of
an observation

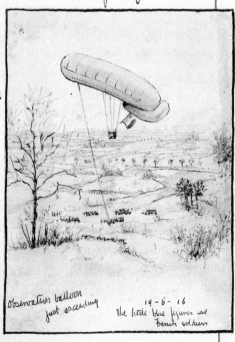

observation balloon
just ascending

19-6-16
The little blue figures are
French soldiers

balloon that had been down for a spell hiding in a protected hollow – while Jerry was too lively with schrapnel.) ○ ○ ○ ○

After three or four days, – on – and off duty – punting round in mine craters – shell holes and delapidated trenches or browsings round in billet. I was told to be up in a certain bit of the front line just before dawn, to be on hand – when the "Shinys" made a sudden raid on Fritz while he was cooking his breakfast. (or would have been ordinarily) but this time he underwent a wickedly fierce bombardment that was very effective this so short – the Hun barbed wire was cut and the boys went over – coming back shortly after, with the object and result of the surprise raid – a whole bunch of German prisoners. It was a most successful affair only one or two of our fellows suffering by it. –

And the Hun prisoners seemed relieved to have survived our onslaught and come under our safe keeping thereby – Although the lads are all out for blood when the "dō" is on – immediately after such affairs they are only too ready to be sporty with their captures and shared "fags" or even food out when possible. ○ ○ I swelled my days report out, with descriptions of the Hun's uniforms etc. and formed one of the escort, for a group of thirty five full blown Jerry's, being taken to H.Q.

FAG – MATE

Several could speak English better than some of our own boys – and from their talk we gathered they were having no hand in dragging the war on, and were as "fed-up" with the whole business as we.

Their clothing was not half so well conditioned as ours – many having huge patches of various materials sewn on – and they seemed thoroughly and genuinely staggered at our white bread (which we got once in a blue moon) instead of the black stuff one or two had in haversacks – and further I noticed complete bewilderment among them when they saw the good humour of our "cockney" boys and the general "don't care a tinker's cuss" air that pervaded us. I thought at the time it would almost have been a good diplomatic move to have sent them back to their own mob – to spread a good report around among their side about the English troops.

We certainly could not afford to give much grub away – we were all short and, on my pal Cooper and I getting back to the billet expecting the rations to be up and ready for the asking, we found them conspicuous by their absence – the rest of the clique all hungry and no sign of anything coming.

We were all left up at O.P.s in the front line again next morning at 4 a.m. and had to be content with one tin of iron ration – bully beef –between two of us from then until 10 o'clock at night.

By which time we were famishing, and nearly ate tin and all of the "Maconichie" ration served out.

On July 1st 1916 – the Brigade was working the COLONNE Sector – and this was a day ever to be remembered with awe.

The long expected Allies grand offensive had begun – AND IT WAS HELL Let Loose. A startling, terrible, withering blast of gun fire seemed to sweep the entire front – we were all expectantly "standing to" on fire steps when the first mines went up and one could actually see men flung high into the air – immediately, every machine gunner, Lewis gunner, rifleman, trench mortar right up to the most powerful heavies, was pouring forth death and destruction.

It was merciless – and pitiful – this big blow had been promised so long – and now every gun seemed to bark – "who laughs last – laughs longest".

It seemed nothing could live over there within miles and miles back – but we speedily found the German gunners were very much alive – long after we started they began to frantically pester us and made our positions very unhealthy.

We made no definite attack on our portion, it was rather in the nature of a dummy affair to thoroughly hoodwink Jerry and allow the French and other Divisions to move – at least this is all troops could make out of the uproar – we only knew the little bit we lived in – and knew nothing of Staff plans.

A Staff officer suddenly appeared in the trench by me – he scribbled a note and handed it to me with the command to take it back to Company Headquarters, which I set out to do – the "tooter the sweeter".

On going back, down "Cork Road" communication trench which I'd used in the early morning was surprised to see a large part of it impassable – completely blown in by a big shell. It was too hot to go over the top – in fact a sergeant forbade it – he was superintending a party digging it out. I was on an urgent job so turned back to take another route but had to stop for a bit – by sheer curiosity – for one of the chaps with a shout had come across two skeletons in the side of the old trench. One English, one German as we could fathom by the metal portions of equipment – all else had rotted. A nasty hint of what we might all come to – before the war ended.

On July 2nd the shelling was still going strong – then a sudden lull came when the 2nd Division, or a portion of it, made a raid on the "Pimple" – VIMY RIDGE. They got our old trenches back – but we heard it meant a terrible slaughter for both sides.

It was the vogue now – to have short sharp attacks. One such took place next day by the 15th Battalion just before dusk. I saw the whole stunt from rather a precarious position up a tree just at the back of the

front line – where I picked a position for sniping. They all went over beautifully as a parade – expecting great things – but to their dismay found Jerry's barbed wire insufficiently smashed by our guns – and so many, many were just caught in the maze and calmly slaughtered by German machine gunners, in fact the whole thing collapsed through this, and who ever could – found or crawled to our trenches admitting failure through no lack of courage or fault of their own.

I put down the next few days as just unutterably wretched – wet and dangerous. One day being spent with a chum up in an Observation Post of the 4th Corps Wireless Station – overlooking a German road. We had a good bag for our watching, using a whole bandolier of cartridges in this spot.

On July 8th – we were thankful to leave the wet slimy trenches and wend our way out to BOUIGNY BOEFFLES arriving at an hour after midnight.

We slumped down with gratitude – feeling secure and happy to be a stiff march away from the line – and felt "all was right with the world" so far – reckoning without the enemy for a bit; we were sound asleep in the barn within a very short time, and would have slept for many hours, BUT plomp!! We jumped up with a start. A bomb from the clouds had caught

our billet properly – knocking the adjoining barn all to pieces. We could hear the drone of Jerry's engines up aloft, and I suppose our being sound asleep – with a sense of false security – accounted for our sudden panic, for we all scooted down the road like madmen – only scantily clothed and some not at all. An officer who we did not know was running alongside and thinking to cut across to a field went headlong into a ditch – we helped him scramble out – a sticky mess – then on the jump again. Tho' it was night, we could see perfectly plainly – for six enemy planes were at work and had set a nearby petrol dump alight, illuminating the country for miles. They had a big cargo of bombs, apparently, by the number generously dropped.

Some of us scrambled over a fence into a ploughed field – why, goodness knows! – just scattering anywhere for cover; I dodged by a hedge and looked up (the drone of an engine seemed so near) and to my horror saw a Fokker above me – silver white in the rays of our searchlights – drop a bomb. I just crouched in a sort of trance – watching it descend slowly, catching the light as it came – and could not move for my life. To my unspeakable relief it dropped the other side of the hedge – uprooted trees and bushes, deluged me with choking debris, badly injured three men the other side and

killed one. A nasty bit of work and to this hour I cannot think how I escaped their fate.

For the rest of this entertaining night – any of us in the neighbourhood of the dump were rounded up to help in the work of salvage, expecting any moment the Huns would return for another exploit – but apparently "they'd delivered the goods" and went home for iron crosses.

On July 10th troop back to old billet at HERSIN – where we rested in every way till Saturday – for two evenings enjoying a splendid concert given by the "Quarante Sept" troop – 47th Division.

The 15th July saw us up again on duty in the line – VIMY SECTOR – our "home" being situated in Hospital Road. Continuous turns off and on duty – mostly on – for the old VIMY RIDGE was a real hot packet to hold these days and kept every jack man in the neighbourhood well awake and stepping lively. On the second day we witnessed a most exciting scrap over the enemy's lines to our front – a group of eight Fokkers were engaged in fighting five of our planes – it seemed to last for ages, we cheered lustily, but the result was not at all to our liking – for three British were brought down in enemy country against only one of theirs having to descend.

There were no definite incidents other than this during the spell up here, just the usual mud, "wind-ups" and hungry bellies. All in sufficient measure to make us mighty glad to pack up and walk away from it all – to proceed to CHAMBLAIN CHATEAULEU on the 25th July – billeted here a night – then further back to HOUDAIN in really splendid billets over a shop – just a bare room – but very clean and our little clique was able to spend the evenings in the best parlour at the back of the shop – sipping coffee, writing letters and generally having all the amenities of a first class club without the subscription. We appreciated all this highly, especially as the weather had set in very bad, cold and wet – frightfully so for July.

Rumours were that the Division was on its way further South and that we should find ourselves down on the Somme shortly. After about a week's rest here – I looked forward to doing some sketching etc – and so was very disgusted when told to pack my kit and be ready to accompany a Sergeant of the 7th Battalion to some unknown destination at 7 in the morning. All the sharpshooters were now allotted various similar tasks – that sort of broke up the party.

Anyway I was up betimes and the Sergeant and I bundled off in a lorry – on a long journey of umpteen kilos. After hours of jolting we were put down and had to find our destination by a bit of scanty road map – over fields, jumping ditches, stepping gingerly round *old* rusty barbed wire entanglements etc till we arrived at the most God-forsaken spot anyone could imagine. Like the middle of Salisbury plain in winter with not a soul for miles beside ourselves. It seemed to be a deserted dump for all sorts of Engineers' clobber, and we were really surprised to see a couple of "Old Bills" emerge from a funny sort of hurdle cabin. They said they'd seen nobody for a week and were running short of grub and starving for "fags" – they certainly looked like castaways on a desert island especially when I noticed a bedraggled torn Union Jack from a post waving in the breeze. The Sergeant said a few choice words, that nicely echoed my thoughts on the subject of taking over from these two dirty, forsaken old darlings. After a chin-wag and a swig from the Sergeant's bottle of Vin Rouge they meandered off and left us – with many a tear and sad farewell ("I don't think").

This ground had evidently been the scene of fierce fighting at some previous date – all the trees were withered and smashed and the whole earth for acres

and acres pitted with shell holes – no grass for miles,
and no water could we get, only muddy stuff out of
a hole that had collected rain. We were subjected to two
"very nice and large" gales that threatened to sweep our
cabin right away. Real hurricanes that charged over the
desolate land like mad, we could hardly hear each other
speak, and the rain teemed down unceasingly for
twenty-four hours, the only consolation in the picture
being that there were no shots or shells to mingle with
the utter wretchedness of it.

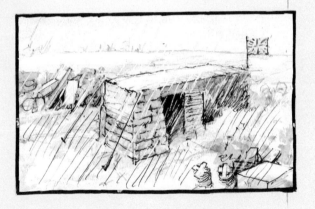

We were supposed to be guarding this dump, but
anybody was welcome to walk in and pinch the whole
issue – as far as the sergeant and this child cared. I think
it was in a way more miserable than the line – it was so
lonely and monotonous. The only place to lay down was
thoroughly sodden straw – so that after three days one

was not a bit surprised to feel "groggy" and begin
to sigh for England - home - and beauty - I couldn't
possibly rise from my "water" bed - and my throat was
practically closed - The Sergeant was a good sort and
got frightfully worried but could do nothing for me. he
was afraid to leave me to myself while he tramped
miles for help - and things got quite serious for me - and
I doubt if I could have hung out much longer - did
not a dispatch rider happen to pass by chance. The
Sergeant got him to deliver an urgent message about
it, and an hour or two after - to our great relief - an
ambulance came up specially for me.   Taking me back -
to 22 Casualty Clearing Station at BRUAY.   ♦   ♦

    Was soon got into a warm bed - but felt too
ill to appreciate even this as I should.   I heard
the doctor pronounce "French fever with Tonsilitis" and
the next time I was able to notice anything at all
was when I woke up out of a trance half-way down
to Boulogne on an hospital train.   Am afraid the
scenery and the comfort of the journey was wasted on me
for off I went again till bumped from train to base
hospital conveyance - I was lucky to have been prac-
tically unconscious the whole way - better than seeing
too much of the suffering and dreadful pain that
goes with a hospital trainload. and hear the stifled
groans from those with awful wounds to dress.   ♦   ♦

I was admitted to this delightful place on August
2nd and it looked a pretty long stay for me from the
fuss and attention they gave to my case.

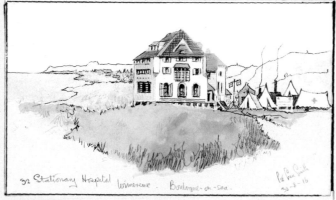

32 Stationary Hospital Wimereux. Boulogne-on-Sea.

The hospital itself was chock full of wounded
men so the sick were put in tents and marquees –
known as the annexe – very pleasant and healthy –
near to the sea.

It was almost a fortnight before I could sit up and
really take notice – and when the sides of the
marquee were furled by day the thrill was wonderful
– to gaze on the sea and imagine "Blighty" away in
the distance – and the kindness of the sisters was
beyond description. One, a Canadian, a V.A.D. being
particularly an angel of mercy – smuggling peaches
and delicacies under my pillow quite frequently
after a visit to the shops in WIMEREUX, together
with fine magazines that had been sent to her from
folk in England.

The food now was very splendid – and to have them so certain and regular was wonderful to me; of course it was eight or nine days before I could have my share – was only kept up on brandy and water till then.

The first job when strong enough, was to write letters home – they'd all be worrying – so I had to beg for paper, as all my belongings, photos, souvenirs etc had all "gone west" on the way down.

Oh! it was a grand change to hear the soothing murmur of the sea, instead of the roar of guns, and instead of ruined, gaping houses and desolation, to look along and in the distance catch a view of the pretty groups of houses about the beach, brilliantly coloured in true continental fashion and of the quaintest shapes imaginable.

On August 14th I was allowed up for the first time, and donned the pretty boy uniform – "the blues". First job handed to me was as orderly to wait on the other bed patients, then two days after, paraded with the other convalescents at 6 a.m. for roll call, then muddled about a bit till breakfast, after which we'd again parade outside the big marquee, for allotment to various duties during the day. I had the cushiest of jobs (the doctor forbidding my being put on any other), just had to go down to the beach with a couple of "Jocks" picking up pebbles for pathmaking. I must have been pretty queer because the matron went right

off "the deep end" at the sergeant in charge – just because I was wheeling a barrow. Had me called in and gave me a nice "posh" job as a sort of clerk, which kept me nicely employed for quite a long time. Filling up forms, printing notices – doing some artistic stuff and so on which kept me as clean and spruce as a "base wallah". It was such a great blessing to have a frequent change of underclothing and three pairs of socks. A fine bed to sleep in with sheets and quilt and a complete new issue of sundries, razor etc. made the whole scheme – heavenly.

While here, word went round that one poor fellow in the ward was dying for want of blood – and volunteers were required. Being pretty strong by now I offered, along with four others, to have some transfused to him, we were paraded in a hurry and had a blood test made – I was selected for the job but unhappily he died before this could be performed. I had not heard of this operation before – but soon learned it was quite a frequent occurrence at hospitals.

There seemed to be a particularly happy, decent crowd of fellows collected at "32" and I made some really close chums – we were all fully occupied during the day but the evenings were free to do as we cared. The few following pages are some souvenirs that I cherish of WIMEREUX days.

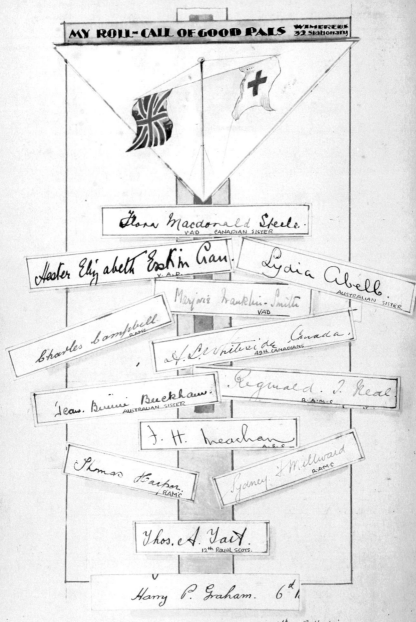

MY ROLL-CALL OF GOOD PALS   WIMEREUX
32 Stationary

Flora Macdonald Steele.
VAD    CANADIAN SISTER

Hester Elizabeth Eskrin Gau.
Y.A.D.

Lydia Abell.
AUSTRALIAN SISTER

Marjorie Franklin-Smith
VAD

Charles Campbell.
R.A.M.C

A. L. Whiteside   Canada.
49th CANADIANS

Jean Bennie Buckham.
AUSTRALIAN SISTER

Reginald T. Neal.
R.A.M.C

F. H. Meacham
A.S.C

Thomas Harper.
, R.A.M.C

Sydney H. Millward
R.A.M.C

Thos. A. Tait.
12th ROYAL SCOTS.

Harry P. Graham.   6th B

6th Battalion
Black Watch Reg.

## "C.C."

Happy I lay upon my bed,
Pains in my arms, my legs, my head
(At least I told the doctor so.)
"To Blighty now I'm sure to go,"
I thought, and broadly smiled within;
In fact, I could do naught but grin,
The future seemed so full of cheer,
And England's shores were looming near.

And when the M.O. came his round,
He looked at me with gaze profound,
And then he slowly scanned my card,
(I saw that he was thinking hard.)
He turned — the skies were fairest blue!
Oh joy! My dreams were coming true!
But as he slowly walked away,
I heard him to the Sister say
The words that crushed all hope in me
He said, "Just mark this man C.C.!"

Harry P. Graham.
France 1916.

CONVALESCENT
CAMP

WINEREUX

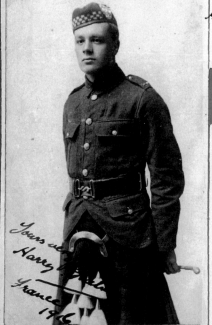

Yours &c
Harry Graham
France
1916

Just as I did, he travelled oer the sea,
To help the fight, the fight for liberty,
To keep the old flag flying in the breeze
And bring the old lands enemy to his knees

He left friends in England, good and kind
Whilst I, Australia's shores had left behind
Shores that sheltered kith and kin, my all,
Before I answered to the Homeland's call.

Twas then True Friendship came!

Tom Cleary.
54th Battalion
Australia.

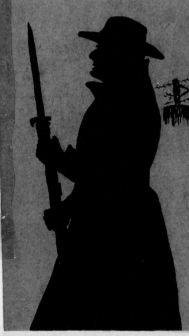

WATTLE - GIVEN
ME BY TOM CLEARY
SENT TO HIM FROM
AUSTRALIA

COMPOSED
BY
TOM CLEARY
AUSTRALIAN
~~CANADIAN~~
SOLDIER

When they found I could draw at "32", I was absolutely swamped with Art work - one of my duties being to paint the names and particulars of men who died in the hospital on nice wooden crosses.

And suppose that I did at least fifty in the course of my sojourn here. * * * * *

Then there was a monster hoarding out the Marquee section - the annexe - which had to be given two coats of paint - and then have "32 Stationary Hospital" written on in fine - large Roman letters - also two huge red crosses - This was a fine job and I took great care with it - enjoying being on such an interesting open-air job for four or five days in the lovely sunshine. *  Everybody who mattered seemed very bucked with the result, and further jobs for my brush were soon unearthed. * * * *

The sergeant in charge of the convalescents jokingly said, more than once, he'd get me transferred to the R.A.M.C. just to keep me on the staff. This was impos. of course - But it conveyed a pretty broad hint - that I shouldn't be bundled up to the trenches again any too soon. * * * * * * * * *

Sometimes I felt very mean and conscience - stricken - to be so well and yet remain at the base - and I tried to console myself with the assurance that maybe I was entitled to a bit of "smooth" to go alongside the "rough" I'd known for many months up yonder.

No "32" Stationary was not actually situated

at WIMEREUX, but about two miles out, and of course quite out of bounds was the town considered for patients. Special passes were "dished out" sometimes on a Sunday or week evening – which were much sought after, and kept us all on best behaviour to get. I had some jolly good walks by the cliffs with pals – especially Harry Graham to who I became much attached. Also another good chum of mine would accompany me now and again to a Y.M.C.A. Service – he was actually a Wesleyan Methodist parson in civvie life – but made quite a bright soldier and a real good sport for a companion.

I fortunately got a sort of "season ticket" pass into WIMEREUX having to go so often for colours and materials that I seemed to use up at an alarming rate in my "studio" tent.

There happened to be quite a decent Art Shop there – LORENZA'S – and after one or two visits to purchase stuff and some interesting conversations, Madame asked me to make a sketch of her shop and street – also do a little autograph album stunt; these I did to her great satisfaction and from then onwards became quite a friend of the family – Monsieur "Len" was introduced to her married daughter Madame Douchy and husband (he was a discharged wounded French officer), and kinder folk I've never met; they pressed on me anything I wanted in materials for artwork refusing to let me pay a sou – and gave me an open invitation to their home for tea or dinner whenever

Adjudant Douchy

I could get leave to go. They were undoubtedly well-to-do people, refined and cultured – as evidenced by the excellent English they spoke – and the sculpture, books, paintings and engravings that bedecked their maison and they were so pleased to show me. So utterly different were they to the class of French people I'd only come in contact with in the mining towns and villages up in Flanders.

That Madame Douchy and Madame Lorenza spoke fluent English was a great advantage to me – when they made a special point of teaching me French. Madame Lorenza was a dear old dignified lady – who took the task quite seriously; I had to sit upstairs in the study and start like a kid with the A.B.C. for a couple of hours at a time – reading exercises, writing and speaking.

After a few good lessons – learnt with raps on the knuckles – they amused themselves while at dinner by pretending to be stone deaf if I spoke English – but all attention if I assayed French, however halting; in fact I formed a shrewd suspicion they enjoyed my innocent, silly mistakes in the language more than if I'd been correct each time – they never left off pulling my leg because I called a baked apple a "pomsqueak".

A Sunday came round when Madame Lorenza had a birthday – and so she must needs send a special request on my behalf to the Hospital C.O. asking that I be given a leave of absence from "petit déjeuner till 10 o'clock at night". They were all known to the Staff and Nurses at "32" so this was granted me.

And I thereupon had a most memorable day. a royal "beano". Several nice French people — who were very jolly - Madame R - the Donchy's and myself - it seemed almost like a thorough English home party - a six course dinner and plenty of fun. Good music and odd sorts of games - new to me. made an excellent programme and a complete change. When I afterwards recounted it to the boys at "32" they were quite green with envy. ❖ ❖ ❖ ❖ ❖

Of course - they would detain me till the last minute and I got rather "windy" of time - it would have been "shabby" to have got back late after such a generous permit out from the hospital — So finally I had to tear myself away from them - with a couple of good miles to run - in a very short time. They came to stand at the door and bid me goodbye, and I dashed across the road with a fine spurt to "make it" before ten - when smack - I'd barged right into an iron standard - obscured by the dark night. By jove! It really was a nasty blow and laid me flat. My friends happened to be still at the door - and dragged me back - "doctoring me up" with great excitement. I'd got an awful eye and had hurt my leg so much - it was impossible to walk. They had to send word to "32" to have me conveyed by ambulance. ❖ ❖ ❖ ❖

Luckily I had a "clean sheet" character

up there - or it would have been an almost hopeless
job to convince the authorities I was not drunk and
incapable - especially as I had, as a matter of fact
been persuaded to drink Madame's health and birthday
compliments just before I left the party.        With
my bandaged head and limp - I caused much merriment
among my pals for a few days -  and many a seemingly
anxious enquiry - as to "where I found the booze with
such a kick in it in "France"     ❖    ❖    ❖    ❖    ❖
  ❖     ❖     ❖     ❖     ❖     ❖     ❖     ❖

            We were given a pass to BOULOGNE
once or twice - and I went with my chum Tom Cleary
by tram - for a look round the Harbour and an egg
and chips "tuck in" - but generally speaking the trips
were not very interesting - as the Military Police here
were too lynx - eyed in keeping us to a prescribed area.
            This picture shows a view that we saw from the
tram on the way to BOULOGNE.

E.S. 1436. Environs de Boulogne-sur-Mer — WIMILLE
Emplacement où eut lieu le Congrès Eucharistique

825. Environs de Boulogne-sur-Mer
WIMEREUX — Rue Carnot

L'Hirondelle, Paris

96 — WIMEREUX. — Vue prise de la Falaise nord. — LL.

Edition spéciale Douchy-Lorenz

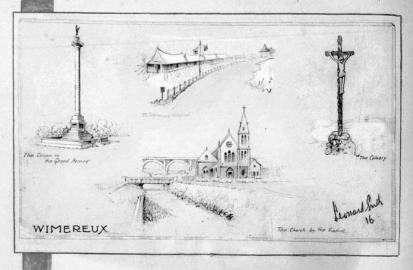

WIMEREUX

*The Column to the Grand Armée*

*32 Stationary Hospital*

*The Church by the Viaduct*

*The Calvary*

Leonard Smith
16

One way and another, things went along very happily with me these days – plenty of congenial work, a fair amount of freedom, and occasional lectures or concerts. Each concert kept me very busy in advance preparing "posh" programmes for officers and nurses.

This seems a funny idea with a big war on and hardly seemed to be "playing the game" as far as I was concerned, but a moment's thought sufficed to prove to my own satisfaction – I was here doing such work, just as much *under orders*, as when told to go "over the top" at LOOS.

One concert given by a Lena Ashwell party specially sent from "Blighty" was a conspicuous success, and a lecture in the Y.M.C.A. hut given on another night by DR. WALFORD DAVIES on singing was truly delightful. The boys were greatly

taken with his genial personality. He was a splendid man – and demonstrated his "educational talk" in the most novel manner. First a series of good hints on "How to sing" – then we sang various favourite tunes under his guidance; he was very critical, and continually pulled us up with a jerk, pointing out errors and improvements in the most jovial way – and so about half way through the evening we were lustily "getting away with it" like a trained choir – thoroughly enjoying the good old English songs we knew so well.

A really big commission I got while at "32" lasted some weeks. It was the preparation of a most elaborate illuminated Roll of Honour on which were inscribed the names of poor fellows who had succumbed to wounds and sickness while patients at "32". There were some hundreds and yet I had to leave sufficient blank for many, many more. This job kept me fully occupied for 10 hours a day for many days – and looked really worth while when completed; as a matter of fact in "Blighty" it would have cost a very tidy sum – but here I was completely satisfied with my reward – regular meals, a good bed, and peaceful security.

The Doctors and Staff in charge of the Hospital were extremely pleased with it – and the Colonel went out of his way to specially and personally congratulate

me, saying "how indebted they felt, and that if anything could be done for my welfare, it should be."

My throat now got troublesome again – forcing me to report sick – the result being I was marked down to have my tonsils out. They made "no bones about the job" and it was practically no sooner said, than done. Of course it meant going back as a bed patient for a few days – where I was again treated "like a lord". Tho' why on earth an orderly woke us all up to wash us at 4.30 each morning I never could fathom.

One amusing incident occurred whilst "in dock" here. It was a Sunday afternoon – and most of us were dozing or sitting up in bed reading or writing when the door opened at the far end of the hut, and a very distinguished group of visitors were seen to enter; this was most unusual in France – visitors were undreamt of. The Matron and nurses went "all of a dither" and the "Tommies" popped eyed with curiosity. Then to my utter embarrassment they stalked straight up to my bed – loaded with flowers, fruit, chocolates and cigarettes – and I recognised Madame Lorenza, Monsieur and Madame Douchy, very fashionably dressed, and a French officer (who I learned was M. Douchy's brother) done up in the most gorgeous blue uniform – bedecked with gold and scarlet, and wearing "umpteen" medals.

Of course I thoroughly appreciated their great kindness, and trust sincerely I showed it – but must confess it took my breath away; they rather surprised and bewildered me – to have all eyes focussed on the event and such special attention paid to an ordinary Tommy was unusual in the extreme. It certainly took a rare long time to live down the good natured chaff that afterwards bombarded me from Matron, Nurses and Pals.

While in this ward my companion on my right happened to belong to the Royal Engineers – working as an artist in the SPECIAL WORKS PARK camouflage factory – over across the field near the hospital. His yarns and general survey of the duties they were there engaged in greatly interested and intrigued me. So much so that I greatly began to wish that I too, could enter some such very useful modern branch of the Army. I understood from him that frequent trips were made to the various sectors to do stunts in the trenches – and so this of course made me feel quite keen, as honestly I did not want to be entirely out of the rest of the show, and as I was really a member of an active fighting arm – the 7th Londons – this would not be a bad change, for variety's sake.

I began to feel I wanted to get on to something more definitely useful – and be where there was

"something to write home about" among the "sodgers" holding them back.

On Saturday morning Nov 3rd I was warned to parade at 8 o'clock next morning – to be on draft going up to the line to join original units – so I got a permit to buzz down town to my friends and bid them goodbye.

Returning later in the afternoon to pack up my goods and chattels (which had got numerous by now) the Matron called me over, and said the Colonel desired to see me at five o'clock. When I presented myself he was awfully decent – saying again how he appreciated my work for "32", wished me luck, sorry I'd got to leave at last – and was there anything he could do for me. Rather a poser for a Colonel – and I was nonplussed – till I remembered the R.E. Park over the way. I therefore blurted out my idea of being transferred there – and he seemed quite pleased and said "I shall be dining over there this evening and will endeavour to fix things for you".

To cut the story short – he did settle it all happily for me and instead of parading and being shunted back to the old life – I eventually had to report with my kit to the CAMOUFLAGE FACTORY – ROYAL ENGINEERS, SPECIAL WORKS PARK on November 10th 1916.

Thus finished
the 1st. helping
of PIE · ·

# Commencing the SECOND SPASM

## With the R.E's

### FIRST ARMY SPECIAL WORKS PARK

#### CAMOUFLAGE FACTORY

WIMEREUX

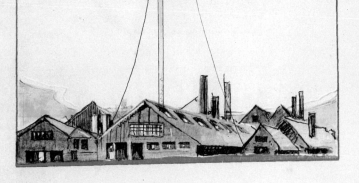

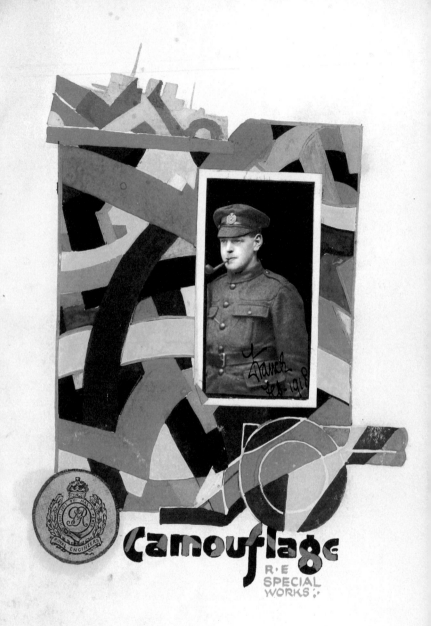

Camouflage

R·E
SPECIAL
WORKS

Now began for me quite a new and novel type of Army life. My first experience at the Camouflage works – approaching something very like a civvie job in a factory at home. The big difference being, one couldn't give a week's notice and get another job if one wished.

The Special Works Park was composed of a number of old buildings, suggesting a pre-war large factory of some sort. These were now divided into groups – with special workshops for various craftsmen – Blacksmiths, Ironsmiths, Carpenters, Painters and so on – with one large, well lighted building devoted to a novel bunch of men for a war – artists and sculptors. Tho' when one saw the nature of their work – and the life-saving possibilities of the whole idea – it made one proud and glad to be linked up in the scheme.

There were about forty men all told and the few Officers here were quite prominent men in the world of Art at home.

There were two fine huts devoted to our living quarters – allowing plenty of room for twenty men each – ten beds arranged down each side of a hut. The beds were quite posh affairs – wooden frames with wire and canvas stretched along.

*SEAWEED FROM WIMEREUX · DEC 1916*

And the ingenious shelves either side kept everything very shipshape – and civvie barrack looking.

Most of the fellows had been at the works for months and so were well "dug-in" with all sorts of comforts – boot brushes, mirrors, an extra Sunday "square-pushing" suit of khaki etc. In fact I took my place here as quite a war scarred veteran – against the majority that had never "smelt" powder.

Nevertheless they were a jolly fine crowd of fellows and made me very much at home from the first minute – "putting me wise" to all the dodges and tricks of the new trade.

The routine was to have reveille at 6.30 – up sharp – make our beds, wash and shave and parade for breakfast at 7 – always a jolly good sound meal of bacon and fried bread, followed by porridge and cocoa. Roll call at 7.30 – when we would be dispatched to various jobs about the grounds or workshops according to the day's requirements. (As orders were sent in from various parts of the front – from batteries and regiments each day – making definite demands for certain stock, which demands had to be met without fail; it meant working twelve or more hours a day sometimes.) At 1 o'clock the whistle would blow to give us an hour for dinner – then on again till seven – if we were lucky. The hours were long but it was all comparatively to *me* like paradise.

All so restful from the trenches – and the work itself most interesting and varied. One day we'd all be out in the grounds marking out and colouring huge spreads of canvas for covering gun-pits, another day I'd be with a group of artists at work on a mock scenery to hide big guns, making sniper suits or painting decoy sniper papier mâché heads.

After two or three weeks here under careful observation from the C.O. I was informed that I should be transferred permanently to the Royal Engineers and be graded right away as a "Very Superior Sapper". This was a nice bouquet – in view of the fact it really meant a very big rise in my weekly salary. And was equivalent to being a full corporal in a line regiment – in fact would always take precedence over one when out on a job up the line.

DECOY HEAD – PUT UP ABOVE TRENCH TO GET AN ENEMY SNIPER TO DISCLOSE HIS POSITION BY DIRECTION OF BULLET HOLES IN HEAD

Another fillup to my great good fortune came soon after this. There not being a very large detachment of us at the "Park" I was pleasantly astonished to learn that they had practically run through their "Blighty" leave list by the time I had arrived – so that mine would shortly become due (this would make it just about a year since I'd had my last).

Thus I was given my ticket for "Blighty" on the 16th December. Had to go down to Boulogne to stay at Rest Camp ready to embark early next morning. Arriving home by the evening full of excitement and "pep".

And then spending a whole week of unalloyed joy,
seeing everybody - and filling up every minute of each
day with some lively activity. Only Once or twice did
enemy aircraft disturb the serenity - but passed over
without unloading in my locality. —    Many things
were new and interesting to me on this trip - The
trains with darkened carriages —   the girls driving
lorries and cars - or acting as conductors on trams -
others coming from munition works with faces and hands,
stained bright yellow.   —   The long ration queues
lined up for necessities. with ration cards for meat,
sugar - butter - bread etc.  was all rather alarming and fresh
to me.       ◇         ◇         ◇         ◇         ◇   ◇

          I was feeling particularly robust. and ready to —
devour stuff like a lion - but found one had to curb
the appetite - it was "not done" these days   ◇         ◇

MINISTRY OF FOOD.
OFFICE. NATIONAL RATION BOOK (B).
ADULT    INSTRUCTIONS.

| LARD 22 | LARD 20 | LARD 14 | R | 7 |
| | | | | 14 |

Leaf 12. Holder's Signature
Arthur G. Smith
Address of Holder 26 Blenheim
Rd. Waltharmston
Serial No. of Book 486979

| LARD 15 | LARD 9 |
| LARD 16 | LARD 10 |
| LARD 17 | LARD 11 |
| LARD 18 | LARD 12 |

MEAT c26  26 c26    MEAT a26  26 a26
MEAT d26  26 d26    MEAT b26  26 b26

SPARE COUNTERFOIL.
(Do nothing until told by public notice how to use this)
Holder's Signature Arthur G. Smith
Address 26 Blenheim Rd. Waltham
Date................19

The only "snag" about this leave was that I was due back just before Xmas day – which of course disappointed the folks at home very much. The time came all too quickly to return – and as the boat-train left early on Sunday morning from Victoria and the *last* local train from my district went out at midnight on Saturday – we had to scheme out the best way to manage. So the little party who were seeing me off caught this train to the City, trooped over to my "Dad's" office in Bishopsgate – and spent the ensuing hours till six o'clock "yarning" and making tea with stuff we'd brought. Then for the walk through strangely quiet London streets (before the traffic awoke) to Victoria, the gateway to the other side.

Here were crowds of victims for the fray, bidding pitiful farewells – bidding old mothers, sweethearts, wives "take cheer"; the "going back" station scenes were always heartrending – and the final wrench for all concerned did much to temper the past pleasures of the leave.

Red Cross workers were awfully kind to Tommies, plying us with cocoa and coffee together with huge slices of bread and butter or buns – they seemed utterly tireless in their efforts to send us off comfortable and warmed.

Finally the guard's whistle – and the dangerous last minute clinging to the doors and footboards as we moved

out by women and children. The reaction among us boys – when on our way – was simply awful.

For miles and miles we'd proceed on the rotten journey without uttering a word – unless maybe from some "Old Bill" who'd had "one or two" to deaden the pain.

After a bit, I found my best solace in a good sleep and woke to find us being bundled out of the train at Folkestone. Then on to the boat and well away to Fair ? France – the least said about the boat trip as far as I was concerned the better. Anyway I'd had a "basin full" when it came to disembark, and was mighty glad to get on land – the sea had been really nasty tempered. On nearing land we'd thought it looked unfamiliar – and suddenly woke up to the fact we were putting into Calais harbour instead of Boulogne. Much to my chagrin, for instead of being able to jump on a train and get back to the works, my pals and nice little bed, I was doomed to march with the others the five miles up to the rest camp. "Rest" camp they called it – there was really no shelter at all – a few bell-tents were being erected enough to accommodate just about a third of the crowd. It was raining very hard and bitterly cold – it meant lying down for hours very miserable and hungry – we'd long ago "scoffed" all the grub we'd brought from "Blighty".

Not fancying the prospect at all I waited till darkness set in, and then very warily stole away, almost ran the whole distance to Calais Railway station, and by pure chance and good luck evaded the M.P.s and jumped on the BOULOGNE train – which finally got me to WIMEREUX and back to my "home from home".

Next day was Xmas day – and we were allowed to stay in bed till eight o'clock – getting up to a very special breakfast of bacon, eggs and tomatoes.

All the food this day was extra to us, as we all contributed quite a good sum each – to put in "the pool" and buy grub worthy of the season.

From some farm or another the cooks had procured a fine pig, which provided a grand feast – together with an alleged Christmas pudding and other good things, spread out in the most approved fashion.

My pleasure did not end here – as I went down to high tea at Madame Lorenza's place – and in the evening finished off the day in royal style with turkey, baked potatoes, and a whole medley of French mix-ups. All told, a very memorable day, that in large measure consoled me for the fact of being so many miles from home on this occasion.

On New Year's Day we had another "do" – a "whip round" for special "Tommy" and in the evening a really clever concert given by the boys – to which

troops in the neighbourhood and walking patients with nurses were cordially invited. With paint and material ready to hand, most of the artistes were absolutely unrecognisable – allowing them to get off some very pert jibes at the Officers and ruthlessly caricature different members of the Park's personnel.

By now, I'd settled nicely in my quarters and as was the vogue had quite a little picture gallery of photographs – of the folks at home, of pals, of picture post cards from Blighty etc. And was getting fastidious about dress – scrapping the old buttons, for "posh" R.E. embossed affairs, polishing my leather belt and boots "good enough to shave in", and doing all that became a true "Base wallah".

A fine texture khaki cloth that was used on some special camouflage business was commandeered by most of us – with which we had "flash" shirts made by French women – down town – and some pretty boys went as far as ordering fully pleated fronts.

Of course being here was not "all beer and skittles". We had a big order down from the line – requiring "umpteen" of our large camouflaged canvases about this time – that kept the whole bunch of us out in the open field from early morn to late at night for three weeks on end – and as the Park was right by the open sea and it was the depth of winter it certainly had its uncomfortable side, and was

considered "the limit" by those who knew no worse. I did.

I knew how incredibly much worse it was for the poor chaps up yonder in the trenches – and pitied them with all my heart.

I found that tho' my heart was quite willing, my flesh was very weak these days – the after effects of trench fever – and just as our bout of hard graft outside was ended, and I was deputed to go into the studio to paint scenery – for gun disguises – I fell sick, unable to find the use of my back at all. It kept me in "32" for a good fortnight, pretty near prostrate and gave me a real thin time. The nurses I knew well of course – and my former Sister Steele was wonderfully kind, finding nothing too much trouble – procuring books, tangerines and other tasty things. All very pleasant and comforting were these days on my back made as far as possible – but honestly I was keen to get back to the job and quickly get strong enough to resume the interesting, vital duties of the Camouflage section.

When I got back to them the weather had changed for the better – and everybody awfully rushed with work. I was treated awfully well – and told to watch my back, not do any "exposed to the elements" stunts, but keep in the workshops on painting sniper heads, screens etc.

So life was kind and went along pleasantly and smoothly for me till Feb 26th 1917. ◊ ◊ ◊

On this day while at work - my name was suddenly shouted out in the workshop and I was warned to have my kit packed up and be ready to leave twimereuxe in two hours time! So it meant a bit of a scramble to get all the tit-bit-souvineers together - make quite a lot of possessions go into a small pack - pop down town to bid a sad farewell to my good French friends Lorenza-Donchy and be ready to step off goodness knew where at the word-"go". ◊ ◊

We used to send our manufactured articles up the line by lorry - and so I found myself attached to one of these - loaded so heavily : it would have been stopped in Blighty as riding or driving to the common danger.

There being no room available on the driver's seat - I had with much difficulty, to clamber to the top of the huge mass of wire and canvas (still wet with paint) and ride the whole six hours journey on this precarious perch. It had a large element of interest, inasmuch as I had a bird's eye view of the country through which we passed. ◊ ◊

Ticking it off in my mind - some good - some bad - much indifferent - nothing to touch England. ◊ ◊ ◊

Finally we pulled up at our destination which turned out to be - another branch of our Special WORKS - situated at AIRE Sur-la-lys. A fine town - boasting a cathedral. and quite a number of good shops.

The whole place very old – and the streets cobble-stoned.
The billet wherein the Camouflage crowd –lived and worked was the most quaint place imaginable, a one time monastery – the whole place propped and supported by huge oak beams – with many quaint little alcoves: picturesque but mighty dark. These were usedly us as sleeping quarters – and cosy nooks they made.

I happened to share my allotted space with a very fine man – an Art-Master in civil life. – Surprisingly different in outlook-thought and conversation from the majority of tommies I'd met, and so considered myself fortunate to be thus coupled with him. "Tubby" we affec-tionately called him and "tubby" he was. We had two fine beds made of wood and wire with canvas – a box wherein we kept grub – writing paper etc – and to cap all – a nice little stove we'd "scrounged" – which helped to make it all very homely – and huge sheets of fine scrim – canvas were hung round in a square from the beams to conserve the warmth; when we'd finished work – (usually late) – had some supper and got into bed to read by candle or write, there would always be a crowd of pals who'd invade our den for a "jaw".

GOOD OLE'
"TUBBY"

When I'd only been here a week I caused a very nasty scare – doing a fool's trick. I came in first, one

evening perished with cold – and hastened to light up the stove for the evening and to welcome my pal. It refused to go – so I procured a cigarette tin full of petrol from the workshop, and shame to confess – not being then aware of the nature of petrol – I threw the tin full into the stove. To my astonishment and horror the flame seemed to leap from the stove to the tin – which I hastily threw down this caught the "scrim" alight – I had to step real lively to beat the fire out – and but for the timely help of the whole crowd of the boys, who'd come in off duty, the monastery would have been razed to the ground – there being so much old timber and flammable material all around. As it was it did a rare amount of damage. At one time it became really panicky and seemed to be beyond control. The other chaps were awfully good sports and made superhuman efforts – and when it was all over assumed an air of complete innocence as to the cause – thereby prevented my getting hung by the authorities – tho' of course, quietly between them, in a good humoured way, "I got the bird", because it started many restrictions concerning lighted candles, smoking in bed, etc.

One funny cove in the clique here I liked very much – he was a costermonger and bookie's tout in civvie life (how he got in the Engineers as a painter goodness knows); anyway he was a real rough diamond – would do anything at any time for anybody – and spent all his spare time cooking on another bigger stove in the rear

of the building – anything we fancied and could procure – he'd spend hours frying onions, just to please us, and season them with many a rare Cockney comic tune or expression while on the job. He was a real acquisition, and not being able to read or write we took turns to write home for him and read out the answering letters – some most intimate – but the funny side was much tempered by the thought of his helplessness with the pen. He brought his cap and civvie lounge suit with him back off leave and was mighty proud of his cerise neckerchief – this rig out would be worn with all seriousness in the billet of an evening – I wouldn't at all be surprised to find him in a carnival after the war as a "pearly king".

I was introduced to a new aspect of the war at AIRE Camouflage factory. Here the British employed hundreds of French girls in the manufacture of disguises. Also a gang of Chinese labourers – these "chinks" were a very rum lot – their job being to load the finished articles ready for the line on to the fleet of lorries kept for the purpose. We of course had some rare fun with these tiny soldiers – and to hear them chant strange tunes while at work was most fascinating to me. They were mostly friendly, innocent sorts to mix with and it was a source of surprise to find how we two, totally different peoples could get some sort of understanding between us. Of course we had to be "top dogs" all the time and during the short period I was in charge of a gang I had to be pretty

AGED 16
A FATHER OF
TWO KIDS

severe or they'd soon get out of hand and take advantage. They were never allowed to roam about – but had to stay in the billet, spending their leisure times playing some weird Chinese dice games.

These are two of my boys – the one on the left being only sixteen and the father of two kids which he was awfully proud of.

The Tommies taught them to say most atrocious things, which they repeated glibly like parrots, and it was often disconcerting to suddenly hear a "chink" blurt out a string of real "Billingsgate" – looking as bland and smug as a parson.

The greater part of the camouflage manufacture at AIRE was done by French girls and women of which there were quite four hundred – with comparatively few sappers to supervise, the system being to make a Sapper like myself foreman over a group. At one time I had seventy or so to deal with, turning out a set number of huge canvases for gun-pit disguise each day. My special job to mark out with a very long thin brush the areas for special colours with the name indicated – Brun, Noir, Blanc, Vert etc – then the girls

would bring along from the shed where the glucous colour was mixed, hot, large "bidons" or pails of steaming colour (a pail carried between two on a broomstick), they would then all start to fill in – till finally the whole sheet 60ft square was covered in a crazy patchwork pattern of paint – sometimes with green predominating for grassy field work and maybe

other times red and orange to mix with ruined areas. The girls wore sabots and overalls – for the splashing with brooms while sweeping on the paint was pretty thick.

On other occasions I'd have my gang inside a huge hangar –painting canvases in a motley array of old brick shades; when these were dry they'd be laid on the ground and several older women would sit in a row on upturned baskets – and proceed to paint with small brushes long parallel lines of cream mortar colour – afterwards coming downwards with short lines to make bricks; they could safely do this "donkey-work" – mechanically – then my

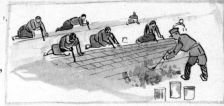

job would be to splash about and make the thing look natural by suggesting clumps of ivy or creeper, moss and shell holes.

This effort would then be stretched on a wooden frame

by the carpenters and dispatched up to a gun-battery – ensconced among old buildings – this would very soon be placed in such a way as to mingle with the surroundings and form an effectual screen for them against enemy aircraft observers.

In another corner of the works, there were some poor old souls – who made and painted sniper suits.

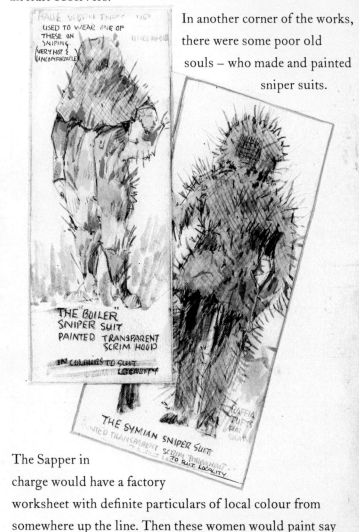

USED TO WEAR ONE OF THESE ON SNIPING. VERY HOT & UNCOMFORTABLE

THE "BOILER" SNIPER SUIT PAINTED TRANSPARENT SCRIM HOOD
IN COLOURS TO SUIT LOCALITY

THE SYMIAN SNIPER SUIT
PAINTED TRANSPARENT SCRIM THROUGHOUT TO SUIT LOCALITY

RAFFIA TUFTS

The Sapper in charge would have a factory worksheet with definite particulars of local colour from somewhere up the line. Then these women would paint say

twenty or so green – splashed with lumps of white for chalk, or red and yellow for sandy earth etc. etc. I think they only got labourers' pay – but they were all mighty keen to work for the British who – tho' they made them work hard – were really mighty kind and considerate.

They all treated the Sappers with great respect except one Corporal – who well deserved the nick-name they gave him – "Ki Ki" (the name for a mongrel cur). Many were the invites we got to their homes (mostly very poor, for the majority were refugees from distant places) for a cup of coffee and a struggling talk in French patois with their folks. One rather nice old dame begged and begged "Monsieur Len" to go home on a Sunday to take a cup of tea – till I at last gave in – and was really quite glad after because she was staying with relatives who I got to like very much – François a young French soldat and his most peculiar old Grandfather.

The old Gentleman I learned was quite a well known, prosperous Chemist who was now retired and he would now sit for hours – with a frightful smoking cap on and with a very very long pipe whose bowl was completely buried in a huge earthenware bowl of ashes (why goodness knows) – and he'd puff away while he told me droll stories and bits of past history relating to his life. The youth got very much attached to me and helped me with French enormously – being able to explain the whys and wherefores in fair English. Then one day he met me with a long face to say he'd been called up to one of the hot sectors with his regiment. He bade me a touching farewell

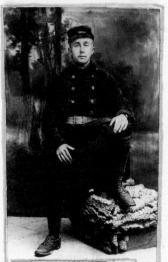

François Sauvage

HE CRIED
AT THE
FINAL
GOOD-BYE

Souvenir from a little soldier

Yours sincerely

François

– gave me his photograph, clasped me round the neck and kissed me umpteen times. All very affectionate of course – but hardly a thing I'd been accustomed to.

One very large hangar at the Park housed hundreds of girls who sat in very long rows at structures put up in front of them, whereon was stretched chicken wire – their special job being to tie strips of canvas close together to form a kind of mat – which when eventually thrown over a gun pit effectually screened and made it unrecognisable in enemy air photographs. The striking characteristic of this hangar being the picturesque effect of all these girls sitting in front of these green masses each with a different colourful overall on – and wearing a lovely bright bonnet, the gift of the Commanding Officer who'd brought and given one to each, many blues, yellows, greens and red making it look like a garden of flowers when the sun shone. I was often quite thrilled by the beauty and unique effect presented.

At one end were a dozen girls cutting the strips from canvas with guilli, and, as we could not keep French girls

from chattering, (through inattention) one got her thumb chopped off, which fell into the basket. I trouble to mention this incident because it struck me as very odd – when two or three days later I caught one of her friends, showing with pride, the thumb she'd fished out of the basket and wrapped in paper – not quite English methought.

On a Sunday it was very interesting to walk along the canal just outside AIRE to watch the soldier bargees bringing Red Cross wonderfully fitted barges through the locks. The more one saw of the war and all its ramifications the more one marvelled.

The town itself was filled at this time with Portuguese – or "Pork and Beans" – troops as they were called and a more scrubby lot of rascals one could never imagine – they absolutely lounged through the streets eating huge onions and generally behaving like gutter snipes. One peculiarity we English could never get over was to see their transport like a lot of grey gypsy waggons pulled by two mules with one shaft; the poor beasts leaned shoulder to shoulder with their legs sprawled out sideways – and so accustomed to this mode they could not be driven vice-versa their legs grew accordingly – they walked together like a letter A.

We had a pretty "nifty" air raid by daylight whilst at work the second week of my being here. We were more or less accustomed to see a formation of Fokkers going high overhead towards England as we thought – and on this particular day the drone of engines up above in the bright blue sky did not stop the French girls singing their usual

ditties "Mattelon" etc when suddenly bang went the wall
of a nearby church. Next moment my gang had disappeared
– home to children and relatives. Leaving me with the other
chaps to wander round the town to render any aid that
might be needed.

Generally speaking AIRE was quite safe – "cushy", and
very interesting, and after six weeks or so I began to think
was a fixture for duration.

But – like the films – "CAME THE DAWN" when I
was told with five other pals to pack up and be ready to
move on a long trip up the line.

So "up the line" it was Sir – each of us laying flat on top
of a huge convoy of camouflage stuff destined for "Plug
Street", and eventually unloaded upon the New Zealanders.
By some strange mismanagement, no one would have us –
had received no instructions etc. and refused to let us "mug
in" with them; we were more or less stranded – the lorries
had dumped the stuff by a dump and returned.

We got pretty fed up with this dark rotten night – and
although there were numbers of huts along the road we
should have been kicked out if we'd forced our way in.
At last getting desperate we spied a little wooden place, in
a corner of the field and proceeded to park down showing
no lights in case we should be spotted – before very long
one felt sick then another till we had to scramble or crawl
to the door for air. We slept outside in a hedge and in the
morning found a notice on the door of the hut "GAS
CHAMBER for gas helmet instruction purposes –

no admission by order". So we were lucky not to have been "snuffed out" in our sleep, tho' we felt peculiar effects for several days after. Well – "all's well that ends well", and fortunately things got straightened out – and we found ourselves officially attached to one of the batteries up here – to put the officers and gunners wise to the correct and best use of camouflage – natural and manufactured stuff. We were on this for several weeks going from one gun team to another round the Division. We had some good – some bad – times on this stunt but it was, thank goodness, never monotonous.

I got rather a nasty punch on the nose during this trip – waking up suddenly, whilst sleeping in the corner of a hut near the road I saw a blaze, and looking out espied a transport lorry on fire. Naturally I got hold of a handy pail of water, rushed over and doused the engine and the driver (a Corporal) with it; he swung round in a vile rage – hit out, and said I'd caused the fire to spread, making a route with the water for the petrol to run along. He didn't put it quite so scientifically as this, but when both he and the fire had cooled down, there were apologies given and accepted galore.

We had a proper roving commission these days among the guns small and large – and our admiration for the work of the artillery increased as we got more conversant with it. We travelled over quite a wide area from Plug Street up to YPRES, and I was able to search diligently to find my brother's battery but despite numerous enquiries,

a special trip to a likely spot near POPERINGE and the most diligent search failed entirely to come across him to my bitter disappointment.

The week we were up at YPRES was pretty rough both from the weather and the Hun. Our guns too were in constant action – and could give no heed to camouflage demonstrations or aught else of the kind, it was "Action – fire!!!" all the time. We were only just able to report at the pits for duty and practically "stand by" the remainder of the allotted time – sufficient to make satisfactory reports.

We were on one occasion told to collect the canvas brick work structures already mentioned and place in proper position round a fairly big howitzer, and it proved to me how effective it was among broken walls and ruined houses – as, when we had occasion shortly after to visit the battery on another matter, we could not find the position at all – until directed specially by a gunner who laughingly told us "it was not thirty yards away".

The guns most near to the front were the 18 pounders and we visited one lot just in time to participate in a really hateful strafe from Jerry. One gun and crew being wiped out in the first half hour's overture. We were perilously near at the time and rendered all the assistance we could to the stricken men.

The weather had got us all down rather – wet, cold and miserable – and much to our joy we were all recalled to AIRE on the first day of May, when it brightened up,

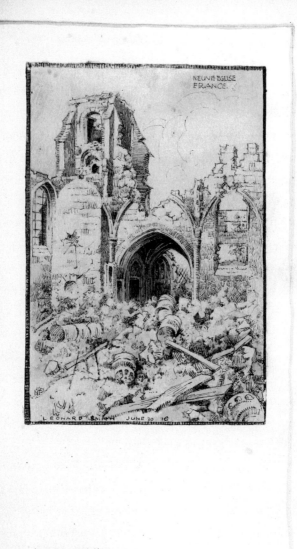

NEUVE EGLISE
FRANCE.

LEONARD SMITH    JUNE 20  16

NEUVRE EGLISE.

JUNE 20 · 16

and I thoroughly appreciated getting back "home" to the comforts of a good bed, food and a nice town with shops (we'd only seen a solitary Y.M.C.A. up at "Pop" for weeks).

Was back here for a week at the usual Camouflage stuff –

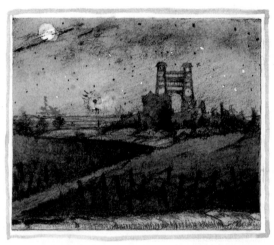

then shot right up the line again to the old LOOS sector, on rather a nasty touch and go job up the towers of hateful memory. Clambering up among the broken iron girders, with shrapnel bursting and clattering all the while – as if Jerry knew we were up there and that we were fixing a new stunt observation post right up aloft.

On this spell we struck the novel task of camouflage painting two tanks, what huge, hideous man-crushers they looked. I was mighty glad to be crawling about over one painting it green, brown and cream, in odd patches – rather than have one creep over me – in the sense of a flat-iron.

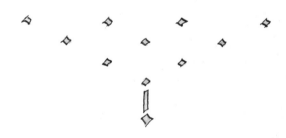

**T**he intervening blank is due to quite a large chunk of my diary getting lost while out on a rather touchy stunt. • • •

It covered a long-interesting period of my camouflage experiences, largely up in the danger zone. BUT not wishing to fall back on a faulty memory, or romance from imagination I must content myself with the words from that old favourite parlour game Winkle's wedding - "AND AFTER MANY VICISSITUDES" - up and down the line - going on leave, - getting married and so on, I again pick up the narrative as written at the time, where I find myself at that poor shell ridden town of ARMENTIARES. I've walked times and times from one end of the ruined town to the other without meeting a soul - never a curtian - seldom a tommy - and therefore looked in vain for the famous Mademoiselle of the song. "who hadn't been kissed for forty years."

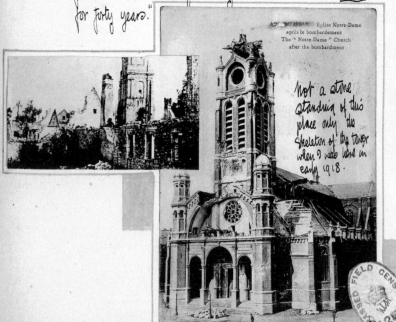

ARMENTIARES — Eglise Notre-Dame après le bombardement
The "Notre-Dame" Church after the bombardment

Not a stone standing of this place only the skeleton of the tower when I was here in early 1918.

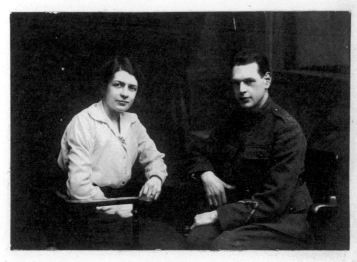

"War-wedding" day   DEC 10 · 1917

The work embraced on this long spell up the line was of a most interesting character. Taken over a very extensive area. It was entirely a solo job - I being quite on my own - loaned out to a whole division of artillery. My stunt being to attach myself to a gun battery and demand the use of six gunners for which I had full authority. A load of oil colours - varnish and turps would follow me up on a limber - and then I would proceed to crawl all over the guns in the pits - (with the light ones right near the line or the "heavies" further back) and mark out the camouflage pattern in chalk or black paint lines - indicating the colours by letters, then the six gunners would follow my instructions filling in the greens - browns and creams. They treated me with marked respect - especially the Officers and I was made most welcome and comfortable as possible for sleeping quarters, and fed in the Sergeants mess.

There were occasions when the gunners patience was tried and their language lurid. They'd have just completed painting their pet gun and taken all the pains imaginable - to make it nice, - thoroughly enjoying the change from the ordinary routine - when suddenly and officer would be shouting down the megaphone "Action Stations" and they'd have to fling themselves round the gun to fire, getting smothered with paint to the eyebrows. ◇ ◇ ◇ ◇ ◇

I met every type of gun on this jaunt - even up to painting the big naval guns - and appreciated the

opportunity greatly (as an old infantry man) of seeing at such close quarters the artilleryman's side of the war. It was very disconcerting to me on the first few occasions when I just stood aside in the pit during firing, and felt the full effects of the concussion in my ears. Eventually I got hold of the special ear plugs from one of the chaps and thereafter was able to enjoy the thrill of it all.

It's really a sort of inspiring scene to witness a gun crew in a real sharp bombardment – stripped to the waist, working like hell. Anything more characteristic of tense activity could not well be imagined. With my proverbial good luck I missed a very nasty piece of work – while down ARRAS way.

The guns of the battery were practically complete as far as my job was concerned – when a sudden S.O.S. went round, and the gunners had "to get down to it" pretty slick. I'd had a bad head through neuralgia and so wandered across to the dug-out while my job was postponed, to have a little sleep. On being roused and going out later I found to my sorrow the whole gun crew and gun, in the pit that I'd not long vacated, had been blown to atoms, by a well directed shell that Jerry had sent to silence them – and silence them he had – cruelly.

"C'est La Guerre!"

This was a sticky quarter altogether up with the spiteful little eighteen pounders, for two days later the boys' dug-out got smashed to smithereens – happily we'd all cleared out so nobody got hurt – we just lost

personal belongings and had to "kip" out in the open at night – not a bad idea on a moonlight one but instead it poured in torrents. I got soaked – and the result was I got a good dose of "the screws" and a touch of trench fever – which accounted for the fact of my going about my job for two or three days with a couple of sticks like an old Chelsea pensioner, until the Sergeants protested and the Officers insisted in packing me off back to a clearing station then to hospital for a week.

By jolly good luck the hospital happened to be just outside AIRE, so that I was able to communicate with my Pals at the works, and so have visitors. This was a queer place, a one-time barracks – with prison attached; I first found myself in a little cell, or it had been with just a small grating window – this could not be altered but the rest had been quite transformed to a cosy nook. After a couple of days and nights – viciously hot mustard plaster treatment – I was put into a big ward, all red and almost raw but with all the complaint much lessened.

Opposite was a real "square headed" German who I couldn't get to hate for the life of me – he looked so worn, helpless and inoffensive *here*. A "pork and beans" on my right, who looked more like an Italian, with earrings, gold tooth and rolling, wicked eyes that led me to ask him for an ice-water and to "top it up Jack" – but "he no speaka der Ingerlisherla", so there was nothing doing.

I understood his lingo however, much better than I

could the Welshman the other side – who rambled on like water gurgling from a bottle.

All very nice generally here, but was keen to get back to some activity – and "wangled" my convalescence so that I was marked "for duty" a good bit on the early side, and thus got back to the old "home" at the Special Works Park. They were awfully good to me here – put me on a light job here, and when after a day or so the lumbago etc. returned, allowed me to just mope abut the works as I liked although I had to depend on a couple of sticks and could not dress myself – had to have boots, puttees etc put on or taken off for me – but I preferred this to being in hospital with different folk I did not know. When really fit enough to "pull my weight" in the factory – I resumed the job of ganger over the French girls painting canvasses.

The paint was an odd sort of mixture made of glue, colour and other ingredients to stand rough usage, and so at the Park we had a long shed with a furnace kept going to boil the gluey water. Two of the girls under my care were at the large tank to have their pails filled – when through some mishap one of them got scalded rather badly about the legs – there was a fine "to-do" abut this, and she was sent home in a conveyance (about 2 miles out). This happened first thing in the morning – and so at night when we "knocked off" I made a point of walking out to the farm where she lived to enquire about her and show a bit of sympathy. I got lost somehow

looking for the blessed farm – all the roads and farms looked alike to me here – so I returned to have another try two days after. I found the place and she was well enough to toddle around, make me welcome with coffee and slices of fat dripping. Now the joke began because her "fianca" – a big burly English Artillery Sergeant stalked in as if the show belonged to him, gave us both, and her sister an ugly scowl and slumped down on a chair in the corner. Now I, working so much with these girls, could hold my own wonderfully with their language – which was a sort of tongue equivalent to French – as cockney is to English. Well we jabbered away – and as we mutually "rumbled", the Sergeant was furiously jealous of me and thought me "the hated rival". We "pulled his leg" pretty severely – he was a rough cove and could not understand a word of our gossip. After a bit he got really fierce and invited me outside, a request I readily accepted – with a brave, brave smile, hiding a wobbly heart.

To my amazement he did not take his coat off and "put 'em up" – but made a bargain with me. That "if I'd clear off – and leave his little bit of skirt alone and not spoil his latest love affair" – he'd give me a brand new pair of riding breeches and puttees next day when he could meet me at AIRE. This tickled me greatly – but I did not "let on" I had not been serious – so I went back and he was true to his word – they were the nicest corduroys I'd seen for many a long day. We spent an hour together swapping yarns and "having one" – I Grenadines and he as much

"kick" as he could stand – then we parted, the best of Pals.

After about a month at AIRE, the Allies were clamouring for my presence up the trenches again, so up I went to just pacify everybody.

This trip was to ARRAS and resolved itself into something of a sketching tour – for the use of the engineering section of the Special Works Park.

*Bearer of this pass Sapper Smith employed as Artist at the 1st Army Camouflage Factory has permission to make drawings in Arras and district –*

*A. P. Str{...}*
*Capt.*
*O.C. 1st Army Camouflage Fact{...}*

FIRST ARMY
CAMOUFLAGE
FACTORY.

No. 207323
Date 1/11/16

One's special job would be to go to a stipulated section of the front line trenches – and by means of a carefully drawn map find the exact spot indicated where an observation post or listening post was needed (always as close as possible of course to the enemy). In this case it was a tree – as over the page – which was standing among the Hun's barbed wire. I would make a careful sketch showing all necessary detail – which when

COMMUNICATE WITH GENERAL TUDOR. R.A.

SITUATION: U. 21. b. 2½. 2½. (S.28)

DESCRIPTION:-

Stump of an Oak - 11' high - 2'2" diameter.
Approach through Plug Street Wood.
Trench railway near. Ground broken and boggy.
About 20 feet behind front line trench.
It is proposed to increase the height of the tree by
3' as it is important to obtain good observation - and
increase the height of the front line parapet accordingly.
latter to be done by occupants.

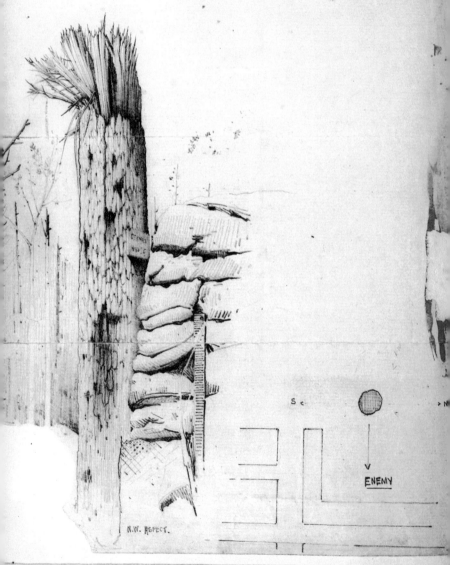

N.W. ASPECT.

S <

> N

ENEMY

completed would be sent down the line, to the workshops, where they would proceed to make a facsimile tree in iron and steel – hollow, with a ladder running up the centre to the top; this would then be painted in natural colours and afterwards dispatched to its destination, the spot where the natural twin tree stood. Now would commence a job of much daring, danger and need for caution – the old tree would be brought down – the new steel one takes it place – all in the darkness of one night, praying Jerry will not "tumble" to the game, and if all went well the next a man would be able to go through the short tunnel the miners had made previously, climb up the ladder and sit among the tangled branches up at the top, seeing much, hearing plenty and coming in at night full of information. All unaware to the enemy, and often much to their disadvantage. A very clever contrivance of some useful brain in the Army – but I bet he'd have thought twice about "putting it over" if he'd had to do the conjuring trick up on the position. I've been on one of these dos – out in "no man's land" with Very lights hanging up above – and the tap of a hammer sounds like a whole foundry at work. Tho' I must add the artillery were usually put wise to the performance and drowned the scene shifters' efforts as much and noisily as possible.

I was fairly quickly back at AIRE this time and had a nice week's respite from the din and clatter of

THE 'INNOCENT'
LOOKING
LISTENING
OBSERVATION
TREE

guns. Two of my very good chums had been "called in" from some stunt up the line – and arrived at the same time as myself – so we went out and had a good busting feed of eggs and chips, also had our "likeness took". Although we were not in the habit of talking much "shop" – we found we'd each had a pretty stiff innings up yonder, very scanty food and little sleep, with real danger as our shadow all the time – and so it probably accounts for the weary, grubby look we wear here.

THREE MODERN MUSKETEERS

The lads had a saying in the infantry – "once in the line – always in the line", and it seemed very true in the camouflage section. A large number had never been up to the trenches ever, and they continued to dodge it to-date – whilst several of us "old campaigners" were picked on every occasion as "being the men for the job" – complimentary, yes – but we were not out for bouquets, but something more substantial, as good beds and grub.

Anyway "C'est la guerre" – I found myself pushed off again very soon up to Wormhoote – a little camp (really a camouflage dump) composed of a few engineers who lived in bell-tents – from which they made trips to various places round YPRES – POPERINGE and VLAMERTYNGHE. I had a wonderful journey on the way here, on a lorry loaded high with raffia- wired camouflage – sprawled out like a kipper right up on top. As we passed over Mount CASSEL there spread before us the loveliest panorama I could imagine – the day was extra good for visibility – and I felt like apologising to France for the hard things I so far thought of the country's landscape.

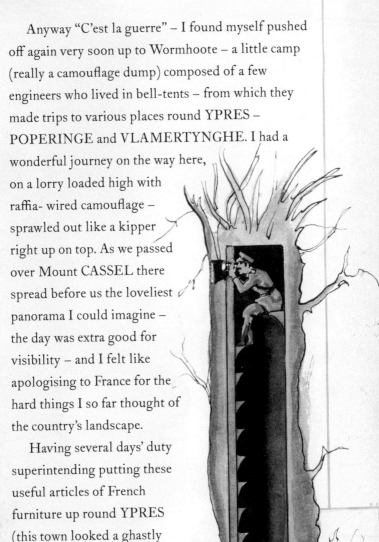

Having several days' duty superintending putting these useful articles of French furniture up round YPRES (this town looked a ghastly specimen by moonlight as we passed) I was granted my turn of two days' rest.

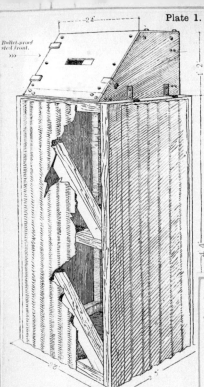

Plate 1.

Bullet-proof steel front. >>>

The Oliver O.P. and Cabin, shewing steel from without camouflage.

24        (Can be taken to pieces for transport.)

Plate 4.

Portable Beehive O.P., unarmoured.
(Weight about 10 lbs.)
Shewing "brick" Camouflage. Any surroundings can be similarly imitated

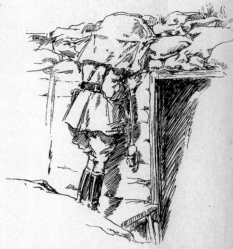

Portable Beehive O.P. in use.        27

Wanting a change badly – and several things from the Art stationer's shop at AIRE I thought the best way round it would be to beg leave to go to the dental hospital there. This was granted and I went back with one of the returning empty lorries – promising my officer to make a special point of catching the next lorry back to WORMHOOTE.

The AIRE dental bloke soon "yanked one out" and I gladly parted with this tooth *that never ached* just for the lovely long country ride that I'd had in exchange. I found a lorry was leaving for the camp in an hour's time, so got my wanted materials quickly and popped round to the old monastery to see my pals. Time slipped by so quickly that when I footed it post haste round to the square to jump the lorry, the blessed thing had vanished. I wandered about, a bit undecided – and then eventually went back to the works to report myself and the circumstances to the Sergeant Major. To my great surprise when I stepped into the yard all the boys were lined up (most unusual) and the whole party of "chinks" mustered in another group.

I tried to get my trouble off my chest – but was not given a hearing, just told to fall in with the rest and marched down to the canal-side, to participate in a real general "wind-up" – there were wild rumours of "Jerry having broken through and advancing" etc

and for some reason known only to the higher authorities
we had to work like slaves for ten or twelve hours
loading up barges with kegs of paint etc. This
job was no joke or child's play—! I came perilously
near, several times, slipping off the narrow plank
from bank to barge,—and then treading the thin edge
along the barge so the heavy kegs of white lead could be
shot into the hold. all by the light of hurricane lamps,
We were provided a little diversion, while on the job— one
of the chinese was either shoved by another celestial or
tripped up— anyway he took a "header" into the water - his
pals set up a fearful chanting and howling - but did
nothing useful—whereas a Sapper corporal grabbed a
long boat hook and soon landed the spluttering Chinee.
spitting and coughing, trying to say "Eenglisherla
no bloodygooderla"— An expression they were always
using when upset— but knew not the meaning thereof.

    ❖    ❖    ❖    ❖    ❖    ❖

    About eight o'clock next morning - very tired and
hungry we were taken back to billets for breakfast. a
tempting? meal of <u>mustard pickles and bread with cold tea</u>,
just as this was settling down, we were pulled up again
and taken down to the railway siding to load a convoy
of lorries with coal from the trucks! this took practically
a whole day, and just about when my back
was breaking—! I with two others was called off the job
and told to report at the orderly room for instructions.

and prepare to go up the line in the morning. It took a dickens of a time to get clean again – the coal dust seemed to get everywhere, and we had to beg an entire change of underwear.

In the old recruiting days of 1914, one thought "overseas" meant a continual darting about with a bayonet or capturing enemy machine guns single handed, and would have been very disillusioned to have seen us now, as a coaling party – more like a bunch of niggers, "sighing for our coal black mammies".

On this next trip which entailed various camouflage duties, we had to visit several of our old haunts – and on one occasion ran up against the dear ole "Seventh Londons". I found one or two old mates, when we nearly wrung each other's hands off, and then I heard to my sorrow only two of the fine set of snipers I knew were alive and well – the rest had been shot on the job, succumbed to wounds, or fallen very sick.

I, with my two comrades, did a spot of work near ABLAIN-SAINT-NAZAIRE, and so Leonard had had a quick shot at sketching the old church – or rather the bit left. From here got fresh instructions from "Signals" and drifted along to

ARRAS – billeted in a cellar under a demolished brewery, on the outskirts of the town – a part known as St. NICHOLAS.

We had a fortnight's jolly hard grind – painting or marking out umpteen guns – a messy business because they were in constant action. Our instructions were to work with all speed – in readiness for a proposed big drive – when it was to be hoped the guns would leave all their present positions and be kept moving forward in the open – hence the rush to camouflage them.

We shared our dug-out cellar with half a dozen gunners whose howitzer was in the brewery yard – and coming back one evening soaked through, statues of mud, and coldly hungry we were mighty thankful to find a stove had been "won" in our absence – and that, having tins of pork and beans for a meal, we could hot them up. We proceeded to make a real red hot fire in the antiquated stove – a long high affair (with no chimney – the smoke effects can be imagined), and then some bright "Erb" put a couple of pork and bean tins in the top – to get hot – but the silly ass forgot to pierce them. Consequently, while the nine of us were huddled up close, to get every scrap of warmth, we were suddenly bowled over with a terrific explosion – thinking it was a shell – I was staggered to see one man's face smothered in boiling beans and two others with nasty gashes, bleeding profusely. The scalded man was in a very bad

way and had to be led out to the
dressing station – as were also the other casualties.

The rest of the stay at ARRAS and district was pretty
hectic – "Jerry" seemed to have a vile wind up – and was
searching for our guns that were worrying him, night
and day unceasingly. I had a particularly narrow shave
from a real big devil of a shell that landed plomp in
"barbed wire square" as I was passing – and I must
admit I ran like blazes to get out of the next one's
reach, instead of which I came to perilously near
getting a packet as I hurried through ARRAS Station,
when a whole side of the partly demolished booking
office came tumbling down – a brick gave me a nasty
painful shoulder and my mate got a snick out of his ear
with shell splinter, but on the whole we were mighty
lucky to get away with as little harm, and just lungs
choked with dust.

We especially felt luck was with us when we passed
a convoy of transport that had been splayed all over the
road in a ghastly mess – one poor horse quite decapitated
– and the hole where the shell landed looked big enough
to take a couple of motor buses comfortably.

The only consolation in big shells landing is
that whoever gets in the way of them knows precious
little about it at the time or ever afterwards – and
that thus a man may be literally in pieces to look at
(and I've seen plenty) his actual death would have been
as painless as a neat sniper's bullet in the brain.

ARRAS Station always intrigued me when I passed through it – thousands of railway tickets spread around everywhere, bits of engines and coaches on the permanent way, looking sad and sorry as after a big railway smash, and the lines themselves twisted into most grotesque characters. I always sort of pictured *past* crowds of holiday makers or train loads of business men and girls – chatting and laughing, full of hopes and fears, or of the fussy French booking clerks, and sloppy porters that had lived and moved here – and now what a picture of hopeless, foolish desolation.

My job was anything but "cushy" these days – in fact a wretched sort of existence; to write about it, would be completely drab and unentertaining, but to live it, infinitely more so. Still even thus I was thankful not to still be with the "P.B.I."

ARRAS. — La Grande Place. - LL.

935. La Grande Guerre 1914-15-16
Dans les ruines de l'Église de

The time came when the particular job of work was through here, and so I was detailed to return and report to the Special Works Park again at the old homestead – AIRE.

It took a jolly long time to get back, by merely scrounging umpteen lifts on passing lorries. Usually I'd wait for one to come up specially to fetch all my

clobber and myself – but on this occasion the need did not arise as the whole issue (paints, brushes, cans etc) had been hopelessly buried in a recent early morning Hun strafe.

When I did eventually arrive, and find my little wooden bed ready – and a good hot meal going, I could have cried with joy.

Needless to say, I appreciated getting back immensely this time, as the evenings were drawing in and nights getting beastly cold – the thought of indulging in two or three blankets seemed almost too good to be true.

It was lovely, after pottering round up at the front, with all its attendant dangers and severe discomforts to once again sit and croon round the jolly old coke stove, yarning with the lads and having the certainty of regular, adequate meals – waking each morning to a settled, definite day's programme and almost sure of a free evening to write letters, draw or visit friends, according to inclination.

The greatest trial I found on the various stunts that took me up yonder on solo jobs, was the fact of not getting any letters or newspapers from home for weeks at a time – due to my constant changing address. Of course it was very wonderful when I did return to headquarters to find a huge batch of letters, cards, and papers – and oftimes a good bumping parcel. On this particular come back, I was amazed to find a huge TATE sugar box waiting my arrival, chock-full of the very best –

tinned fruit, meats, pastes, biscuits, sweets etc. etc.
together with candles socks and various wearing
apparel. Also enclosed, a very sweet letter from my
WIMEREUX friends, Madames Lorenza and
Douchy. I was almost overcome with gratitude,
and together with all the boys, proceeded to
celebrate the wanderer's return. I had more mates
than I'd ever suspected this night. We lit all the
candles they'd sent, and kept them going, till gutted
out, while we jawed, sang, and generally fooled
about. I kept them up long past bedtime, but had
plenty of gift fags with which to bribe the sergeant,
even tho' they were only French "stinkers".

I was able to settle down now
for several weeks – and had quite
a big gang of girls to boss on
canvas painting – but fortunately
not in the open this time amongst
the mud and rain, but on the large
ground floor of the monastery.

We had a jolly fine officer
attached to us by now, an Irish
Major, and he happened to see
some sketches of mine go through
the post that rather interested
him. The upshot being, that I was
commissioned to undertake quite
an "arty" job for him.

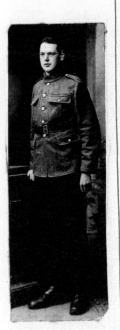

He'd written a long rigmarole Irish poem that he wanted written out in fine Celtic characters – with richly embellished borders. It covered over thirty pages when completed and was mostly done with a quill pen on parchment (all quite in keeping with the monastic surroundings I thought, but wondered if the old monks would have wept to have seen me at their game – dressed in khaki – working with a candle on a Tate sugar box). Anyway the ole Major was awfully bucked with the booklet – and paid quite liberally for it. But the best part of the business as far as I was concerned, was the fact that it brought me in contact with some more good French people, by name of LEQUIN, who kept the only art stationer's shop I'd seen outside WIMEREUX. I commenced to procure my parchment and Art materials here and they treated me wonderfully well. Quite an important sort of business I should think they had in normal times – printing and bookbinding as well as the shop. On Sunday I went to get some ink and colour and to my surprise was invited to come back in the afternoon to tea. I went and had a most enjoyable time. There were several nice French people present including two French officers on leave. Oh it was a treat to have a civvie tea for a change, and this happily was the prelude to many more pleasant meals.

Madame Lequin, a very stately person, could play the piano beautifully, and Monsieur Lequin was a very fine old gentleman – with white, long snowy hair, and all the appearance of a typical Professor.

He treated me with great hospitality, and when I did a couple of decent showcards for his windows ("Freeman's") his pleasure knew no bounds.

ALWAYS WORE THIS SMOKING CAP

I happened to be here one night – stopping later than I should have done – when we were suddenly plunged into a very sticky air raid; the piano had been going, with a crowd of Frenchies singing, so we'd not heard the warning drone of the engines. And thus were unaware of our visitors till the first bomb dropped. It caught the shop two or three doors away with a nasty packet, the top storey was all sprawled over the pavement and road, and they were just moving two old people who'd been killed outright in the fall when we bundled out into the street to look round. I'd got to the front door when Lequin's servant girl barged full pelt into me with a huge bundle of belongings, she was in hysterics and went off helter-skelter down the street, screaming blue murder.

The Hun birds, flying up above, laid many "eggs" this night, and I instead of going back to the billet, decided to stick by my friends. After the first panic, they cooled down and proceeded to make tea, just as folk did in England on similar occasions as I noticed on leave. The "Old Dad" insisted on us making ourselves comfortable in his stock room, a kind of very tidy cellar below ground, while the big strafe was on, which quietly rather amused me, because if I'd been round the corner in the billet –

we should probably have been unconcernedly playing "Solo", unless "standing by" for orders ready to hop about on fire picket if need arose.

The next day – whilst standing at the gate of the "Park" – in charge of a gang of "chinks" loading lorries and camouflage stuff, I saw pass on the other side of the road, a wretched looking old hag – being bundled and hustled along by a whole crowd of Frenchies, mostly shouting women. And was told in answer to my curious enquiry that she was accused of signalling to the Hun airmen of the previous night's entertainment – with a lighted candle and looking-glass up at an attic window; whether true or not I don't know – but she certainly seemed to be sickening for a very nasty half an hour with the town authorities or at least the mob at her heels.

We had now got to November 1918 and all the Special Works Parks people were working night and day to cope with the heavy requirements of the line, they seemed to be hitting up for something big up yonder and were evidently working overtime like us, as far as we could gather from the constant, unceasing boom of gun fire.

And we were staggered at all the signs of marked and increased activity all around.

For months there had been rumours of a tremendous Allies big drive, which we merely treated

as rumours from the place all old soldiers recognise as the hatching ground thereof. But this time evidently the rumours were founded on fact and had not been given birth there. For day by day were seen big-guns dragged by traction-engines, and little spit-fires galloping along merrily – all towards Jerry, together with columns of Infantry constantly passing through the town in the one direction – forward.

On November 2nd – I was picked with a small party to leave AIRE that evening – and proceed to LILLE. So after packing my kit and getting quite ready to move off at a moment's notice, I made a dash round to my friends Lequins, to bid them farewell, and directly I mentioned my destination as LILLE there was wild excitement.

It appeared Madame Lequin's brother had been Head Surgeon at Lille University Hospital until it came under German rule, and she had not heard or seen anything of him since, so was uncertain whether he was alive and well – or dead. Consequently I was regarded as a great messenger to take a letter with me and endeavour to find him.

I of course gladly accepted the mission, and had to wait while the momentous epistle was written – then with many a handshake, wishes of "Bon Voyage" and a positive load of food for the journey, I bade them goodbye. Getting back to the billet just

in time to jump on the lorry and away. We did not proceed very far on our journey – but stopped and put up for the night with some engineers. I was glad because we started off before dawn next morning and we were able to see the places as we passed along. It was a trip of some sixty odd miles and awfully interesting to pass the fields of blood and battle for the last four years. And horrible to witness the miles and miles of churned up ground – and battered villages that no amount of clever writing could adequately describe in its wretchedness. We passed through tracts of country only recently vacated by the retreating Hun and were able to see on every hand the dreadful destruction our own shells, and airmen's stunts, had wrought in enemy territory – and we felt with a certain amount of quantified pleasure that Jerry had shared our terrors and discomforts.

We arrived in LILLE about $\frac{1}{2}$ an hour before the triumphal entry of the 47th Division ("my old mob") and wilder scenes of joy and excitement could never be imagined. Up till an hour before, the Germans had been in complete command of this big town and of everything therein, including men, women and children, and we were the first British troops that had been within many miles since 1914. We were everywhere acclaimed the great deliverers and it became absolutely embarrassing and at times even tiresome to be hugged and kissed by countless

crowds of civilians of all types. French boys and girls begged leave to carry our packs and rifles – and loaded us with strange useless presents. I had by now got mixed up with some of my old "Seventh" pals and we were all practically stripped of buttons, badges and any moveable thing in the least worthy to be reckoned a souvenir.

They were only too anxious to tell us about the wretched, bullying Huns who'd made them suffer intolerably during his four years' sojourn here. Even the rich people of the city (like a small London) showed and spoke of many instances of privation, cruelty and hunger. Although we were so well received they could offer us nothing at all in the way of food – and in fact begged our rations from us. Even when we were pressed to go into some home to see some poor sufferer of the German regime they could only thrust coffee on us – without milk or sugar. This first day we learnt that a loaf cost the equivalent of English money amounting to 5/6, a candle 2/– and a box of matches 7$\frac{1}{2}$d.

They'd all had to be indoors before dusk every evening – and locked up till the morning, anybody found out after this was locked in the cell of the fort jail. We saw many awful emaciated folk, and very few grown men (they'd been commandeered for hard work in the German lines), those men we did see – looked not fit or strong enough for anything on earth.

One boy showed me the stump of his arm that had been mutilated in the early part of the occupation through some form of alleged insolence to a German officer. In another home the poor old dame took me to the bedside of a living skeleton of a young girl who was a hopeless invalid through harsh treatment as punishment for hiding her fiancé from the Huns in 1914.

To realise what real deadly hate can possess a human soul, one had only to hear a poor French woman talk about the Germans and the life that had been forced on the civvies. Many times one's blood absolutely boiled, to visualise the years of agony and suppression.

LILLE was a fortress town we noticed as we came in, with very high banks like a huge reservoir wall running all round – with gates in and out of the city. Think of alert German sentries on guard at each porte, and it can be seen how hopeless to get any news, letters or the least touch with the world outside. We learnt too how terrible were the English air raids and how panic stricken were the "Jerries".

Going down one side street I saw rather a horrible row – a motley crowd of Frenchies were almost tearing three French girls to pieces – their faces were bleeding and their clothes practically torn off. And I found the cause to be righteous indignation on the part of the crowd – who accused the girls of consorting with the

German officers while they been living there. Most of these girls were "marked" and had a pretty rough time of it, now the tables had turned.

In the windows of shops and private houses now were placed placards on which were written in crude English – "horay Galant delivers", "Bon fête 47th DEVISION" etc etc.

I got in with a party of six camouflage boys and, down the main street where the "Bond Street" shops were, we could hardly walk ten paces without being invited in for "a leetle somesing". I stuck to the black coffee – but almost had enough of this to make me "dippy". My pals who were not so squeamish on this little matter had enough wine to last them many a day – the wine and spirit must have been awfully well hidden all this time to have so evaded the German prying eyes.

We had been put in a billet that was part of a large tobacco factory, and had been allowed to wander about where we liked till dusk – and I was mighty glad I'd been content with a bellyful of coffee instead of anything stronger (tho' I doubt if anything on earth could be) because when we'd done a spot of work lasting till nine o'clock I was able to get a pass from my officer allowing me out again on the special errand of finding the Rue SOLFERINO where it was hoped by Madame Lequin I should still find her brother Docteur Chardon.

After sundry enquiries I found the house –
a large one standing in an important street. All was
in darkness and I rang the bell. And after a bit the door
was slightly opened, and a girly voice timidly asked,
"qui va là". I hurriedly explained that I was the bearer
of a letter for Docteur Chardon from Madame Lequin
of AIRE and at this the door was flung wide open,
lights were lit and this girl of 17 was in her nightdress
– flinging her arms round my neck, kissing me and
crying at the same time. The doctor, her mother and
two servants had evidently just tumbled out of bed
and crowded round while the wonderful letter was
read aloud to them, between tears of joy and relief. It
was the most touching scene imaginable – to witness
these good folk who'd been so long starved of news –
now feasting on every word. I could only get away and
back to my billet, by promising faithfully to call next
day as early as I could possibly get leave.

From this time I had an open invitation to their
home, and had some very enjoyable evenings and a
Sunday or two – the girl Gaby could play the piano
wonderfully well, and they delighted to try and
teach me French songs – I was certainly not a very
apt pupil, but caused a good deal of amusement.

Gaby was a pretty girl, and when she with her
mother and father took me to the museum, the
Park etc – I was the target for many envious looks
from all the British troops we passed.

GABY

The Camouflage works were soon in full swing
in LILLE, carried on in an old tobacco factory.
As soon as the news got round – that well paid work
could be found with the British Army – we were
literally mobbed with applications from all classes of
French girls. Two hundred were started – and we few
sappers had our hands full, teaching them the various
stunts. Then we soon had a staff going practically
night and day.

My own special job at this time was the repainting
of French Street names on boards to replace the
several hundreds the Germans had put up in their
own language. I was quite "best boy" with the French
people for doing this work as they had writhed to see
these enemy signs everywhere in their beloved town.
(They were very nicely done in Black Letter type.)

It was inspiring tho' pathetic to see the efforts
these people of LILLE were making to remove all
evidence of Fritz ever having been there.

They were trying to get the trains starting to
run again through the town, and were working day
and night shift on the railway (with British help)
to remedy the havoc Jerry had wrought before
decamping. The Germans had deliberately blown up
all the permanent way – rolling stock and station –
also they "pinched" everything in the way of metal
that could possibly be removed – door handles,
knockers etc. etc. They'd put up a huge monument

in the cemetery – made of stone and cement, that the
French swore to blow up with dynamite. And a
wonderful theatre the French had started on at the
outbreak of war – or rather just before – the Huns
had completed in their own fashion, making a fine job
of it, and proving they certainly expected to retain
possession of LILLE for all time.

Nov 4th 1918 – One evening six of us sappers got
permission to have a late pass – enabling us to go to a
very special concert, being held at the big theatre.
We got there in pretty good time – but were awfully
disappointed to see "House full" notices outside.
It seemed years since we'd seen a decent show and we
tried all means in our power to get in, but failed.
Coming dejectedly down the broad stone steps in
front, I collided with a Sergeant Major who cursed –
then looking hard at me smiled, and at the same
moment recognition was mutual. He had been a fellow
artist with me in a London studio before the war.
Saying "can't you get in"; I explained the situation,
and he then told me "he was running the show, and
would soon fix me and my pals up with seats". He
thereupon took us round the rear of the theatre then
through a little door – eventually finding us a seat
each among the Officers and Nurses up in front –
we had a great time.

# The 11th NOVEMBER 1918 came

in like any other day. Little did we dream on waking up at six o'clock - that this would be the day of days - that before dusk we should see the reign of uncertainty - terror and destruction finished.

So all unwittingly we went to our various jobs at seven o'clock, working hard and preparing stuff that would never be needed, thank God.

At eleven o'clock the momentous wire came through from "signals" and was read out in English - then French to everybody in the works, the ensueing scenes of gladness and intense excitement I hope never to forget. The sorrows of the past years almost seemed to be wiped out in one great shout.

Of course our job finished on the stroke automatically, tho' it sort of took some time before it properly dawned on us. Our officers were great sports and quickly arranged a proper break-up "do" for six o'clock that night - inviting all the French girls who'd been in our employ.

They were very tickled - and went their several ways to rejoice with their own folk - while we Sappers but our backs into the job of getting things ready. We made quite a "posh" ball room of one floor of the tobacco factory, with canvas - white men (used for gun blast disguise) etc. And then turned our attention to make a huge affair for two hundred girls and

VICTORY

sixteen sappers to sit down for "eats". Of course the Officers were with us, but they planned rather to keep the ball rolling by helping and waiting – they could not possibly have been more decent and willing to make the celebration a success.

A great success it was – worthy of the day; each man was hopelessly outnumbered by girls – so had the choice of umpteen dancing partners. There was plenty of food – to which the underfed Frenchies did full justice. Where it had come from I couldn't guess – because we ourselves had had precious little of late.

Being still in the Army we had to keep to rules, so our boisterous, rollicking affair came to a close at nine o'clock. We then formed a huge party and went shouting and frolicking around the town.

Now throughout all the war days I'd been a teetotaller and had even passed the rum jar by on the coldest nights in the line. But tonight the 11th was different to all somehow and I simply couldn't refuse the innumerable liquors and strangely named drinks that were thrust on us by the excited populace.

Suffice to say that I woke next morning with a dark brown head ache and bruised all over – the bruises I couldn't account for until I sought this information – which I got.

Our billet here was a sort of double decked affair. The Sergeant Major, Sergeant, two Corporals and three or four Sappers on the ground floor – and the rest of us up aloft which was reached by a long shaky ladder. To avoid negotiating this at night two huge buckets were placed beside the top of the ladder, for a certain purpose. And it seems this night I came in very late and alone, when the others were all asleep, or at least till I trod on one or two. I reached the top of the ladder alright, but happening to touch one of the buckets – I with a silly laugh gave them both a hefty kick, sending their full contents down below. Well, hang it all it must seem a bit thick – to be dreaming peacefully that the war is over, then suddenly be aroused by a young Niagara, a nasty wet shirt and a dripping blanket. I certainly deserved a good hiding and by all accounts got it, for they rose like one man, and went for me with fists and belts – fortunately I knew little of this, save the bruises afterwards.

Of course, now Armistice had come, we all expected to pack our kits and be on the homeward journey very, very soon, but alas we were all sadly disillusioned. There was the "skivvies'" work yet to do – washing up and clearing away, and this took weeks. Which was very trying to our impatient spirits.

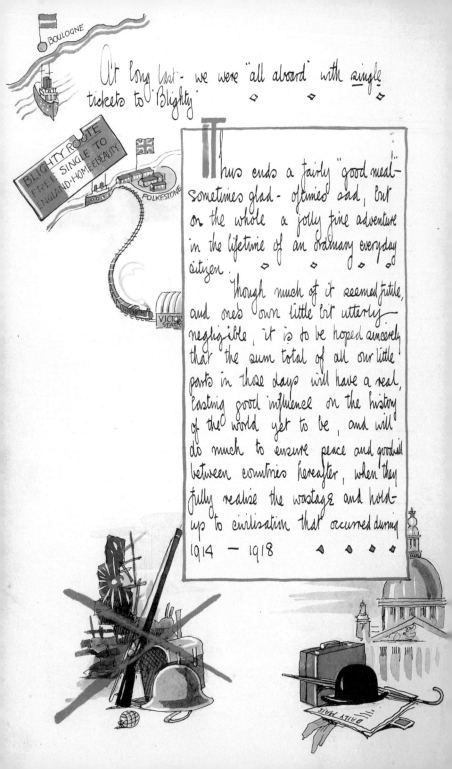

BOULOGNE

At long last - we were "all aboard" with single tickets to Blighty.

BLIGHTY ROUTE
FREE SINGLE TO
ENGLAND·HOME·&·BEAUTY

FOLKESTONE

VICTORIA STATION

Thus ends a fairly "good meal" - sometimes glad - oftimes sad, but on the whole a jolly fine adventure in the lifetime of an ordinary everyday citizen.

Though much of it seemed futile, and one's own little bit utterly negligible, it is to be hoped sincerely that the sum total of all our little parts in those days will have a real, lasting good influence on the history of the world yet to be, and will do much to ensure peace and goodwill between countries hereafter, when they fully realise the wastage and hold-up to civilisation that occurred during 1914 — 1918

DAILY MAIL

8235

CERTIFICATE of° { Discharge Transfer to Reserve Disembodiment Demobilization } on Demobilization.

Army Form Z. 21.

Regtl. No. 204323  Rank Sapper

Names in full Smith arthur Leonard
(Surname first)

Unit and Regiment or Corps from which { Discharged Transferred to Reserve } 1st Army H.Q. R.E.

Enlisted on the 14th September 1914

For London Regiment
(Here state Regiment or Corps to which first appointed)

Also served in Royal Engineers

Only Regiments or Corps in which the Soldier served since August 4th, 1914, are to be stated. If inapplicable, this space is to be ruled through in ink and initialled.

authorized prior to 11/11/18

†Medals and Decorations awarded during present engagement     nil

*Has Has not served Overseas on Active Service.

Place of Rejoining in case of emergency } Chatham    Medical Category A1

Specialist Military qualifications } Painter    Year of birth 1891

He is* { Discharged Transferred to Army Reserve Disembodied Demobilized } on 29. 1. 1919
in consequence of Demobilization.

R.N. Smith
Signature and Rank.

Officer i/c R.E. Records. Chatham (Place).

* Strike out whichever is inapplicable.   † The word "Nil" to be inserted when necessary.

(20996). Wt. W 8211—P.P. 2329. 3,000m. 1/19. D & S.  (E 1256.)

PEACE CELEBRATION TEAS AND PARTIES
HELD IN THE STREETS EVERYWHERE

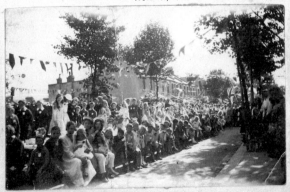

IN MY HOMETOWN
WALTHAMSTOW ESSEX

# APPENDIX
## Letters from Len Smith
## to his family

The following letters were sent home by Len to his parents and brothers, and subsequently laboriously copied into a journal by Len's father as a keepsake. Unfortunately the original letters do not survive and some letters were missing sections or missing altogether from the journal. Also, Len's letters to his wife Jessie do not seem to have survived.

A selection (almost half) have been reproduced below. They span the period from Len's training until October 1916 when he was recovering from trench fever at the 32nd Stationary Hospital in Boulogne. The letters provide an excellent contrast to and expansion of Len's world as seen in the diary.

Text has been kept as written, apart from obvious errors in place names. Dates and locations were not always included with each letter.

7th City of London Batt.
Camp Hill Camp
Crowborough, Sussex

Dear Mum, Dad, Sid & Nibby

This is a lovely place to be encamped about 700 feet above sea level. There are from six to seven thousand of us. It blows a bit cold at night in the tents for they are all pitched on top of the highest hill. They say we shall only be here a little time and then going to be billeted in houses at Tunbridge Wells or Folkestone. We shall not be allowed much freedom, in fact we are always kept within a 200 yards boundary.

I wanted to write you a long letter but there seems such a lot to do, and the fellows are so jolly that it's difficult to give much attention. There's plenty of food but not luxury. I shall be cured of many faddy ways. Fat bacon, bread and jam, lumps of bully beef, tea with no milk and such like, but you'll be surprised to know I've eaten up all they've given me and absolutely enjoyed it. My tent companions are grand chaps and I can see some fun in future.

Bugles call us every five minutes or so, so cannot write much, in fact I just want to send this to let you know I'm alright and hope to write more fully soon.

If you've got some spare cakes or that sort of small luxuries I'd appreciate them very much.

Yours lovingly

Len

17 Yarmouth Road
Watford Nov. 16 1914

Dear Mum & Dad,

Just a word or so to tell you that my Sunday spent with Aunt and Uncle was a complete success, and that they want me to go again as often as possible. They live a good half-an-hour's walk away.

I assure you that I'm making a bee-line there on Wednesday evening as Aunt has promised me another box of foodstuff and further it's early closing day for Uncle.

They were both very kind to Jessie and did all they could to make us happy. I can promise you a good time when you both can come.

I've had a busy day and feel nearly ready for bye-bye. We had as near the real thing as possible this morning in skirmishing and fighting with the whole battalion, the two Maxim guns and ammunition waggons, ponies and every man racing about over all sorts of ground; rushing through all thick hedges, falling flat on wet muddy ground, or strong ploughed fields, and doing a hundred and one things that would have killed me at one time (not so long ago) and yet I now delight in, and it's astonishing how well and jolly we all are, and how free from colds.

We got back and had our dinner at five o'clock and then all turned out for our final medical exam. Jack and I got through easily and so are quite fit for further business.

It pleases me to get any letters from home, and am longing to get Mum's.

Yours lovingly

Len

17 Fairfield Road
Braintree Essex
Dec. 3, 1914

Dear Sid,

Your letter was a very glad and welcome surprise. My word! dear boy I did not even dream that you were such a really brilliant scribe. I hope to hear from you again I assure you. You must have thought me somewhat ungrateful not having answered earlier, but I really have not been able to write much recently owing to circs.

You will see that I am getting about and really having a fine experience, and although sometimes very trying I should not like to miss any part of this big game, especially as I am sure we're on the winning side.

We all had to parade at 6.30 on Monday morning in the dark and it was pouring with rain, so you can guess your humble private felt a bit Mondayfied.

We then marched to St. Albans and after some long delay entrained for Braintree and arrived at the mouldy show about three o'clock in the afternoon. We then were sorted out into billets, and I have got

with four other chaps into a common sort of house, not altogether my style or to be compared to the Watford digs, but seeing that we are only here for a brief while we can jog along on anything almost.

They have us out at seven every morning and beside our usual pack and rifle we now have to carry a pick and shovel each with which we then all struggle to the station. You ought to see us bundle into the train, it don't half sound navvy like, with the language and the clang of the tools.

We have all been strictly forbidden to say anything about the work we do as it's rather an important part of our home defence scheme. Suffice to say that we go by train within ten miles of the sea, then we detrain somewhere on the line, at a very lonely spot not near any railway station, then we proceed by various winding pathways and fields to our ground of working.

We are working with a company of the Royal Engineers making trenches, underground stores, communication trenches, field hospitals and such like. Really it's very interesting, educational and wonderfully thought out; and altogether this work extends for about seven miles and forms the second line of defence.

I have been engaged on making trenches for the firing line and shall be able to tell you more about it all when I get home, but at present am afraid to gossip too much about it all as it is considered a very serious offence.

Our battalion has been highly praised for hard work and we may get finished earlier than expected. We've already dug a mile of trenches six feet deep all along, and they are very comfortable to sit in and eat bread and cheese, in true navvy fashion. I must confess as do the others that it's dreadfully tiring work, and one's back feels like breaking most of the days, but I expect we shall soon get over that, as well as the blistered hands. Anyway we shall all get back some of the muscle and chest that we lost while always sitting cramped up over the desk.

I cannot stop for more dear boy as my time is limited, hardly ever more than an hour free.

Yours lovingly

Len

Very kindest regards to Dolly.

17 Yarmouth Road
Watford 31/1/15

Dear Mum & Dad,

Glad to say the weather has much improved which means a great deal to us chaps living so much in the open air.

I am also pleased to say we've finished all our firing courses at North Mimms. It was such a long tramp every day on top of all the other stuff, and to stand about and freeze in water and mud marking targets, as was my lot the last three, well I cheered as much as any of the others when the last shot was fired.

Friday and Saturday we once again resumed our ordinary skirmishing and field drill, and it seemed quite pleasant, almost a holiday to get back to dinner about four o'clock instead of eight.

We are expecting to go up to Dunstable for a day or two shortly, to go through the regular soldiers last course of field firing, that is, one has to run a couple of hundred yards, fall down, fire away at some moving targets, then get up, run again and finish up in trenches to blaze away just in real style. This is all good experience and keeps one pretty lively you can guess.

Anyway I'm not tired of soldiering yet by a long way. Of course I shall be as relieved and happy as anyone, to once again get back home to you all to stay but till that time comes I've made up my mind to make the best of everything and get all the good I possibly can from the present very healthy life.

Tomorrow is an important day for us, as there is to be an inspection of our division by the King and Kitchener; anyway we've heard these two are coming (on the quiet) and we've had extra special orders to clean equipment and look extra smart, so maybe there's something in it, although nothing definite has been said; probably so that there will not be a big crowd. We must wait and see.

I will write again soon and let you know any news.

I am writing this at Parrotts and they send their love.

Yours ever lovingly

Len

France  March 25 1915

Dear Mum & Dad,

Through some mistake my letter has been delayed and returned to me, so I add a line or two of my further adventures.

Yesterday we marched about ten miles further on from the last billet mentioned and are now stationed in a fine large block of military barracks in a decent sized town.

We have forty men in my particular room. At night we sleep on the floor, and it's a bit crowded as you may guess. The platoon to which I belong is doing duty as inlying picket, which keeps us confined to barracks for twenty-four hours, so we have not been round the town yet. Our job is to be on the alert and quite ready to shift in case of sudden alarm.

We have been told to expect our first taste of being under fire in trenches very shortly.

The post comes up every day, and I long for a letter from you at home.

We keep meeting "regulars" about here, and get many snatches of startling news about the firing line, but otherwise we are all totally ignorant of the progress of the war; in fact you folks know heaps more.

Out writing is too restricted to tell much, still I'll write as often as poss. Sitting on the floor, among a crowd of chaps, joking, singing and playing cards etc is not quite the easiest place eh, what? I'm in perfect health and spirits and earnestly trust you all are.

With very much love,

Your Len

P.S. I wonder if Dad could let me have some writing paper, it's difficult to get out here, in fact I'm borrowing this.

Same address
2 London Division  28/3/15

Dear Mum & Dad,

Still going along first rate and happy to say none the worse for having undergone my first taste of the trenches.

"A" Company to which I belong, after being congratulated by the Colonel for being the first in the battalion to go into action, marched

away from barracks on Friday and made for the firing line. One sees many signs of war long before actually reaching there. Tremendous holes in the road, houses absolutely blown to atoms, barbed wire along either side of the road en route. We had to wait till quite dark before attempting to enter our particular part of the trench.

We been attached to the regulars there, and a very distinguished regiment by the way. They are jolly fine chaps and do anything they can to help one. We were in the very first line of trenches, about 200 yards away from the enemy. There is no actual open fighting, but loopholes made in the trench, and it really means patient waiting and watching through them, then firing directly on seeing any movement in front.

A very interesting sight commenced about seven in the morning, when several aeroplanes circled over the trenches; then the German big guns commenced.

They make a frightful row and their shooting is good; it's breathless sport to watch the shells burst in the air, almost hitting the flying men. They must be wonderfully brave and seem to continue their course quite heedless of the bursting shells which crowd the sky.

Then later in the day we had some experience of the "Jack Johnsons" and "coal boxes". The noise of them is deafening. They flew very high above our heads over to a town in our rear, doing much damage. The worst half-hour occurred about tea-time when our trenches were shelled with shrapnel.

There's nothing can be done but sit tight and watch them burst all around. There's a flash, a tremendous bang and whizz, and then a shower of anything but rain or snow. We were very lucky, only two men slightly hurt, though another had his pack blown off. Lucky chap, less to carry.

We were relieved at dark and got back about eleven last night. They then served us out with stew and rum for those who wanted it, and today we've had a rest, which we much needed, especially as we return to the trenches late tonight.

March 30 1915

Dear Mum & Dad,

Have just received your letters and thank you ever so much for them.

I note with deep regret that obviously my two long letters have not yet reached you. Maybe I have gossiped too much, but there's so much that I know would interest you and it's hard to leave any out. I earnestly trust it is only temporary delay, for I have some most important items to tell you, for to go into action in the first line of trenches, only a couple of hundred yards from the enemy is rather a big step to take.

I wrote at some length about this and was keen on your knowing, so directly you do get the letters let me know and so put me at ease please.

Anyway I only intend this as a brief note to reassure you that I have not forgotten to write home, a picture card too you ought to have.

Should be delighted to hear from Sid as well as Nibby when poss., for it is the kindest thing any of you can do just to send a line or two.

Although biz is very brisk at times I'd rather be on the stage taking part, than in the orchestra stalls as you mention.

We are going up to the trenches tonight again and no doubt I shall soon have plenty more to write about.

Yours with fond love

Len

Monday April 12 1915

Dear Mum & Dad,

I much enjoyed your long letter recently received. You'll be happy to know that at the moment I am billeted some miles away from the firing line. Our battalion has moved here evidently for the purpose of giving us a period of rest after our recent trying experiences up yonder.

I must confess this is very acceptable and to say the least quite free from danger, but we by no means lay in bed and sleep all day. We now spend our time more or less as at Watford; trench digging,

skirmishing and route marching. Of course this will not continue long for we are at any time liable to be called upon.

I am afraid this time I have very little of interest to write upon, but send with the express purpose of letting you know all is well with me. In fact I never felt better in my life, and the weather of the last few days lends colour to the thought that it's all a fine holiday.

Please tell Nibby to buck up and finish that letter he started. I trust I shall soon be able to write of more lively doings, we are not out of the "bush" yet you know. Meanwhile hoping both of you and the dear boys are quite well and gay. I remain

Yours most lovingly

Len

Tuesday April 26 1915

My very dear Mum & Dad,

Have today received a very welcome parcel from you for which I tender many grateful thanks.

My word! I've got a well-stocked larder nowadays for besides your very useful dainties I only yesterday had a large parcel of real good things from Aunt and Uncle Youngs. Honey, sweets, a large sponge cake etc, etc. Jolly kind eh? Then also Aunt Emmie sends from Bicester, Banbury cakes, dough cakes and a number of other luxuries. All such kindly thought making a most acceptable, joyous change from tinned bully beef and biscuits.

In fact I warn you, if good folks continue thus to send, I guess it will be some time before I ever intend turning up the soldier life war or no war. I would specially mention in my dispatches Mum's coconut haystacks, the like of which one cannot buy for love or money out here; also the toffee and supply of notepaper. As for the milk one almost forgot what sort of stuff that was before Nestlé's arrived.

Although I cannot tell you my address at any time, I think it is a new one each letter I write, for we only seem to stay in a billet for three or four days; then suddenly orders demand a shift to some other town. Incidentally we are thus getting a fairly decent survey of the countryside of France. We are at present situated in a really delightful spot. The particular barn wherein I dwell with some forty other "Tommies", is perched on top of a hill from which we can see for miles

around. Jolly fine work. It's amazing what one can endure when the need arises.

We've had virtually no real rest for some fifty hours or so. Up in the trenches on the usual routine one does look-out duty for a certain spell, then another sentry goes on in the section of trench while the previous one rests, but there is so much to be done up this way that during the intervals we had to keep on filling sandbags, carrying them to and fro, and such like hefty work.

After forty-eight hours in the trenches we come back about five hundred yards, billeted in a barn to act as supports to the first line, ready for the immediate service of our lads up yonder should occasion arise.

This we've been on for two days and nights, and so again we go up to the trenches tonight for another spell.

The Germans opposite us here are very lively. We hear them singing and shouting a good deal.

Our duties this last two days have been carrying food and ammunition from the supply stores away back about a mile and a half. From thence we have to carry great boxes of stuff, sacks of coke etc to the firing line. This job is far more dangerous than actual trench occupation, for the enemy do all in their power to cut off the supply, and so one is under fire nearly all the time; even to fetch water is at the risk of our lives.

Of course every hour has some item of special interest that I'd dearly like to relate, but there we must wait till I get home, then you won't get unduly alarmed.

You'd laugh if you saw the "Shiny Seventh" now. Not bright and new looking, but obviously on active service, and looking the real thing. There being no spare water for washing, so no shaves, our hair close cropped, clothes mucked up, the wire taken out of our hats so that they look all wibbly-wobbly. Still it all looks very business like. I cannot stay to write more now but hope to continue soon as poss.

Not had our boots or clothes off for a week.

New address: A. Co. 3rd Platoon
7th Batt. London Regiment
47th (London) Division
14th May 1915

Dear Mum & Dad,

Thanks ever so much for your two letters. I trust you will have received my other by this time, you having only mentioned my card. It worries me a good deal that I cannot write so oft as I wish, but really circs. combine to make this at times quite impossible and always a task beset with obstacles. Have now decided to stop writing elsewhere and concentrate on home and Jess.

I'm afraid, did I set down in detail my experiences during the last eight days, I should at once lose my reputation as a cheerful letter writer for we have indeed been through this spell. Anyway a hint or two may suffice.

Not once during all this time did the slightest chance of a wash or a cat-lick come our way; neither shave, nor were we able to take boots, puttees or clothes off for even an hour or so. Food too was more scarce than is comfortable most days (don't take in the newspaper gas about us being overfed). And just here might I break away and ask you to send me some biscuits or a cake. It would be such a treat after everlasting hard, very hard biscuits, bully beef or stew. The parcel Jessie's good people sent reached me, but sorry to say much spoilt and some missing.

The greatest item of discomfort has been lack of proper sleep, either day or night – only being able to snatch half-an-hour, anywhere at odd times. It's a marvel how many have come through without hurt. The fatigue party alone being a mighty dangerous job for it means traversing a mile and a half of road literally swept by bullets the whole way. Three or four journeys along here each night and day with a really heavy load every time soon gets one hardened to the feeling. When off this important job of supplying our boys in the firing line with necessities we are ourselves in the trenches, where things have been very merry and bright.

On Sunday at the time I once should have been bringing you up a cup of tea, we were in our trenches witnessing "some" bombardment by several hundreds of our guns. It was indeed an experience almost beyond expression. Think of the very worst thunder claps you've

ever heard and multiply it a thousand times; add a splitting head ache and a fearful sick feeling caused by the dense fog of powder all around and there you have some impression. We could see where our shells were landing on the enemy and I can assure you it was not quite such a peaceful scene as the Blenheim Road garden, or so soothing as a stroll round the houses with "Jimmie". We could not hear each other speak and it lasted some five hours without break.

Of course the enemy had a little to say after – when we had to crouch down in dug-outs just hoping for the best, and I quite comfortable in the glad knowledge that I'm a Christian. It means a lot nowadays out here.

Last night we went out at dusk till two this morning to dig near the fireworks and on the way back witnessed a truly magnificent sight, but in one sense an awful one. Several hundred of our big guns began to speak at once. The noise was deafening and the vivid flashes of light and flame through the sky made any lightning I've ever seen look dusty up against it. We could see the red balls of fire whizzing through space to land in the far distance with a fearful crash – nightcaps for Les Allemandes.

We have four howitzers in our back garden. It's fine to watch them fire, but somewhat inclined to disturb one's sleep – very much like receiving rather too frequent slaps on the side of the head.

We were expecting the Germans to try and find our guns by shell fire this morning so we are all hanging about in readiness prepared at any moment to rush into dug-outs (holes deep dug in the earth) when the occasion arises.

I do not think I can spare longer time in writing now but will continue as soon as possible.

Don't worry should delay in mail arise.

Wish I had a chance to see our "Nut". Tell him a line or two would make some soldier happy.

Do you good to see the scramble round the mail bag.

Very happy to know all is well with you. I am in the very best of health.

Yours lovingly

Len

France
Sunday May 22nd 1915

Dear Mum & Dad,

I guess the first thing you want to hear about me is that I'm alright – well I am absolutely top notch.

Went on a working party last night, and on the way back encountered such a storm as words fail me to describe. The lightning so vivid as to stun one at every repeat. We were all groping along as though blind most of the way, and the rain, well absolutely soaking.

Along with the rest of the party, I'm staying in (bed)? this lovely morning with nought but overcoat and the socks on, whilst all else dries out of the window.

Am comforted to know you are really praying and trusting to God to bring me through, believe me many times one is convinced He alone will be able to accomplish this in face of all the perils which beset one's life out here.

This is what makes me so truly happy when I've seen all around me men dying of ghastly wounds, and others in great extremity – just a word of prayer and I, the naturally timid one, have been granted the presence of mind and strength to bandage up and aid in many ways these dear fellows without a hair turning. Don't think me boasting or preaching, but when I've been in the midst of death all around and kept safe then I promised God that I'd not forget.

My word the worst thing that has so far happened in all the time I've been out here concerned me very personally.

I was sitting in the trench looking up at the periscope when suddenly a vivid flash and I was thrown to the ground. When sufficiently clear to look around, such a sight met my eyes I hardly dare describe. Suffice to say that out of the thirteen who had been sleeping or sitting down there, only Jack and I are here enabled to write about it. We at once set to work to do all we could for our dear pals. When all was over you can guess or will appreciate the gratitude we felt at being preserved. It is nothing to speak of, yet I might add, being only two yards away from the other boys, the explosion burnt my neck just a trifle and a splinter of shell bit my leg. I tell you this to point out how near yet how far, to one who believes with all his heart in Psalm 31.

The Seventh is getting quite distinguished, at least we are getting highly praised by high Authority and had the honour of occupying the German trench just captured. This was a highly important four days' job, as you can well understand, for the enemy was somewhat annoyed at having to vacate the place they have held so long (since October). Ah! and they didn't forget to tell us so during this period. We lost many good men from the persistent heavy shell fire. It makes or mars a man for sure to sit in a trench and see portions blown down and things flying about, never knowing where the next is coming. At one period things were "98" in the shade, and two of my comrades seemed to be feeling the effects of the last three days' nerve pulling (give any one jip with sense at all) when I brought out my tonic and read some of the Psalms aloud. My word, to be heard above the guns. It made a wonderful difference, one of the happiest hours we had spent, so we agreed after, and I defy anyone to find me a better remedy to soothe one when danger or distress is imminent.

Last Sunday was the day of rest (?) No, hardly. We had some two miles to traverse under heavy shell fire. The enemy apparently suspected that reinforcements were arriving, for their shells seemed to follow us at every turn. Insomuch that at intervals throughout the journey we saw chaps one by one laying aside, some with most ghastly wounds and heartrending groans.

Our Major was hit during this period. Our way lay over a horrid course with dead horses and others laying about. We had to wade through two ditches up to our waists in mud and water till we eventually reached our destination, rather less in numbers and a wee bit flagged out.

Here we relieved another regiment and occupied our position. There were decided signs on every hand of what the capture had cost and to try and imagine a more awful contrast to the lovely sunny day would be vain indeed. When we settled down a bit and looked around, it was evident the Germans had skipped in haste, the various articles left in their hurry witnessing the fact. I jumped at my souvenirs which I have sent along. I did have a fine helmet but at one point I went out with a party in front of the trenches in the night and the job was many degrees too warm to consider helmet carrying so left it. We here got a volley of bullets in our direction but by a miracle only one man hit. We had to leave him till our job was over. On reaching the trench a couple of volunteers were called for, and two of

us went out there again. Some hefty job to carry a big helpless chap a couple of hundred yards in the dark across a ditch too, but we did it at length without in some way getting hit, and trust he will get through alright. Anyway we two were breathless but happy.

From this time onwards began a series of experiences which to look back upon now seems a dream, a nightmare.

Whilst in the trenches we witnessed a glorious charge by the regulars. They went over the parapets by one and twos in grand style, though met by a shower of bullets at once from the enemy. Later some dribbled back wounded, a most unhappy sight, but still game. One old sergeant came over with a beastly bayonet wound in the leg. He had it field dressed, asked for a fag and went over again to the enemy.

I think we've done almost as much ambulance work as was possible, combined with our main duty and right glad too.

I could go on and on thus, but must refrain for the time being. Trust I shall soon be able to fill in the details to you all verbally at Sunday tea table. Anyway we've got them on the run. It may sooner end than we dare hope.

With fondest love

Len

Monday, June 21, 1915

Dear Mum & Dad,

We are leaving these trenches tonight after nine days' sojourn therein, and aren't we ready for it too! I think the old fellow on Pears soap advertisement looks quite spruce up against some of us hairy looking creatures. Time forbids a lengthy account of this spell.

Though as a matter of fact even then I would prefer not to enter into details, for such a close resemblance to a bad dream hardly makes good reading. Anyway over thirty of our chaps were on yesterday's doctor's parade with nervous breakdowns. Four officers have felt it too, and a day spent down here, six feet below the cornfields, would convince anyone that such is not surprising. My dear chum Jack has cracked up this journey. I miss him greatly, though glad to know he was taken back some way for a rest and change. He will be quite his usual self when he's had some of the sleep we've been unable to get lately.

It's quite painful to see the chaps struggling against such utter

weariness, some being perilously near sleeping on duty, which of course is the greatest crime known out here, on active service.

To be really short of water is an item only understood fully when experienced. I was severely reprimanded by the officer the other day for just wetting the end of my towel to wipe my face with. One sadly needs a wash all this while you may guess; can almost hear your face click when you laugh. I sacrificed half my cold tea this morning to give my fingers a dip before writing this. Not being able to take boots or puttees off is not too nice either. When on my turn at sentinel duty I've had to stand on one foot like a chicken, while the other rested, then vice versa. Then again the food, or the lack of it, all combine to make one consider the idea of a picnic a trifle untrue. Many thanks for the biscuits and chocolate; came at the psychological moment when I had resigned myself to an imaginary tea. The heat of the day makes one really frizzle; the cold at night freeze – and flies – well I guess old Pharaoh would have rubbed his eyes in some concern had he seen such a plague.

There now, isn't that a good old soldier's grouse? Well that is the dark side but the silver lining is here. In spite of these, among other experiences I find myself so fit and well, in fact as strong as the strongest out here, and what a blessing eh? And as Mum says, to be without hurt is truly great, for of course on either side they still persist in throwing things at each other over here, in spite of home talk about lack of missiles. For instance I did one hour headquarter guard at midnight, last night, and during that time I counted thirty heavy shells from one gun alone being bowled over into one of the villages. It's a weird, wonderful sight indeed to keep watch in the dark, for on every hand lights and gun flashes continually light up the sky. In one direction flames where some village or other is burning; in another where all sorts of signals are being shown by coloured lights.

"Listening patrol" is quite an adventurous job. A corporal and four of us went out the other night. We had to go out between the two lines, as near the Germans as possible, crawling all the way, and then lie flat down at some point and just keep ears and eyes at concert pitch for any suspicious signs from the enemy. They do the same sort of thing and should both parties meet – well one or two would have quite an adventure to relate – the others would not bother the censor again; that is if the Germans have censors.

Wouldn't I just like to see the garden again. Dad will find me handy for the digging job after my trench work; be a treat not to do it at night time to the tune of bullets ... I shall be able with the greatest ease to sleep in the garden among the flowers.

Glad you enjoyed that photo. Of course it was taken a long way back from the firing line, when on a rest in a big town. No civilian or photographer of any kind is within several miles of the fighting area, so you can take it from me most war pictures must be "fakes".

It's awfully funny. I usually get your letters saying you are pleased I am having a rest out of the trenches at the very time I am roughing it and vice versa, but believe me a line is ever welcome, the post is far and away the chief item of the day.

The Shiny Seventh is quite well known and might I say recognised as of some real use among the "regulars" here. It's an honour in itself to be "first line" troops as we have been all along; for we have again and again relived some of our best regiments.

I am spending some of my odd moments sketching the lads and have met with much applause for they all send them home – it is essential I keep my hand in as it were. We are in trenches chiefly dug in chalk and nearly all the regiments having occupied them write the names and draw badges in memento. Well I did one which has made my name entirely. The Major of our battalion sent for me to do something especially for him. This is good biz in view of days to come.

Must close with much love

Len

June 30th 1915

Dear Dad,

No time for a letter at the moment. Just a card with many thanks for your useful packet and fine letter. If by any chance you have not yet sent, would you kindly look among my boxes and send me a few colours and a brush. I may be able to do a few interesting little sketches. (A red, blue, yellow, crimson lake, black and white.) I have also lost my writing paper when in the trenches last time, and would be glad of a small writing pad with lines. I hope I am not asking too much lately but it is impossible to buy these things out here.

I suppose everything in the garden is lovely. I'd give anything almost to have a peep at it this moment.

Yes it's looked upon as quite an achievement to write letters in the trenches, but it's really a good thing to occupy one's mind in spite of surroundings. Of course one is on duty most of the time and when off to get a bit of sleep is the one thing greatly needed.

Yours lovingly

Len

July 10th 1915

My dear Mum & Dad,

Have been living below the ground several days, things having been comfortably quiet the while, I am glad to tell. The weather is glorious. Thanks ever so much for the pad and the colours. In between the sentry duties I have managed to do two coloured postcards which have been praised by the boys, in a way that quite surprised me, in fact I have got more than a dozen purchasers of replicas at a franc a time (10d), some pay, eh? I will send you one soon. Must ask you to send some more postcards as before, soon as possible. I think I shall thereby be able to do myself a bit of good. By the way will you try and find me a better brush among my things and another colour or so. I am regarded as some freak, drawing whilst in trenches, but there, much better than wasting time playing cards I reckon. Don't have the idea it's all a sort of recreation club this way. It's only odd half hours when off duty, and one has always to be alert for instant service all the while.

I am much afraid as my conscience tells me that it has meant neglecting you dear ones, but I ask you to excuse me and understand how pleasing it is to lick the good old brushes once again.

At the present time I am writing this in a little room by the window looking out on a very decent sized garden. Three chaps at my side peeling spring onions. Sounds strange, eh! but true. This being a very nice village just behind the line, and only recently vacated by the civvies owing to the severe shelling. So whilst acting as firing line supports we find ourselves sorted out into the charming little villas. The vegetable gardens are very plentiful, helping our section today to supplement our bully beef stew with green peas, kidney beans, onions, new potatoes, and stewed rhubarb. Two very good cooks

kindly volunteering to stick down in the murky cellar, preparing a repast that approached in some measure to 26 Blenheim on Sundays. Although
I shall not believe the rumour blindly, yet there was something in the wind to make me look forward to being there for a few hours maybe not so very long ahead.

I have some beautiful roses near my arm using an empty shell case as a vase; and we have just finished a unique religious service – about twenty one chaps congregated together in this little room and had a glorious time, singing several of the good old hymns. Jack gave a lovely short address and we enjoyed it much. A bit homelike.

Shells remind one every moment how far away tho. In the day time one is having quite a holiday time, the concert party among us being real good. We are not allowed in the streets, it is absolutely dangerous to show oneself, being under close observation. But as soon as it's dark then it's clang, clang, dig, dig, till daybreak. In fact I am parading in ten minutes for this delightful pastime. There's every reason to think we are going still further back in a day or two. Then I will try to write more.

> Yours lovingly
>
> Len

16th July 1915

Dear Mum & Dad,

Received packet and letter today – and very highly do I appreciate same and all such kindly thought.

Am afraid this must be only a brief acknowledgement, my time being too fully occupied for much writing for the present.

As regards news, things remain just about the same as recorded in my last. Rumours galore – travelling half way round the world are we thereby but we still remain where the bullets whizz, and shells plough holes in neighbouring buildings. The redeeming feature being the continued appearance of the beans, new spuds etc on the menu.

With you, I and all the other fellows out here are right glad to perceive the vigour with which the Nation is putting its shoulder to the wheel. It all points to a speedy victorious end. Though the men out here put the best face possible on all the various hard unpleasant circumstances under which they live, we all long for it to be over, that

we may return to the old accustomed peaceful life. One and all dreading such a thing as a winter campaign. The oldest regular soldier equally with us.

I am as well as ever – even surprised at myself considering all things, getting soaking wet on guard, drying in the "togs" etc.

Must close somewhat abruptly – the sergeant is yelling for the fatigue party now.

     Yours lovingly

       *Len*

                          August 12th 1915

Dear Mum & Dad,

I am very sorry so long a time has passed since writing you, but really this is the very first opportunity that presents itself. In fact I almost wonder if you have yet heard we are now back – yes back from the firing line – quite a comfortable long way. Some journey it was too, a good few hours' march, and right glad were we to eventually strike our billets. The main thought now with us is the question of leave, for in our opinion it's soon or never.

Yesterday we had an important inspection and turned out in grand style, giving the General evident satisfaction. A glorious day – the shiny buttons and bayonets making a fine picture. All the chaps looked absolutely fit despite our rough experiences. I managed to beg a new suit (which was sadly needed) and in every way we did our best to look smart.

How the time has flown – nearly twelve months now have I been soldiering. To be sure it's not all been looking pretty, parading the London parks; especially over this way. There's been plenty of the darker side; the dirty work that war stands for.

At the time of writing I am sitting in a glorious wood perched on top of the hills, from which one sees wonderful views around. A very lovely picture indeed, altogether having a great time. Incidentally too the wasps seem to enjoy my position – a couple of stings so far – a most interesting bump coming on my finger while I write. And strafe the flies; they seem bent on making me pack-up and stop writing.

We – that is Jack and I (the inseparables) – have recently joined the machine-gun section – after having our names taken and waiting some good time.

In action this job is reckoned a wee bit more dangerous, for the enemy directly they get the wheeze just where our gun is placed do all they can to silence same; but there, in my opinion there is little to choose twixt any job in the line, and this particular detail is heaps more interesting and it takes some months to become a skilled gunner.

This battalion has two fine new guns, besides our Maxims. These "Vickers" are truly wonderful machines, firing shots at the rate of seven hundred and fifty a minute. Fairly useful speed eh?

This last few days we've been learning the purpose of some of the hundreds of intricate parts as well as the drill which is very strenuous; pushing about with the gun (quite a hefty weight); putting it together on stand etc. in double-quick time etc. Now today we are in this delightful spot, doing our first spell of firing. A somewhat nervy experience at first I can assure you. To sit immediately behind the gun, swish on and let it rattle out round after round at express speed; the noise deafening and vibration very disconcerting. We are using a good natural range formed of high cliffs.

My word! we do work nowadays from early morn till eve, up at 6 for a stiff bout of physical drill, then everything to clean up, a fairly hurried breakfast, then continue many varied duties till dark. Route marches etc; not the ideal programme as a rest but quite happy in view of the calm security in the fact of being out of range of shot and shell.

I continue in the best of health. Good eh? Not a day's sickness in five months of war time. Trust each one of you dear ones are also enjoying this first of blessings. I would now thank you for your lovely letters, and all the dainty gifts of eggs etc sent, which I've consumed with so great enjoyment. The I.C.S. Mags also pleased me much.

As you suggest Bank Holidays and Sundays seem like other days here, practically all work and no play but by no means dull boys.

We've been brought into contact with the "new blood" a good deal. We have had the pleasure of welcoming them and giving some a "show on" for their first time in the trenches – fine hefty chaps too.

Am still hoping to see Paul – just had a card from him – such a sad one though – truly a grievous affair. It was only three days ago Aunt Pollie sent me a nice parcel, a great shock it will be for all of them and so unexpected.

Thanks for newspaper clippings, just the sort that appeals to me. The laughing horse from Nibby tickled me much; also that long Chronicle article. "Impression in the danger zone" very true indeed,

just such as we experience daily out here. Glad you read them for it tells you in a better way the sort of job the soldier does nowadays in France.

Consistent with your wish, you now hear that we are back from the line. Now we must trust that your further desire comes true, that I soon return to each of you again.

Yours lovingly

*Len*

POSTED BY A MAN ON LEAVE.
WRITTEN ON A PROGRAMME OF SPORTS.

We are now billeted in an abandoned village by name South Marocq waiting our turn to go into the trenches; maybe tomorrow, for a week or so. These trenches are only about three hundred yards off known as Vermelles. We there occupy the extreme right of the British lines, the last British touching the first Frenchmen. For the first time in five months you will know just where I am. Cannot write more, he's off at once.

Sept. 6th 1915

Dear Mum & Dad,

Many thanks for so long and breezy a letter, beside the other extras sent. Quite cheered me up, which I needed more than usual this time. Not that I would distress you in the least by idle grumbling, but this spell has been a teaser. Summed up in a nutshell, continued misery day and night – wet – cold – and not least, hungry. We have been here for some few days now and shall be much cheered when relieved.

I've just got in the dug-out for a brief time until turned out for duty – after being on sentry duty in the pouring rain, getting soaked through and through. Yes, well I've got used to a wet skin by now, but the cold, especially at night will take a lot of sticking. When one got cold in the good old days there was home, fire, and something hot to go to. But here one just has to stand quite still hour by hour and just grin and bear it, leaving any luxuries entirely to the imagination.

That is the time for homesickness, when staring over the parapet waiting for dawn in the morning and wondering when the day of peace

and return to you dear ones will come. The one bright speck is the arrival of the mail. I assure you it makes heaps of difference if there's one for 2621 or no. The six pages received from you this last time for instance helped me forget a raging toothache for some agreeable time.

But there it's too bad of me to dwell at all on these little discomforts, when I but stayed to think of the blessings of being preserved so wonderfully thus far. Especially in view of the nasty wounds that some of the fellows receive daily from the shells which are very hot round this neighbourhood.

Yes that "Chapel" sketch was a success I thought. I hope the enclosed one will appeal to you. Make an interesting collection when I return eh?

Rossiter seems to be having a cushy time now, but certainly, a chap who returns like him deserves all he gets I'm thinking and ought not to come back again.

Pleased Sid has had a holiday and a good time. I dreamt whilst having a nap that he was out here fighting, you've no idea how it worried me to even dream it. I'm quite happy in the knowledge there is only one of us for you to be anxious about so far.

Jack and I are not fully fledged enough gunners yet to be put with the proper section in the firing line, but hope to be soon. He sends his kind regards.

Trusting things may all continue well with each of you dear ones.

> Yours lovingly
>
> Len

P.S. A very interesting account though so sad was the cutting from the *Bicester Herald*. Thanks for sending it.

I'm simply longing to catch sight of Paul but doubt if I shall.

That leave still is coming – but when I know not. There's a faint hope of being home for Christmas – which year you ask, so do I.

Sunday Sept. 12 1915

Dear Nibby,

You evidently took great pains to write me that long letter sent with the very excellent drawings for which I thank you very much; and thus am writing to you in return this time. I know Mum and Dad

won't mind, for they can peep over your shoulder to read anything of interest. Firstly please just kiss and thank them for me for the box of goodies. All very much appreciated and, might I add, needed at the time. The tooth stuff too was jolly effective. I've not had my teeth properly attended to yet.

We shall eventually be in some real business and I did not like the idea of appearing to shirk it. Of course I must not gossip about things, but it is plain on the surface that both the Germans and us will have a big scrap before long, to try and prevent a winter campaign, and therefore if we are in the neighbourhood are sure to have a finger in the pie; so I would guard you against worrying if at any time letters or news should cease for a time.

At present we are on a turn at trench digging at night time. We started last night after being back some way for jolly stiff training. We had a most delightful journey here; the Battalion actually rode all the way on a fleet of motor buses painted grey. We behaved like a pack of giddy schoolboys out for a treat. It was such a pleasant change and novelty to have a ride, for the first time in six months. You can well imagine the jokes and yelling. "All the way to the Bank". "Change here for the firing line". "A tanner all the way to High Beech" etc etc. Made me think of the times when I get home again.

I must remind you one is not allowed to write the sort of letter you desire. That photo gave me no end of pleasure. My word you look tres bon. A big chap you look there with the long uns. Shall be glad when I get into civvies again.

I'm still looking forward to leave, though as you suggest the parting time would not be easy or sweet.

I feel almost too tired to write this so please excuse a brief letter. We were working hard from seven last night till four this morning, and are due out again soon.

I should very much like to hear again from you soon – and perhaps more drawings. I should think you passed the exam with flying colours.

That's all at present dear boy.

With much love to each of you

Len

Friday, October 1st 1915

Dear Mum & Dad,

Only a word or two now – more anon. I trust the field postcards have eased your anxiety concerning me.

At the present I must confess that I cannot think and write calmly of the hideous sights and hardships of the last few days, together with the lonely feeling of so many dear chums gone. We have each been tried to the limit of endurance and feel right dead beat and exhausted.

God be praised! Jack and I have won through unscathed, but even then one does not escape the severe mental strain.

Folks in England would never forget the sight could they witness us chaps crossing the trenches in the pouring rain through the night, just a staggering crowd of cripples, wild eyed and filthy dirty.

I happened to stray from my battalion and so got a good way along the road with some of the Guards – though to be sure you would hardly recognise them – half-bearded, crouched up with the cold and covered from head to foot with thick mud.

Please save all reference to the fighting along this front for me, especially any reference to the Shiny's. I feel sure we shall be much mentioned for our work, for which we have already been highly praised. Our charge was a brilliant success. Will let you know more later.

Will close now as I'm falling asleep.

Len

Saturday October 2, 1915

Dear Mum & Dad,

You will understand by now that one is not allowed to write fully about our job here, but I will try and give you an outline account, trusting to fill in the twiddly bits when home at some future time.

As you dear ones at home have read of the big move in progress, hail with delight the good news that something definite is being done, with success attending our efforts – just so in as great a measure do we chaps out here welcome the opportunity of striking a really decisive blow at the Huns when backed up so splendidly with artillery and munitions.

Well the "Shiny's" chance came at last and from every source we

have been congratulated on the way we carried out the important task allocated to us. Though nevertheless 'tis very sad to count the cost in good men's lives – to miss the many chums one has lived and worked with since "listing".

For weeks and week past have we seen armies – takable signs of something big coming off – the maze of trenches we've spent night after night on digging – the barbed wire carrying parties – in fact a hundred and one wonderfully thought out preparations, that in themselves must argue well for ultimate victory. And then too, just recently the constant stream of transport. Guns of all sizes and many men have filled us with confidence and we really hoped that the Seventh might have a finger in the pie. Well be sure we did – and quite enough to satisfy any man's taste however much he possessed the fighting spirit.

To our great satisfaction we were more or less taken into confidence over the whole business and even rehearsed our particular part some half dozen times or so. On the last day – at the full dress rehearsal – our Divisional General came over the course to us and gave a most helpful word of encouragement and advice which each man much appreciated.

Such were the preparations – then we were glad of the change when at last we moved to some few miles nearer the firing line. We went by the old grey motor buses, somewhat the worse for wear from constantly carrying soldiers, who are none too dainty as passengers. What a jolly party of chaps they all made though. A crowd of men abroad going to a cup-final are usually pretty lively, but not to be compared with the high spirits and singing that prevailed among us chaps, who realised that before many hours had elapsed we should be fighting in deadly earnest, and some among us were even then taking our last ride.

Rain! why it poured in torrents, but who cared. To get soaked is quite a common occurrence nowadays out here.

Having finally reached our destination we took possession of our allotted billets, a one time school room and were quite ready to pack down and sleep until reveille. Practically nothing doing the next day, but each man made a point of preparing for eventualities – tearing up private letters etc., taking each other's name and addresses, and many such actions, which at first looks rather morbid, but are really quite important and a matter of duty. In the afternoon our Captain still

further enlightened us on the job ahead. So that all was done to make us feel keen and do our part intelligently.

It was about dusk when we lined up in full war paint; minus our overcoats which had to be left behind so as not to impede our progress across. And what a motley crowd we looked; some with picks, others with shovels; in fact every man carried something or other extra, all of which we needed in a really big show.

Strange it will sound to those who know me best that I was given a gallon bottle of rum to carry up there. Then we started on a seemingly never-ending tramp through communication trenches some couple of miles or so, eventually reaching our positions, and taking our places by the ladders specially erected for the speedy scaling up and over the parapet.

The order then came along that we might lay down and rest if possible. We tried but the rain made it somewhat difficult and "uncomfy" and I for one felt more inclined to think. Strange are the thoughts that pass through one's mind with the knowledge of the purpose we were there for – waiting – of the sacrifices some would be called upon to make. I should think we waited huddled up there some three hours – then the order was given "stand to". We straightened ourselves out and had a mouthful of food with a nip of rum all round – then we were quite ready.

What surprised and indeed worried us all most was the fact that it was getting quite light and we feared that the attack has been postponed or something of the kind, and were much relieved and reassured when our guns burst forth with one accord. Then commend some bombardment; such a din it would be vain for me to try and describe – every gun in the neighbourhood was having a say, beside our trench mortars, etc. I felt almost sorry for the Germans away over the top there.

It was bad enough an experience on our side having hundreds of shells whizzing over one's head for some two hours unceasingly, and then as they suddenly stopped at the same instant (a little before seven o'clock) the word was passed from man to man swiftly down the line "up the ladders boys and over the top"; at last we found ourselves well away on our journey, with real business ahead.

The fun had begun and so had the machine guns and rifle fire from the enemy. They gave us a really murderous fire under which to advance and the distance to our objective was quite five hundred

yards. It is really extraordinary what drill and discipline can make of men. Although without the slightest means of cover or protection, yet we just walked over as if at drill, and though chaps were toppling over on all sides yet none wavered or dreamed of going back, but just kept on steadily, determinedly until the enemy's barbed wire was reached; happily well smashed by our gunners previously. Nevertheless it meant picking our way very gingerly through it, under heavy fire the while, and then came the final rush with the bayonet. This is just where everyone of us who are left find ourselves fogged in trying recollect exactly what did happen, in that first mad minute. I for one cannot remember how I got into the trench – all I know Germans were there galore and we had to get really busy until they were not.

Many prisoners were captured beside four machine guns; in two cases the gunners held on bravely to the last. But I happened to strike a dug-out with a gun at the port hole, abandoned as it seemed. I reported it to a corporal who thereupon put me to guard it. About a minute later four savage looking Germans emerged from an underground dug-out at the side much to my surprise. Of course I had been pretty alert and directly they saw the bayonet at the ready they put up their hands and cried for mercy. It was a toss-up as to whether we gave them quarter or not, considering the mood we chaps were in, but at any rate they were put under escort with others caught in a similar way. But in some cases I know where the beggars rushed into their dug-outs to hide, our grenadiers promptly threw a bomb in, telling them to share it between them, and their fate can be imagined. But don't for a minute think they all ran away or hid at sight of us – no indeed there was really a very stiff resistance given; in parts fierce hand-to-hand fighting, and many of us laid on top of the parapets, firing and being fired at from all directions. We accounted for many Huns that morning but at a great cost to our dear chaps who were laying all around with dreadful wounds. The bombers were in urgent demand backed up by us, and a most critical time ensued between our grenadiers and theirs. Truly a matter of life and death it was to keep up the supply of bombs and awful damage was done and many brave deeds wrought there. Our Captain and other officers were right on top of the parapet in full view of the enemy – spurring us on. We lost each of them thereby besides all our sergeants, but their lives were not wasted, for this example told for

victory in an unmistakable way, and great indeed is our pride in having such leaders.

The slag heaps in front gave us a deal of trouble too. (These heaps are composed of waste that comes out with the coal from the collieries in France. They dot the landscape all around and rise to an enormous height, extending in length about three hundred yards.) We had such an affair looming up immediately in front of this captured trench and many of us climbed up this, the better to fire down on the enemy. But of course we were meanwhile also exposed to their view and by jove! things got really hot, especially when a venturesome party of them came making along the slag towards us. It took a long time to disperse them and then the remaining one or two of us returned to the trench. There are many details of interest I could tell, but not on paper. Now, suffice to say we eventually gained the day, capturing the position and keeping it.

We stuck to the new trenches for five days afterwards and had to work jolly hard the while making the place secure. The rain was a jolly nuisance – and the shelling – well, that was to be expected for of course the Germans were somewhat annoyed at our intrusion, in fact we feared or rather waited for them to counter attack, but they somehow did not whilst we were in occupation. But had they tried, a jolly warm reception awaited them.

It's a bit of a fag hour after hour on watch, especially by this slag heap, feeling at any moment hordes of Germans might suddenly present themselves over the top. Each day we could see the troops advancing over the ground to our right and see also the shelling of Loos, nearby.

We were quite ready to leave when we made our way out from these trenches at last, thinking we should shortly have the chance of a decent sleep and wash. Some were carrying helmets and other trophies (though things had really been too serious for one to think much about finding souvenirs). To our bitter disappointment we were taken to another part of the line and stayed there another two days.

After making a charge and going through all the subsequent trials, that are too numerous to mention, we felt pretty fed up at not going right away out. Anyway all good things come to an end, and at last we started out one night (still pouring with rain by the way) for a fourteen mile stroll back to this rather decent village.

We were indeed a sorry sight to behold – all limping with swollen

feet, sore, wet, filthy dirty and utterly fagged out, straggling all over the place. When we got near the end of our tramp we made a proper "hopeless dawn" picture. It took a couple of days at least to assume anything like our normal state – the cleaning oneself up alone takes hours. And then there's the necessary fitting out with equipment and new "togs" in place of those that somehow get lost or destroyed in the fray.

The roll call especially makes one's heart ache to hear, when formed up on parade.

And now again we find ourselves "resting" – interspersed with a route march, a bit of drill or such like to keep us fit – just wondering meanwhile what our next action will be, and giving

[*rest of letter missing*]

Monday October 25 1915

Dear Mum & Dad,

Just out of the trenches after an extra long period therein. We have been through another hot time; of course not another charge but the place we held was in an extremely dangerous, exposed part and one's nerves were kept at concert pitch the whole time. I think we felt more done up after this turn than usual, owing to us returning so soon to action after the other turn, but no doubt such is necessary at the present serious time. I could not do more than scribble a field card – still the simple message "I am quite well" means everything to you I imagine.

We occupied a part only eighty yards from the Hun's trenches the whole time and being one of their captured lines where we've recently advanced a very considerable way you can understand how they behaved towards us, which accounted for the vicious shelling.

We lost some, more of the original chaps and our constantly having drafts will in time make a fresh battalion of us. There's not so many of them who came out with us in March.

We are out for a little while then another smack I expect, then things will no doubt settle down for the winter. I am more or less resigned to it now, but trench life will be awful in a month or two I reckon. It is sometimes pretty bad now – one hardly dares go to sleep for on waking up one's feet are frozen. Speaking on these lines I would like to contradict that "Mirror" paragraph you sent. They mean the 3rd Seventh and not us by a long chalk. I do not want to

grouse, but it has annoyed us all round for folks at home to reckon on this scale when it means on the other hand the scantiest food and nothing more tasty than bully beef, hard biscuit and water.

Thanks ever so much for the letters I've been unable to answer, and the news slips – the grapes too were grand.

It's really a good reproduction of my work by the I.C.S. and I'm delighted they accepted my account of the show. I know you are pleased. Will you kindly send half-a-dozen copies of both issues and let Jessie have one.

Mr W. G. Smith's nephew is in quite a different section to mine, that accounts for my non-appearance in photo.

The Division Chaplain here has become very interested in my drawings and as he goes on leave in a week or two has got me to promise to write and ask you to send one or two of those drawings I've done out here, on to his home, St. Peter's Rectory, Greenwich, addressed to his wife (Mrs Morney). He thinks he might do me some good thereby, and I think it would be well. They would be safe so will you please do this – send the smiling face one. He promised to return same quickly to you.

I thought of you on sentry go. I was on the same job with bullets whizzing by and their shells strafing us merrily.

Aunt Emmie has just sent me a delicious cake etc. and I must write in acknowledgement. I am owing letters to a lot of folk so will close now and will try and write again soon.

  Your loving son

           Dec. 19th 1915

Dear Mum & Dad

I think by the time you receive this you will have heard I have been admitted into hospital. But I would assure you it is with nothing at all alarming, just a little throat trouble. Am afraid I shall not get home Xmas week now, as might have been, but never mind so long as the chance comes eventually. Will write letter as soon as possible. Wishing you each a very Happy Xmas.

  Your loving son

C. Ward
"Roches" No. 1 General Hospital
B.E.F. France
Monday, December 27 1915

My dear Mum & Dad,

I do so hope you have not worried overmuch about me. I've thought a lot about it, but it has been impossible for me to write before, not feeling up to it, or in fact anything else.

I will not harass you with overmuch detail. Suffice to say, I've come through a very severe time. I believe Dad knows something about "Quincies". Ah! and so do I now. Unable to eat the least morsel for twelve days; drink with great difficulty and quite speechless the whole while. I am well on the way to recovery now, but it will take a week or two to pull round to the accustomed fitness.

I travelled down to this base hospital by an hospital train, a really splendidly fitted up affair; just like a hospital on wheels, with attendant nurses and Doctors, rows of nice beds and everything for the comfort of sick or wounded men. They also cook the meals en route which is really necessary, the journey taking two days and a night.

Of course I could not view the scenery, being wrapped up in bed the while. Arriving at our destination I was carried up a couple of floors into a most delightful little bedroom, furnished just as sweetly as one could wish. Two other decent fellows share the room and out of the large French windows one has a fine view of the sea and cliffs. Yes! actually! I am at a big French seaside place. This building was formerly a huge hotel right on the front and so when I can get up and out, there's the joyous prospect of strolling along the shore. Lucky chap eh! At least now the other trouble is over.

Before I came here I spent about five days in an isolation ward where the Doctor had consigned me as down with "diphtheria". That was pretty gloomy being in a tent all alone. He came to the conclusion just before I was transferred it was "acute tonsillitis" and then here somehow it became "Quincies".

Anyway "a rose by any other name is just as sweet" and so in my experience "a throat by any other name is quite as horrid".

You would laugh could you see the other fellow patients here when dressed. I've got a suit waiting when I'm up. A red flaming tie, a cricket shirt, and bright blue tunic and trousers with brown shoes.

Letters can be sent and received at this address for which I am truly thankful, and if perchance you could float a bit of Xmas pudding over the pond, well, what better eh? I expect to be here a little while yet.

I do trust you all had a jolly good Xmas time. How I longed to be with you. Still we've got the joyous anticipation of leave which I shall claim directly I return. It will certainly be my turn.

I will not write more now, as it's quite time you heard from me. Wishing you each one ever so much better and happier a new year than this old thing has been.

Your loving son

Len

Let's hear from you as soon as poss, please won't you.

> "C" Ward Roches No.1 General
> B.E.F. France
> Sunday January 2 1916

Dear Mum & Dad,

After a period that seemed like months I was delighted to get such a long letter from home and pounced upon it with excitement. So pleased to find you had received my letters alright.

I cannot feel but grieved when I see how confidently, anxiously you expected me, all the Xmas time while I was imprisoned in bed here. More especially on reading it was so eventful an occasion. How lovely it would have been to so celebrate it by a return to home sweet home.

But there 'tis vain to dwell on this side of the picture and far happier can we be in the Knowledge that leave is still in view and not now but a memory of the past, but still a joy to look forward to – and assuredly we are all the brighter and happier in having something real good to look forward to day by day.

I still remain at this delightful place having a complete rest and change which one needed badly after all the trench life. I am afraid if I stay here much longer I shall lose all my toughness and become a "featherbed" soldier. The food is plain and good and together with the sea air and real nights' rest I feel grand indeed. I am allowed out a bit now and it's just lovely wandering about the beach and cliffs,

sitting on the pebbles watching the boats come in etc. The air is very strong though and one gets real dog tired by bedtime – seven o'clock.

You must forgive a not very lengthy letter; there's so little of note to tell. Of course when I see you I can chat unreservedly about little items that one cannot write in open letters.

I was practically helpless when I left word for Jack to advise you and therefore was glad and relieved to learn that you had heard through him and in time more or less to set you at ease as you mention.

So sorry that the parcels sent have not reached me, but there is a wise rule observed all round, that absent men's parcels are shared among his own immediate chums in the section, and as I have often had a portion from a wounded pal's packet, I am well content with the thought that the boys had no doubt a bit of a feed at my expense, probably in the trenches where it is so precious. And so I would thank dear Mum, Sid and Wally from my heart for their kindly thought, even tho' unable to participate thereof.

You ask is there aught I need. Well I will ask just for once would you kindly send a little diary, not one with days marked, a plain little note-book would serve, and perhaps one of those boxes of sweetstuff I used to have and enjoy so much – would be a bit of a change to have a little taster of cake.

There, fancy finishing up a letter thus. But there's no more to say this time, only I will try and let you hear frequently if only a message, "All's well".

     Your loving son

      *Len*

Tickle old Sid up to let me have a line from him, my brother in arms.

                                  Roches, Jan 6th 1916

Dear Nibby,

I think that was really the jolliest, funniest letter I've yet had the pleasure of receiving. I laughed all the way through, and thank you very much for it. An admirable, free, conversational style you've got, certainly worth cultivating. I am going to ask you as a special favour to send me a few lines once every week, just chirpy and chatty like this one. I should be very pleased. Sorry to say I've very little news at

present to exchange. I got up once, thought I was well, went out on the beach and had a lovely breath of the sea air. But must be greedy enough to find a quincy somewhere, which kept me in bed and fasting for another few days.

Nevertheless am on my legs again now, and all that trouble a thing of the past.

I thought Sid would speedily win promotion, but as you say a strike means a lot more worry and responsibility – especially out here. A bob per day though extra is some consideration. I think infantry only receive a couple of bob for the week extra.

You complain of the incessant rain and certainly the continual gun fire is the cause of much of it, so severe a disturbance of the air must tell. I am sorry for my pals up in the trenches these days of wet and cold.

I like your poetic spurt re the frolicsome waves and would add they are might noisy too. It's almost a job to get to sleep at times and the wind does howl so.

That's what I most wanted to know, that dear Mum and Dad keep up bravely and I hope dear boy you do all you can for them. Keep the home fires burning until your brothers come home. I mean keep cheery and bright and help Mum and Dad all you can.

That's all this time sonny. Much love to yourself Mum & Dad.

Len

Sunday, March 10th 1916

Dear Mum & Dad,

I should like so much to write you a fine long stirring letter – but at present there's nothing doing in an interesting way. Our programme at present just consists of gravel scrunching and skirmishing, hither and thither through snow and mud from morn till night. One thing though, however hard we work in this way it's all "as safe as houses" (miles from the line) though to be sure houses are not so very safe nowadays.

Must tell you, one's immediate surroundings here are not the least bit conducive to pencil gossip. So jolly cold don'tcherknow in this creaky old barn – besides having to keep up a running fire of "smokes" in honour to Mr and Mrs Hog in the adjoining sty. On the other side my very near neighbour the cow, keeps pushing her nose

through the broken woodwork trying to eat my bed up (straw), can hear her chewing the cud even while I write. "Oh to be a farmer's boy." The draught too seems bent on sending my candle to sleep. So thus can you picture a gallant warrior, sprawled on the ground, writing home.

Thank you ever so much for nice letter of the 5th inst. I can tell by the spirit in which you write that you all enjoyed my little visit home in just as great a measure as I did – and that was a mighty big lump – truly a glorious spell. I delight to think over all the various little incidents again and again. Mum's singing "Keep the home fires burning" – the little turn of road patrol – Nibby and I, how we stared in open-mouthed wonder on first meeting, and many other memories that help keep one going when circs. would tend to produce fed-up-ness.

I find it a great help on a long trying march for instance to let one's thoughts dwell on all these happier times, keeping up a good heart, hopeful that it will not be too long ere they return.

Am afraid dear Nibby, with others, was rather disappointed that I did not recount any yarns or say much about my war experience. Well I made up my mind long before I got my leave, that I would not talk war while at home but try and forget it, and am glad I was fairly successful. I did not want to cause any undue anxiety as I was returning so soon again. Never mind, when I get home for good, shall make ole Nibby's hair curl with true stories.

Hope Sid is well on the way to resume his usual duties, feeling quite fit and strong. So glad I saw so much of him as I did.

Have enclosed drawing of towers as promised – hope you like it, and also a sketch that I consider very successful.

By the time you receive this no doubt you will have had my photos. Jessie tells me the proofs are jolly good. Tell me what you think of them.

Well, I think that's all for the present – will send to you as oft as possible.

Right glad to know you are all so well.

Your loving son

~~Up the line~~   March 17th 1916

Dear Mum & Dad,

Happily things are still very quiet – uneventful. Trust you will not mind a rather brief letter as we may be on our way up to the trenches at shortest notice now, and so I will make sure of at least a line or two if only enough to assure you of my well-being.

Expected to be in the line by tonight but for some reason it has been put off. Good job too, meaning at least one more night's good sleep. We are at present occupying nice large huts, recently vacated by French soldiers. Are kept out of mischief all day by doing various odd jobs. I have been a sort of military dustman today, shuffling around with a stick and a spike on the end, bayoneting pieces of paper. The weather is lovely, so we are quite comfy while this lasts.

It was a fairly long march here, but the lovely country we passed through helped one in a great measure to forget the burden on the back, and I assure you it takes a deal to do that at any time.

We are miles away – much further south – from any part of the line we have occupied during the past year. Very hilly, far different and more interesting in every way to the dismal flatness of the coalfields up yonder.

Rumour hath it that the warmth of the neighbourhood we shall soon resume a rabbit-like existence in is not entirely due to the heat of the sun. Anyway don't be alarmed at any post delay. If field cards have to suffice, will send as oft as possible.

Today is the anniversary of my first landing in France with the "Shiny" crush. Fancy a whole year in the fighting area and still as merry and bright, fit and well as ever. What hope eh: why I am looking forward to my next leave now, or else marching down the Strand with the flags waving and "the boys come marching home".

Am looking forward to another letter from home, sweet home – perhaps shall only be able to acknowledge by card.

Your ever loving son

Thursday March 23rd 1916

Dear Dad & Mum,

The chief purpose of this epistle is to inform you of a change of address, which has happily come about by my having at last struck a nice congenial job. I am henceforth detached from the battalion and put with the brigade section of sharpshooters as an observer.

This detail is composed of a small number of specially picked men from the four battalions and I was recommended for it chiefly through my sketches, which ability will be of great advantage on this work. My job is (whilst the brigade is in action) to go up the trenches or maybe some point of vantage somewhere behind the line, with field glasses and keep my eyes well open, making a sketch or written report of anything, any activity worthy of mention, remarks as the accuracy or otherwise or our guns etc. Any ole German sniper that happens to be worrying our men, to endeavour to get him taped – make a sketch of where he seems to be hiding, and then put our sharpshooters on to finish his career, and such like jobs. You will readily see it is a much more interesting and I might say intelligent sort of game.

Further I have bade goodbye to all those exhausting working parties, and best of all don't stay in the trenches at night. We take it in turns, alternate days to go on duty, working in pairs, a sniper and observer. Yesterday, for instance, two of us went up the line (we are in comfy billets three miles back) early in the morning, spent the day there and knocked off at dusk, about five-thirty, returning to a nicely cooked meal of steak, potatoes and boiled rice.

I am with a fine set of chaps and our rations are much better than ever I've found with the companies. This morning could get up what time I liked – my day off (by the way 'twas eleven o'clock). So you see I am on a good thing, and shall try and stick to it.

Still I reckon one deserves such after a whole year's extremely active service. Of course I still have to live in the neighbourhood of shells and things, and work right in the danger zone; but my! what a difference spending hours instead of many days up there. Another point is, we are entitled to another 6d per day on this job, but rather expect it will come after the war – a long time after too.

Should much like to tell you where our boys are now in action,

for it is one of the most famous districts, the scene of some of the fiercest fighting with the French. Where the "Shinys" are at present in occupation, the trenches – or rather there are no trenches for they have been blown to atoms and are now merely a series of shell holes, half-filled with water in which they lay huddled up during the day; and have to dig for all they are worth to make into trenches during the night. I hear they get "strafed" severely just at their part.

During my travels yesterday I saw a most extraordinary state of affairs in another battalion's portion of the line. I was amazed and even wonder if you will think I am exaggerating when I tell you that thirty yards away from us, Germans were strolling or sitting down on their parapets in full view, grinning and shouting to our men and we are doing the same. More than once have they met between the lines and chatted to each other, exchanging souvenirs etc. One of our men yesterday walked out to the middle of "no man's land" and threw a tin of jam over to them and in return they sent over a packet of a hundred really good German "fags".

I had a taste of their bread – which is dark brown and bitter – and looking through field glasses saw a German officer looking over at us, smiling though he looked a brutal sort of josser, in fact they all look fierce when not laughing. No firing whatever is going on here, though to the right and left of this portion it is business as usual with vigour.

None of us can account for this amicable state of affairs. I personally do not trust the enemy and feel there is something very cunning in the wind – or they are extremely "fed up" with the war. In fact it rather suggests to me the sort of thing that may develop – the way the war may fizzle out eventually. Two Huns came over to our lines just before dawn yesterday morning and gave themselves up. They spoke a mixture of German, French, English, and from their manner felt quite comfy in British hands, fully expecting to be better off as our prisoners. One said he had been a barber in the Holloway Road and the other a waiter in Fenchurch Street.

My future address is thus: No 2621 140th Brigade Sharpshooters c/o 15th Batt. London Regt B.E.F. France.

I expect there will be some delay before I get anything that may have been sent to my old address, but of course shall do so eventually.

I believe I thanked you for your last nice long letter. Anyway if I did, was well worth repeating it.

There is nothing more worthy of mention at present.

Trusting you are all as well and happy.

As your loving son

Len

Sunday ~~March 25~~
April 2nd 1916

Dear Mum & Dad,

For letter of 21st many thanks and second parcel which came as a most happy surprise. I should have written earlier, but, well you know the old saying "the best-laid schemes of mice and men oft go all awry", and that's just me this time. Intending to send last evening I was tempted to go and see Capt. Money's Lantern Show, which included about ten slides of my drawings. They look very well too – about five hundred times enlarged on the screen.

The Brigade is now out on rest – and I with the other sharp-shooters are enjoying a really lovely time. The weather absolutely ideal.

Am billeted with my other new chums in a nice little village, nestled among the hills, with jolly fine scenery around. We are about three miles from the "Shinys". I stroll over there in the evenings to see if there are any straggling letters for me; and also have a chat with the boys. Could not help noticing how very tired and "fed up" they all seemed. Too bad – they are supposed to be on rest but still do strenuous parades and working parties by night. My word! I did miss something last time, not being with the Seventh in the trenches. I think their description puts it in a nutshell at least I can understand, "it was Hell". During that terrible severe day or two and nights as well of bitter cold and snow, to just lie huddled up in nothing much more than mere shell holes. They had to endure some very hot shelling also.

So thus I have got heaps to be thankful for – on the job I have there is now no night work, no more exhausting working parties guards or drills. Besides having the best billet I have yet known in France, the food we now get is absolutely tip-top. Sunday joints each day, plenty

of bread. This in itself, and in many other ways, is quite above comparison with being along o' the battalion.

The fellows themselves too are the right sort, speak nicely and are refined in behaviour.

Instead of "polling" over hill and dale with the old burden of a pack, parade is now quite a pleasure. For instance we march out a mile or two (the sun shining gloriously this last few days) to a very pretty spot on top of a tremendous hill and then spend a couple of hours or so practising observation – which is, to say the least, most interesting – looking through field glasses or telescope at the surrounding country picking out all the little villages and places we know within a dozen miles, finding them on the maps or making sketches. You can well imagine this is just my "alley marble".

My word – it will take a lot of this sort of soldiering to upset me, in fact I feel absolutely brimming over with health and merriment. Hope it won't be long now before the war's finished and I can bring some of it home to share among you.

Of course you know I've had to take a mighty lot of rough in the past months to go with the present bit of smooth, and thus you will be extra pleased.

We went to the baths yesterday; funniest thing you could imagine. I cannot in words do justice to the scene:– Half a dozen at a time strip and then stand in a line behind each other. There's a big biscuit box fixed up with holes knocked in the bottom, a chap is perched up on a box and pours about a gallon of water into this when we walk through as quick as possible to catch a drop or two, then we lather over with soap, and "about turn" back again to wash it off. Of course we need not wash again till Easter or so now.

Will tell you the yarn of the dug-out as you request – later on.

Those photos are indeed first-class I reckon.

Glad to know you are all so well. I often let my thoughts wander homeward and wonder how you are faring, and it's good to know all's well.

There's nothing more this time to tell you.

Your loving son

May 14th 1916

Dear Mum & Dad,

Am afraid I've been a bit of a wayward child of late over the writing outfit, for which I am duly repentant. But really I could not help it. Fact is I've been awfully busy on some most important military work recently. The last time the Brigade was in action I was entrusted with the job of making a landscape panorama map or drawing of the German front line trenches opposite our Brigade front.

Of course it was quite too hot to attempt to draw up in the line so could only take little rough sketches with notes and then have to spend hours and hours whilst back in making a finished sketch. It really looked very bon when finished and coloured. When pasted up it was about 2 yards long.

The sergeant submitted it and the same evening the message came through from Headquarters that I was down for an interview with the Brigadier General at nine in the morning re. the drawing.

I received quite a chorus of cheers from the boys, and later it caused much amusement when I went round the billet trying on other chaps' articles of clothing, my own old torn things being quite unpresentable; borrowing one chum's tunic, another's trousers, yet anther's puttees and so on. Then we had a mock inspection, till at last the boys passed me as a fit specimen of our little "crush".

Next morning I duly reported at Brigade Headquarters and was taken before the General, to thereupon receive most effusive words of congratulation.

"Very clearly executed", "colour and drawing most artistic" and above all "extremely useful". He thought to undertake and make such a sketch during that several days' spell of hot shelling and mining activity, bespoke much devotion to duty and reflected all the greater credit on the work. He promised to lay stress on this when submitting it to the Major General, who he felt "would be delighted with such a sketch as it would surely prove invaluable to him, having such a realistic drawing of the enemy's front line at his finger tips".

I can assure you I felt awfully bucked at being thus addressed by one of such authority.

Then again this morning I was summoned to Headquarters to receive another warm word of thanks from the General of the Division, who added a remark – "that the work had been viewed by

himself and the General Staff with the very liveliest interest, and no doubt my name would be mentioned in a further dispatch". Good eh?

I do hope you will understand me making such a song about this, it looks such awful swank, but I thought you would like to know all abaht it and share my pleasure at such recognition. For a mere private to be suddenly perched on a pedestal is something quite unusual don'tcherknow.

It certainly is very hot stuff in the trenches down this way; a mine going up practically every day and most grievous bombardment. But still I've naught to worry about, having to do only three half-days in six. Mighty thankful am I to be away from the battalion. The poor chaps looked half demented during the end of the last spell, and the casualties were very high.

We have been out for quite a nice spell, the weather has been scrumptious and the surrounding country looks absolutely lovely. We expect to be going up the line in a day or two.

Thanks so much for pencils and things; also nice letters. Hope to be able to keep more up to date myself now.

I am going to stop now rather abruptly, for I'd like this to be collected for next post.

Trusting you are all well and happy as

Your loving son

*Len*

May 24th 1916

Dear Mum & Dad,

Cannot make a long letter of this because we are standing by ready to be on the move at any hour in case of emergency. And I am right anxious to let you have this word or two whilst I have the chance.

Although I must not write any details I can assure you we all have much to thank God for that I have come through one of the very fiercest battles during the last few days without hurt. The battles of Festubert and Loos were hot stuff in all conscience, but even they pale before this as far as casualties and awful shelling goes.

It's painful to write now, one's eyes are so sore, for the gas shells the enemy have been belabouring us with are most trying – making one weep copiously and eyes and mouth smart.

The Germans followed their bombardment with a big attack, and our boys bearing the first onslaught and brunt of it, have done splendidly in so well holding them in check.

I expect you will hear all about it in the papers – collect any references will you please.

I will endeavour to tell you more later, at present it's really a job to collect one's thoughts at all.

One of our companies is practically extinct and I should probably have fared worse had I been actually with the battalion. Although we (the observers) nevertheless have been prominent in it all this time, at one post for hours we were the only means by which communication could be maintained.

We also were much used as guides to new reinforcements, running a gauntlet of fire time after time getting them into various parts of trenches.

At present we are in a lovely wood in huts just a mile or so back, just awaiting the next item on the programme.

So don't get all alarmed dear ones, we may even go back a long way for a big rest. We are hoping this rumour's true.

Am feeling bonny and well.

> With much love

> Len

Thanks so much for last letter.
They are worth their weight in gold when they do arrive; up the trenches especially.

June 9th 1916

Dear Mum & Dad,

This sketch and the one I've already sent on (which I trust arrived safely) are replicas of some I have been doing the last day or two to advertise about the town, a concert that is being given tonight by a "Charlie Chaplin" glee party of the Fifteenth battalion. An officer of this regiment had seen some of my stuff whilst censoring the post and so sent for me to do these things for them.

Being a very rare cinema goer before the war as you know, and not being able to turn up references out here, you can see at what a

disadvantage I was put to. So please go easy with criticism, they were made from memory and imagination. Trying to rig up "Charlie" as a brigadier was a tall order. Nevertheless the officers were very pleased and are giving my sketch to the real Brigadier after the show.

I've been excused other work to do this and other odd things. For instance little items for the comedian to use in togging up for the part on the stage, such as a wide blue band with crossed button sticks painted thereon to put round the arm. A tin of "Brasso" surrounded by gold laurel leaves for a hat badge – red band to go around, with a shiny peak and Brasso written around the edge. Also a massive set of three rows of highly coloured medal ribbons, etc, so that it ought to make a very good turnout.

All our little crush of Sharpshooters are going there together so it ought to be "some" evening to relive the monotony.

Thanks for the cutting herewith returned. That's the affair we paraded for the other day. I believe I've already mentioned in my last letter. I didn't notice Philip Gibbs there – he must have been in uniform; anyway he's written a very accurate pen picture – different to some of the newspaper folk.

General Munro is a fine looking man and his words to us were a source of much inspiration (we certainly ought to have looked nice boys after the trouble to took to polish up and clean equipment).

There's nothing more to chat about, though will write again soon.

Am in the pink of condition. Happy to know you are all well.

Your ever loving son

Len

June 19th 1916

Dear Mum & Dad,

At last a leetle minute arrives when I can spend a little time chatting to you. Tho' as a matter of fact, other than thanking you muchly for your recent numerous letters and that very welcome pair of socks, besides the happy assurance that I am in the best of health and spirits, there's very little further to relate.

The xxxx war still drags on, and we trench dwellers especially long for the whole show to pack up, fini; and let us haste back to Blighty and you dear ones again.

The weather is a bit beastly for June eh? Some of the trenches are knee deep in water, and one gets quite cold at night, which makes the socks most valuable and needy.

We are working this spell in a part of line somewhat to the left of our last delightful danger spot, and find it a similar nervy sector. In fact things are mighty active along any bit of the front nowadays. It's a fair treat on my job not to have to stay in the line at night time, though I am inwardly glad to have done full share on that in the past. Yesterday made the fifteenth month out here. Some old soldier eh?

Our billet is in a little shell scarred village tucked down in a pretty valley about a mile from the front line. It's really grand to return to a meal and night's "kip" after a day's hard "strafe" up where the bullets whizz and bombs explode.

Yesterday was my first turn up there. The three days previous a sore throat had troubled me, besides having the teeth a bit humpty, so the Sergeant gave me the job as temporary cook, and thus was able to stick indoors. Rest assured I am quite alright and gay now tho' and shall be glad to be out and doing again, being very keen on getting several good sketches of this part. Glad my throat did not develop – two of our chaps only yesterday went to Hospital with suspected diphtheria.

We are at present "showing on" some of the naval men who have come from Gallipoli. You can imagine it seems very strange to run up against Naval officers and able-bodied seamen in the trenches.

That concert was a huge success; got my little party front seats on the strength of my share. The Civil Service Battalion have really excellent talent, instrumental and vocal, and the chap who took the part of Brigadier was a top-hole actor. You would be jolly surprised if you ever heard one of these concerts. The "Knocks" and sly suggestions given to the "Heads" during the songs or pieces are very bold and funny. Nearly all officers attend and take all in good part fortunately, or seem to – maybe they rave inwardly.

Good thing you thought of the pressed flowers idea – can guess they look most effective. By the way – no letter with last flowers. Neither was anything missing from busted envelope.

Good biz getting stuff accepted by I.C.S. Hope it's with sketches in the July number. You ask how I manage to do so many odd jobs, I think it's entirely due to my getting up earliest in the mornings like I used to do at home.

To Mr Ablett send about six of my best sketches and just one of the pre-war paintings "The Dream Ship". You will find it among my other drawings. He will let you have them back safely.

Will write again when there is aught worth while to talk about.

Your loving son

*Len*

June 24th 1916

Dear Mum & Dad,

That was a real welcome delicious parcel I received. When miles away from any shops, 'tis jolly fine for the post to bring some such change in a most monotonous diet.

We are still in action up the trenches, and they are absolutely vile, this very wet weather. We are provided with gun boots that come up well over the knees, but the water even beats them in many places coming over the top. So high that in two or three cases I've seen chaps trouserless and bootless paddling about … [censor's pencil] … but of course it wouldn't reach you. So suffice to say I am going on first rate, and my sketching still proving successful. I was pleased to see some of my recent ones of the enemy's line have been reproduced and appeared in the official intelligence reports.

At present am sending you some flowers that I've gathered from the gardens just behind the line here. Good souvenirs. Am looking forward to Mum's letter.

With much love. Yours

*Len*

4 small sketches enclosed.

6th July, 1916

Dear Mum & Dad,

Still just one more letter. Maybe they won't be stopped after all eh? I hope so – yes hope so sincerely. It would be really too bad for you to be deprived of all news, other than those very curt though useful field cards.

Your last letter of the 28th June took seven days to come out – much longer than usual. I expect the transports are being used up in

so many directions elsewhere relating to our big push. We certainly have started off in fine style as no doubt you have read, and now we all hope that "getting them on the run" will become a great reality.

Everybody is so thoroughly fed-up with this long drawn out trench warfare, that we can hail with relief and almost delight this great combined offensive, which may get the Hun into the open, although we know the cost will necessarily be grievous to think of.

Expect I shall have more to do with my rifle than the pencil in the near future.

The weather doesn't seem disposed to help us very much. Just lately it has been a continuous spell of rain. I got thoroughly soaked up the trenches yesterday – deep enough in many places to swim. We've had "some" old iron knocking about up there too, galore.

Fritz is by no means so hard up with shells and the like as some press accounts suggest, and undoubtedly has got a good bit of fight in him yet. Ah: and so have our boys I'm thinking and a lot more. Our victories in face of great obstacles and defences so far at the very beginning of the move show that.

Thanks muchly for the last letter, drawing block which is O.K., and socks which are most valuable these wet times. Could do with a little writing block like this please (have borrowed these pages). Don't wonder where all my stuff keeps going. It is the hardest thing poss. when moving from one dark cellar to another so frequently to keep things fit to use.

Keep trusting that whatever part I am called upon to take in this big show out here, that I shall win through alright as I have done this last fifteen months, and that we'll all soon be home again.

Am feeling wonderfully well. Hope you all at home are.

Your loving son

Len

F. Marquee, 32nd Stationary Hospital, Boulogne Base.
August 4th 1916

Dear Mum & Dad,

Can only just let you have a line or two just to set you at ease. The field cards were the utmost I could write so far.

We were marching on our way down South when I fell ill and had

to go into a Field Dressing Station, with trench fever through sleeping in wet dug-outs. Since then I've been transferred to this very fine hospital, situated by the sea.

I have had a really rough time, subsisting entirely on brandy and water the first six days. Am still feeling extremely weak but going on well.

Please write soon. I don't expect to be here very long. Maybe they will pack us off convalescent before we are really ready, for there are so many coming down from the line.

Trusting you dear ones are all quite well and have not worried over much.

Your loving son

*Len*

Boulogne Base
August 12th 1916

Dear Mum & Dad,

So sorry to have kept you such a considerable time for this letter. The reason being that when just in the Field Ambulance Station I was quite helpless and lost everything I possessed, photos and all, and have had no paper to write on till I received this tonight, and having no money at present cannot buy.

The recent illness has been a veritable blessing in disguise. God has indeed been very, very good to me. Whilst all my chums and regiment have gone down South right in the thick of the fighting, He laid me gently aside, and has eventually led me to have a most joyous time, at the seaside where instead of the ghastly roar of guns one hears the soothing murmur of the sea. And instead of ruined gaping houses and desolation all around, and the other dreadful things of foremost trenches – one sees the very pretty groups of houses along the beach, brilliantly coloured in true continental style and of the quaintest shapes imaginable. Then there is the sea, where just dimly in the distance one oftimes catches a glimpse of dear old Blighty (Dover Cliffs) with the constant passage of boats to and fro that boys of all ages are always so interested in.

I am now a convalescent – that is I am not in the Hospital ward, but in a separate Convalescent Marquee. Have done with the Hospital misfit and donned Khaki (I think the bright blue clothes,

brilliant red tie and red handkerchief tied round the head only wants the addition of a belt and pistol to make one look just like an old time pirate of adventurous tales).

We have reveille at 6 a.m., parade for roll call and muddle about a bit, then have "brekka" at seven, after which we all parade outside the tent and get labelled off in parties for various duties during the day.

I have had the cushiest of jobs, the Doctor forbidding my being put on any other. Two mornings I've had a most delightful job, going down on the beach with some half-dozen "Jocks" picking up pebbles to be used in pathmaking, getting some few boxes full during a morning (I must not even help carry the boxes). It's simply glorious dabbling about in the sand and water, the sun shining beautifully the while. Take a lot of that to upset me. A proper "happy sandboy" stunt.

In the afternoon and evening of the first day up I was given a job on the officers' mess – helping the cook – for which little bit I did I got a first class tea and three course dinner. Next day I was orderly in one of the wards, taking the patients' meals round and such like duties.

Now for the last two days I have been given a clerk's job which promises to last some while. Filling up various forms, printing notices, half Artistic stuff and the rest ordinary writing. Just my "alley marble". Hope I keep so nice and interesting a job. One can keep spruce and clean just as at home.

One of the great blessings of hospital life is to have perfectly clean clothes, 3 pairs socks and double underwear and a new razor with oddments. A fine bed to sleep in at night with sheets and quilt, all tres bon eh?

I almost feel a sneak to be down here whilst the boys are fighting hard away up yonder, but there I try to console myself – 17 months' trench work deserves some such rest as this.

Oh, there I must now beg – or greatest of calamities, you won't get any sketches and I know you will miss them. Will you send me as soon as possible one of those sketch blocks, a rubber, tube of lamp black, blue, vermillion, pale chrome yellow and burnt sienna, also a small good brush. Awfully sorry to have to bother you.

The other day a man was dying for want of blood and a volunteer was called for to part with some so that it could be transferred to him. I was selected but unfortunately the poor chap died before anything could be done.

Learned afterwards that I would have had a spell in bed to regain strength and then be given a trip to Blighty, for the trouble. My word, would have given a lot for a glimpse of home again. Let's hope the war ends mighty quick now.

Am not in Boulogne itself (a mile or so off) but you may be sure I am quite content with this pretty place with the country and sea.

Have sent to my sergeant for any strays that may have gone to my usual address, but don't entertain much hopes. They will have a job to look after their skins there without bothering over post.

I was jolly pleased to get those two letters – one from each of you – made a new man of me. One of the hardest things to put up with is going without letters any length of time.

Will write Paul when I get a chance, was extremely sorry to hear he was ill.

Sid wrote me a fine letter in which he says what a very easy time he has. Your later letter seems to show he has suddenly been rumbled and doing the last few months' work all at once. Egypt won't be so bad – better than France anyhow, couldn't be livelier.

Am pleased to hear you are all so well. I can't write two letters this time I want you to get this quick.

Sorry Mum went to the expense of sending socks of which I am now well supplied. Never mind, my pals can well do with them where they are.

Will close and post at once.

Your loving son

Len

Cheerio! Cheer-awfully-oh!

Thank Nibby very much for his letter and splendid sketch. Hope to write him soon.

Some more notepaper please, like this.

August 19th 1916

Dear Mum & Dad,

Thanks one, two, three, "umpteen" times for letter with pencils, rubber etc. enclosed; only waiting for paints now and I can sail along serene.

Very glad to say have received all back numbers forwarded on from Sharpshooters, so feel highly pleased mit meinself.

Ah! and with my job too. I have a very pleasant little tent to work in, and they find me plenty to do, painting notices, large signboards and a certain amount of clerk's work too. My companion who shares the desk is one of the very best. Although only a private in R.A.M.C. working as a clerk, at home he is a Primitive Methodist parson, with a Church and congregation of his own. He was the first to join in the Church and thus led the way for the young men, although his congregation were rather against it at the time.

He quickly discovered my colours and thus we have a lot of very helpful serious talks. At the same time he is a very jolly sort of chap and we "pull each other's legs" a great deal.

The Sergeant dropped a broad hint that I am alright here for some time as they have lots for me to do yet. So you can be at ease. Refrain from being anxious and smile, smile, smile!

Still I know you want to hear from me just as much, so assure you shall write whenever possible. Whenever it has been otherwise it has never been thoughtlessness or neglect; only some stunt or other possibly prevents.

In mentioning that incident in my last letter about the poor chap who "went west" I did not tell you in any boastful strain, though it struck me afterwards as looking like it. The fact is I always endeavour to tell you everything that happens and I know you specially desire it. Compre?

Was that money useful? Yes rather, thanks dear Mum. In a financial way we are kept on short commons, but otherwise our food is excellent; one does not want much outside stuff. Porridge and bacon for breakfast; roast meat and potatoes for dinner, with pudding after; a plain tea, and cocoa with bread and butter for supper. Not much wrong with that is there.

Dear Sid has just written me. He seems pretty full up with his training packing it all in together.

Egypt won't be at all bad for him; heaps better than France and safe as houses or safer. There are all types of regiments represented here. A number of Anzacs who tell us quite a lot about Egypt. And from what I can gather the enemy there haven't half the guns and various death dealers they have round this front.

Jolly shame to have both of us away at once, but there, keep up stout hearts. The good old days will repeat themselves again some day, with some improvements alongside. We shall all appreciate the best things better than ever before.

Well, so long for a bit. I shall have to run with this to catch the early post.

Living like a lord, feeling strong as a lion.

Your loving son

Len

September 10th 1916

Dear Mum & Dad,

You will quite think I have forsaken you – but no fear I dinna forget, rather I've been really kept busy each day which leaves little inclination to stay indoors for the evening, and after all there's nothing of note to pack out a letter. To tell you I am absolutely happy, well and fit – the war's still on – the weather lovely, just sums up every bit of news.

So Sid's had his long leave eh. I am anxious to know his destination. Wouldn't it be a great handshaking business if we met in France. But better still if the war ended quick and lively so that there was no need for him to leave Blighty at all.

I hear leave has started again and with it my hopes for another chance of having a second lovely spell as last time.

You did indeed have an exciting time with the Zepps. Wasn't it a grand deed the airman performed[1]. You can crow over me a bit for, though I have been so long in the front seats, I have not witnessed such a really stirring unique affair as a Zepp in flames. I am very thankful the crew had not previously caused any damage near home.

1. On 3 September 1916 William Leefe Robinson became the first pilot to bring down an airship over Britain, and was awarded a Victoria Cross for his efforts.

Can't bear to think of the consternation it would cause to dear Mum or any of you.

Went for a walk to a Y.M.C.A. some way out the other night and heard a most entertaining educational lecture on "singing", quite a novel affair. Lasted an hour and a half. Started off with Dr Walford Davies giving us a talk on the way to sing, then later the audience had to sing under his guidance. He was very critical, kept stopping us and pointing out errors and improvements in a very jovial way. By about half way through the evening we were all singing like a choir – quite well. All the finest old songs that Uncle Ted likes. I much enjoyed it.

I am now on a Christmas card job, designing the cover, and then inside covering the double page with a wash drawing which I shall make of the Hospital and grounds. So you see I am getting good practice at the right kind of stuff. They do not pay me for the jobs but I am quite content to be sure. It keeps me here and is far superior to any other jobs I would otherwise have to do.

That's all at present. Trusting you are bright and breezy, bonny and well.

Your loving son

Len

October 9th 1916

Dear Mum & Dad,

Well things are going along in just the same old way at my little home of rest. I've actually been here for over two months now and in top hole health.

Have certainly got the best job in the whole outfit. No hard, tiresome spells like the other part of my service, but just quietly allowed to proceed with my work of which they continue to find me plenty to do. Have just completed a large Roll of Honour, on which are to be inscribed the names of poor fellows who have succumbed to wounds or sickness while patients of 32 Stationary Hospital. It's an elaborate illuminated thing on which I have spent a fortnight's hard work, so you can tell it looks pretty busy. I feel awfully pleased with it and have been highly praised by the Colonel and other people that matter. Of course at biz in the ordinary way it would be worth quite a tidy sum of money, but my present reward suits this child down to the

ground, which is of course the prolonged stay here; the certainty of a good rest every night; the sense of security and the excellent meals.

A word of warning dears. Don't be alarmed when I suddenly get my travelling ticket to go up yonder and leave the back of the front and all the good things behind. For belonging to a fighting unit as I do (and here my chest swells with pride, tut tut) the authorities here must not keep me a single day when the time comes that my battalion sends for me (which is the usual thing for them to do). Can't think how they have managed all this time without me. But there, away with the suggestion of leaving here just yet. Living a day at a time is wisdom and joyous – and then when the full stop comes, well you can rest assured Len will go back to it with as good a heart as any one. Wonder when that will be eh? Not too long now methinks.

Peary is up in Manchester now but I don't think he will remain in hospital long, so look out for him.

Am right glad Sid has not come out yet – it puts off the anxiety stage for you dear ones, but of course when he does come, then even you must not worry. I have got through some busy times unharmed – no reason why he shouldn't.

Don't think I am hard up for paper, just happened to go Y.M. for a coffee and bun and sat there writing.

Your loving son

*Len*

October 22nd 1916

Dearest Mum & Dad,

Had such a gorgeous letter today from the sweetest spot in all the world which accounts for the sumptuous miniature banquet that I have just rendered "happo fini" at this Y.M.C.A. hut.

If at any time you feel you must out of sheer love send "somefink" well mark it down to me in the spirit but put dear Sid's name and address on, because I know he's not so used to soldiering and going without ability as I, yet. Besides at present I am in no need whatever. Folks oft tell me how much I have improved in health down here, and I know so many good friends that I can get just all I ever want. I can see a gorgeous Xmas time should I still be here.

The shop where I have been getting my materials for work, lately,

is kept by some French people who for some reason or other have taken a great fancy to me. It is a large business and they are obviously well-to-do. By just doing something in an autograph album and a little designed card, they have been exceedingly good to me. Whatever I buy in paper, ink or paint they flatly refuse to accept money for – and it tells up, with the lot of stuff I get through.

Last Monday I was invited to tea, a gorgeous affair I can tell you, and they being able to speak fluent English, I enjoyed a very entertaining conversation and spent an hour or two afterwards looking at some wonderful old paintings, photographs and books.

Have to go again tomorrow, to Sunday tea and dinner – a wee bit homelike it will seem again; Bible class at the English Church in the afternoon, out to tea and then to service at the Y.M.C.A. with my friend Harper and other chums in the evening.

The Authorities here are endeavouring to do me a good turn by getting me transferred to a special corps of Royal Engineers, when the time comes that I must leave 32. Of course it's only a perhaps – at present – nothing may come of it. But I tell you for interest and I have some reason to hope, considering the powerful influence to be exerted on my behalf. Should it come off, I should be on a permanent Artist's job at the works at Wimereux. A permanent base job. Tres bon eh?

The Xmas card orders have now reached fifteen hundred, some tribute to Leonard eh? Have got through another Roll of Honour this week, and have at present ten jobs on hand so you see I am kept going.

Through Mr W.G. Smith will you ask Dickens to write me about the old battalion and send him my best wishes.

Thanks for I.C.S. Mags – have interested quite a number of folks. Again thanking you for all things.

      Your loving son

        *Len*

Wimereux,
Saturday November 10th 1916

Dear Mum, Dad & Nibby,

It was indeed good to get a letter from you, one which seems to have suffered unusual delay – about a week in transit. Am happy to know you all remain so well and as for myself I am in tip-top health.

I can quite imagine your great joy at having Sid home once again. I too jump for joy at every little incident that delays his coming out here. I guess you didn't in the least mind going down to the door even at midnight.

It seems to point to his coming eventually, in fact I begin to expect to hear that he's in France in the very near future, and I assure you a groan will ascend from this child then.

The weather has been extremely boisterous over this way just of late making the marquees almost uninhabitable. To be at the seaside in winter time is some experience, though the sea looks at its best when most angry I think. All the patients have been moved from the tents down to the newly erected huts and most of the convalescent section dispersed, tho' I seem to stick on through many changes. For the last week or so I have been quite alone in my little bell-tent studio, but yesterday I was told to move into a little wooden hut, hitherto used as a small dressing room. It makes a charming little workroom, plenty of light, warm and secluded. I quite fancy myself and itch to decorate the walls and paint a becoming signboard outside.

I must really, right now tell you the finest bit of news I know at present. Last Saturday I had another interview with the C.O. of the Royal Engineers, and he said (after taking numerous particulars) that he would fix me up as soon as possible. Meanwhile Colonel Barnes would keep me here at the Hospital until required. So now this big matter of moment to me is practically settled, and I shall be duly installed as an artist on special work. Grand isn't it! You won't have to bother and be anxious about my welfare anymore, for to be at the base here is safer than London nowadays.

I can never thank you dear ones enough for the apprenticeship – it introduced me to a business that has meant wonders to me in Army life. Think what it has meant, and will continue to be to me if I stop away from the horrible side of war for duration. They have some first

class artists on the staff over there, and to be among them will be some considerable art education.

I think it would be wise to have my spectacles out if you will send them, for I want to look after my eyes well.

It will give me great pleasure to send as many Xmas cards as I can get hold of. I think the least they can do is to give me a few, and I expect they will.

Of course still send letters to 32 until I acquaint you of new address, because I am to stay here until sent for by the Royal Engineers.

Would Dad please print me a nice little card with my private address on – Artist and Designer – or if that last block of mine could be found – a few cards off that would do admirably. The reason being that I constantly meet men of quite good standing at home – men who might be very useful at some future date. A card might probably remind them of my business. Thanks very much for cover papers – shall readily use them up you may be sure.

Still getting along famously with my French friends, and am seriously being taught the language by this very kind old lady, starting right at the alphabet like a schoolboy. Shall be able to parlez vous with Nibby alright when I come on leave.

That is one of the chief points of my new job; it may bring leave very near. It is getting on for a year since the last. Then won't we have a lovely time. It will even be more enjoyable than the previous one – knowing I would not be coming back to the blood and thunder part.

Well, that's all at present. Will close with heaps of love.

Len

P.S. Might I suggest a little thing that us boys would treasure much. You both get your photo taken together to send us for Xmas. Being away from home makes photos invaluable and I should love one to put up on the wall of my dug-out, cabin, etc., alongside of Jessie's.